D1426389

THE
UNSEEN
LUSITANIA

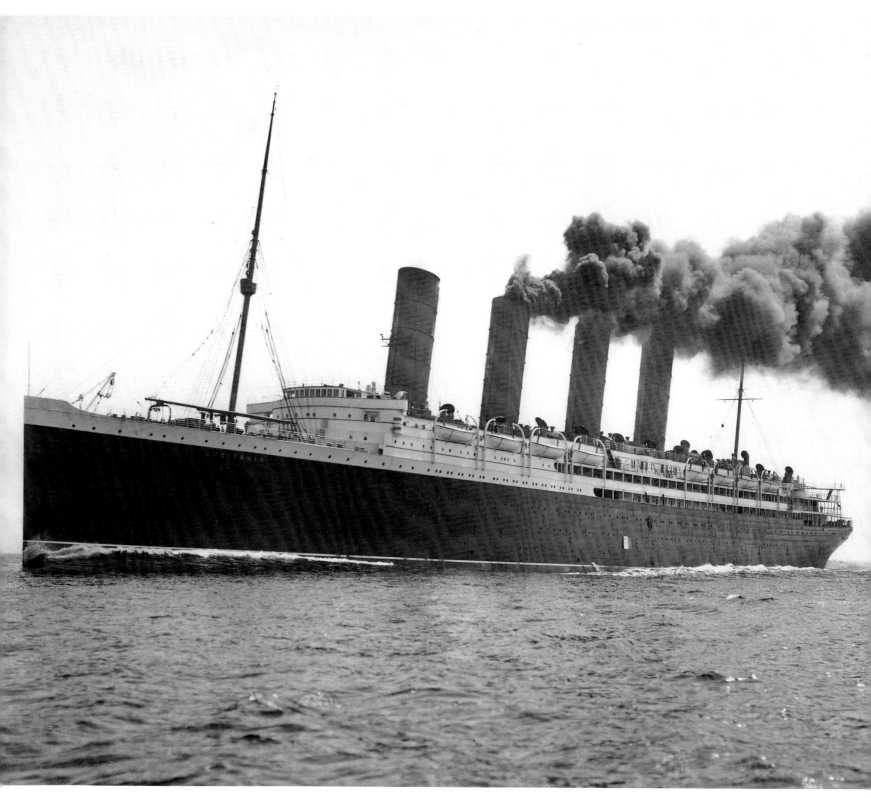

RMS *Lusitania*.

THE UNSEEN LUSITANIA

THE SHIP IN RARE ILLUSTRATIONS

ERIC SAUDER

To the naval architects who drew her, to the employees at John Brown's yard who built her, and to the passengers and crew who gave her life.

First published 2015
Reprinted 2015

The History Press
The Mill, Brimscombe Port
Stroud, Gloucestershire, GL5 2QG
www.thehistorypress.co.uk

British Library Cataloguing in Publication Data.
A catalogue record for this book is available from the British Library.

ISBN 978 0 7524 9705 1

Typesetting and origination by The History Press
Printed in Malta by Melita Press.

CONTENTS

ACKNOWLEDGEMENTS

A project like this could not be undertaken without the help of a great many people. At the top of the list is Brian Hawley, who deserves a special thank you for his patience in guiding me through the tangled web of Cunard's finances and the near collapse of the company at the beginning of the last century. He has been a constant sounding board for many ideas, and I am especially grateful for his spending countless hours in libraries and archives throughout the UK, helping me uncover much of the information and many of the photos contained in this book.

Thanks to Paddy O'Sullivan and Geoff & Alma Whitfield for their never-ending support over the years, for which I am most grateful, and to Dan Cherry for his photo work, which has made a huge visual impact on the book.

Although they have now all passed away, thanks must go to the following *Lusitania* survivors for their generosity in sharing their experiences with me and for allowing me access to so many of their family photographs: Chrissie Aitken Barnett, Desmond Cox, Alice Lines Drury, Avis Dolphin Foley, Elsie Hook Hadland, Frank Hook, Audrey Pearl Lawson Johnston, Barbara Anderson McDermott, Cecil Richards, Edith Williams Wachtel, John Edward Williams, and Nancy Wickings-Smith Woods.

Many relatives of *Lusitania* victims and survivors also kindly allowed me to use images from their family albums: Dorothy Bell, Andrew Cockburn, Margaret Collister, John Crank, Patricia Darby, Gwen Fairfoull, Margaret Frankum, Audrey C. Fraser, Helen Johnson, Prudence Jones, Karen Kingswell, Harding Macdona, Kit Abbott Mead, Patricia Abbott Michl, Joyce Ramsbottom, Paula Rosal, Tony Scott, and Hallie Slidell.

Thanks also to Peter Donnelly at the King's Own Royal Regiment Museum, Lancaster, England, and the late Walter Lord for the use of their photos.

The following friends and associates have helped in ways both big and small throughout my years of research and the preparation of this work: Craig and Shara Anderson, George Behe, Leigh Bishop, Marcus Chapman, John Chatterton, Alex and Angela Cheek, Mark Chirnside, Alexandra Churchill, Margie Clark, Joyce Cox, Peg Cronk, Peter Engberg-Klarström, Eddie and Barbara Gochenour, Ben Holme, Eric Longo, Don Lynch, Senan Molony, Patrick Mylon, Mike Poirier, Jonathan Quayle, Chris and Cindy Sauder, Ella Sauder, Alicia St Leger, Russ and Sandy Upholster, Braxton Williams, Stuart Williamson, and Iain Yardley.

The kindness of Siân Wilks and Lorna Goudie at the Sydney Jones Library, University of Liverpool, is very much appreciated.

And finally a thank you to Amy Rigg, Chrissy McMorris and Declan Flynn at The History Press for their incredible patience while this book was being written.

AUTHOR'S NOTE

The history of RMS *Lusitania* is a complex one. Despite her relatively brief career, her life was so rich that it would take a multi-volume set to do her full story justice. The intent of this book was not to tell the complete history of the ship in an unwieldy volume, but rather to showcase this exquisite liner in clear and mostly unpublished photographs, allowing the reader to experience her in a way never before seen in book form. Decades have been spent gathering these photos, and those that were chosen for inclusion tell her story.

The overriding consideration for deciding on the images can be summed up in just two words – 'clear' and 'rare'. The majority of photos presented here have never been seen in print, and the ones that have been were chosen for specific reasons, mostly because they are full of detail that had never been seen before.

With only rare exception, all information in this book came from no sources other than official memos, correspondence, board-meeting minutes, shipbuilding committee minutes, etc., from Cunard or John Brown, Ltd.

In quoted material, all original spelling and punctuation has been retained, and except in direct quotes, the present-day town of Cobh is referred to as Queenstown throughout for consistency.

INTRODUCTION

Lusitania. To most of the world, the name conjures up thoughts of a long-ago war and the needless loss of human life. To maritime researchers, however, she is much more than the sum of her final eighteen minutes. Her story is about the two sister ships that helped save Britain's most well-known steamship line from near-certain financial ruin. It is about years of faithful service. It is about what came before and what came after those fateful eighteen minutes on 7 May 1915. *Lusitania* and her sister, *Mauretania*, were the bridges between the transatlantic steamers of the nineteenth century and the superliners of the twentieth. Despite being the most technologically advanced vessels in the world when built, in some ways they looked back to the simpler ships of the nineteenth century. In other ways, however, they were the forerunners that looked forward to the great ships of state of the 1920s and '30s.

Lusitania's sleek profile instantly set her apart from anything that came before or after. She and her sister were the culmination of Cunard's 1903 agreement with the British Government that propelled the company to the fore and set them up to dominate the Atlantic for the next sixty years. They were also the beginning of the long and comfortable association between Cunard and the government that found each there when the other needed them. Without these two superb liners to lead the way into the twentieth century, Cunard almost certainly would have ceased to exist, and to them the ships that followed owe a debt that cannot be overstated.

Eric Sauder
At sea on board *Queen Mary 2*

'AN OCCASION ... OF NATIONAL INTEREST'

HRH Princess Louise, The Duchess of Argyll

House Flag & Funnel.

The Cunard Board of Directors was stunned. A confidential, coded telegram had just been received from Vernon Brown, Cunard's agent in New York, that Bruce Ismay, Chairman of Cunard's chief rival the White Star Line, had just sailed on White Star's *Celtic* to New York to complete a deal for the sale of White Star to the American-owned International Mercantile Marine Co. (IMM). The voyage was a closely guarded secret, but because IMM had recently acquired numerous British shipping lines, Brown had kept his eyes and ears open and discovered that, by early 1902, White Star was in final negotiations with IMM and was about to accept an offer to be added to the American company. Ismay was coming to New York to make it official.

For the past few years, Cunard had been losing its preeminence on the Atlantic. The company had not built a new transatlantic liner for the Liverpool-New York service since *Campania* and *Lucania* in 1893. Since 1897, the two major German steamship companies had built five fast, new four stackers, and White Star had begun construction of their 'Big Four' and their brand-new *Oceanic* of 1899 was already in service. Cunard had to do something. But what?

Born 17 September 1861, George Arbuthnot Burns was the grandson of John Burns, one of the founders of the British & North American Royal Mail Steam Packet Company, now known as the Cunard Line. Upon the death of his father in 1901, he became Chairman of Cunard at one of the most critical points in the company's history. After long negotiations with the British Government, he successfully finalised an agreement that produced *Lusitania* and *Mauretania*. Lord Inverclyde died on 8 October 1905, at the age of 44.

For the first few months of 1901, Cunard itself had been approached by various sources making inquiries about buying the company, including from steamship magnate Sir Christopher Furness. Furness wanted to add Cunard to his holdings. In fact, the purchase of Cunard seemed very likely because of their weakened condition.

Vernon Brown wrote to Lord Inverclyde that '... it is somewhat strange that no overtures [by IMM] have been made to the Cunard people either direct or through me ...' One of the reasons for this, as Brown pointed out, was that: 'Our present fleet in the New York Service consisting of two single screw ships seventeen years of age and two twin screw ships eight years of age, all of which have fallen off so materially in speed, may not be deemed of sufficient importance to induce them to consider our demands ...'

With IMM's recent acquisition of White Star, Lord Inverclyde had only one chance to ensure Cunard's survival. His first step was to approach the British Government about increasing Cunard's operating subsidy, which was vital to the company. The request for the loan to build the two new steamers would come later. So important was the additional subvention that Inverclyde testified before Parliament that without the increased subsidy, Cunard could not and would not build any new fast ships. The company was in such a weakened position that no one expected them to survive on their own. The consensus was that the company would either be bought or go under, but Inverclyde would not give up and, in the end, saved Cunard by his expert manipulation of the situation.

Although they first resisted, the government realised that it had no other option but to come to an arrangement with Cunard. After months of negotiating, on 8 August 1902, Inverclyde wrote to Cunard Board member William Watson to advise him that an agreement had been reached the day before:

> At last my labour has had some result, but, in the end everything has been carried through with such rapidity that I hardly realise that it is all done with ... The whole matter was before the Cabinet yesterday, but, at any rate, it was done and it was finally left to Mr. Gerald Balfour and myself to conclude the matter.

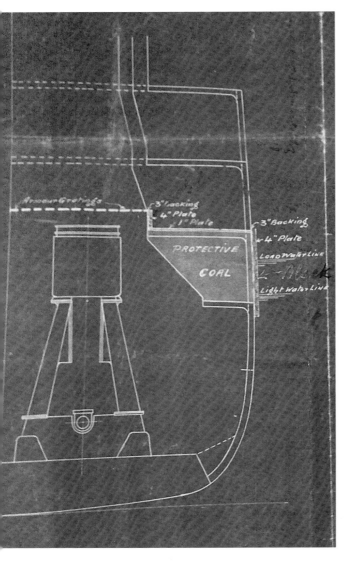

An extremely early, undated plan showing one possible arrangement for the protection around the machinery spaces on *Lusitania* when the design still called for her to be fitted with reciprocating engines.

Of course the least satisfactory part of it is that the Cunard Company gain no immediate benefit. That is a comparatively small matter to the great future I consider is before it ... Meanwhile everything must be kept *most confidential* as the Government have not decided when, or how, they will announce the arrangement ...

I consider that it is one of the biggest and the most important arrangements which has ever been made between a private Company and the Government of this Country.

One of Inverclyde's only disappointments with the agreement was that Cunard would receive no additional government subvention until the new steamers were completed. He did manage to arrange, however, that Cunard would pay no interest on the loan until the liners entered service.

With the government backing in hand, Cunard sent out tender requests to a few shipbuilders in the UK, and among these was Vickers Armstrong & Fairfield Shipbuilding. When the official announcement was made that Cunard was building two new liners, numerous other shipbuilders asked to be allowed to tender as well. One request came from a German shipbuilder at Stettin. The shipyard understood how unusual the request was because one of their assurances was that the ship would be built using all British materials. Cunard politely declined, commenting that 'their offer cannot be entertained even under the conditions proposed by them.'

By the beginning of 1903, Fairfield had dropped out of contention for the contract for several reasons, the most important of which was that they would not submit a maximum price for building one of the ships. The company stated that it would only build the liner on a cost-plus basis, the 'plus' being 20 per cent of the total price of construction. Cunard declined the offer.

Several months later on 8 May 1903, an interview was arranged at Cunard's Liverpool headquarters between the Cunard Board and agents from the two top construction candidates – John Brown and Swan Hunter. After the meeting, the shipbuilders' representatives were told that Cunard 'were inclined to favorably consider the placing of an order with each of them for one of the proposed fast steamers, provided they would meet and collaborate with the view to producing identical ships ... and submit for consideration of the Directors the result of their deliberations and show the steamer which they would recommend.'

After some preparatory consultation and design work between the builders, preliminary plans were submitted to Cunard, and the contracts were awarded. Because speed was essential, the engine machinery was one of the highest priorities of the design team, and there was some uncertainty about whether the new liners should be fitted with reciprocating engines or the new

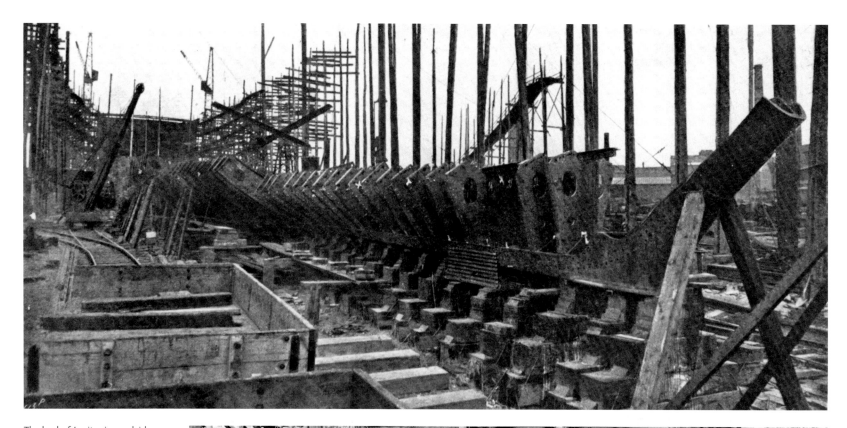

The keel of *Lusitania* was laid on 17 August 1904 by Lord Inverclyde. Much has been written over the years about the Cunarders *Caronia* and *Carmania* being used as test beds for deciding whether Cunard's 'new fast steamers' should be propelled by turbines or reciprocating engines. This, however, is not the case because Cunard memos show that the decision to use turbines on *Lusitania* and *Mauretania* was made almost a year and a half before the turbine-driven *Carmania* entered service.

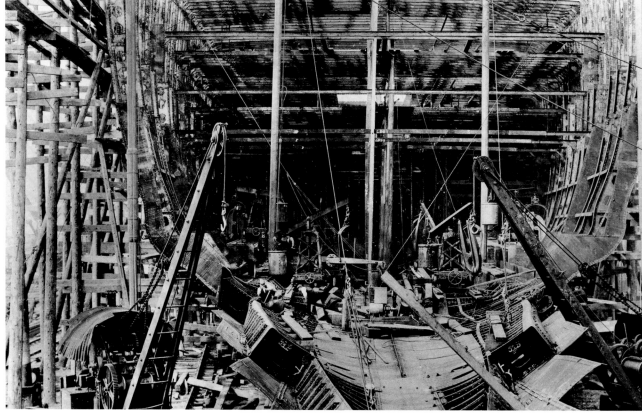

turbine technology. To answer that question, a 'Turbine Committee' was established. The Chairman was James Bain, Cunard's General Superintendent, and among the other members were representatives from John Brown and Swan Hunter. One of the most important tests the committee undertook was to run comparative trials using the newly built turbine ship *Brighton* and the reciprocating-engined *Arundel*. The Cunarders *Caronia* and *Carmania* had no influence on the decision because they would not enter service for another year. On 24 March 1904, after carefully reviewing all aspects of engine operation and comparing the performance of the two steamers, the Turbine Committee recommended that turbines be adopted for the new liners, and the Board of Directors agreed. On 17 August 1904, the keel of Hull 367 was laid at John Brown's yard on the River Clyde, and construction commenced.

Another question that occupied the Board of Directors from an early date was what the names of the new liners should be. By November of that year, the Admiralty was already asking Cunard to name their 'New Fast Steamers' as quickly as they could in an effort to make corresponding about them easier, although the Admiralty realised that this was no easy task. A flurry of correspondence was sent between various board members and Andrew Daniel Mearns, Cunard's Secretary, making lists of possible names. As soon as word leaked to the general public that two new record-breakers were being built, huge numbers of people sent in their unsolicited suggestions. To say that the names submitted by the public were interesting is an understatement. Among them were *Manfredonia*, *Oxia*, *Makaronia*, and *Karavi Nisia*. Among the top contenders considered by the Cunard Board were *Olympia* and *Britannia*, and another of the possibilities was *Aquitania*.

On 30 January 1905, James Miller, a Scottish architect, wrote to Cunard, hoping that he might be considered with the other contenders for a chance of a contract to design the interiors of one or both of the new ships:

I have learned your Directors desire to obtain designs for the internal finishings and decorations of the various Saloons and State Rooms of the two great ships which are at present being constructed for the Cunard Company. I would esteem it a favour to be permitted to submit designs for these. I have had large experience in designing interiors of the highest class, chiefly in mansion houses and hotels.

I believe from the practical experience, which for many years I have had, in designing and carrying out the internal finishings and decorations of apartments, of practically all sizes, and in various styles of architecture, qualifies me to undertake and to satisfactorily design and superintend the execution of the interior decorations of your Steam Ships.

The correct choice of interior architect for the liners would be critical to their success, and there was much discussion and even a great deal of anxiety among the Cunard Board members that the right decision be made; so Cunard asked many of the best designers in the UK for samples of their work. One of the first companies contacted was the well-respected firm of Mewès & Davis. In mid-May 1905, they replied:

We much regret that owing to the fact of our being already engaged as consulting architects for another shipping Company it will not be possible for us to act in that capacity for the Cunard Company.

On 3 June 1905, Lord Inverclyde wrote a memo to Andrew Mearns expressing concern about whether the architects who were being considered were what the company actually wanted. Inverclyde was apprehensive that few of them had ...

... any experience of designs and decorations for ships and it is so widely different from anything they have been accustomed to in connection with houses that I confess that I feel anxious in case we should be led into something which might not turn out successful. Looking at the matter all round I fear that my inclination is to leave matters very much in the hands of the Builders, as we have done in the past, but I know that the Board are inclined to try something else. I am quite willing to fall in with this but do feel that it is somewhat of a risky experiment.

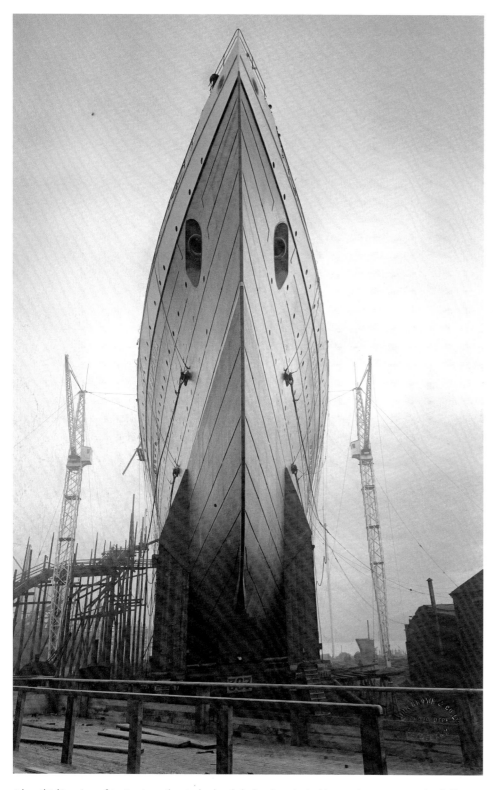

A breathtaking view of *Lusitania* on the stocks shortly before launch. At this stage in construction, her hull was insured for £750,000. Once launched and construction continued the insured value rose, and when the liner was complete the total insurance value was £1,250,000.

After several months of deliberation, the two top contenders had been narrowed down to Harold Peto and James Miller. Cunard liked Miller's work as well as his terms, but Peto's case was different. Although his work spoke for itself, Cunard felt strongly that he was being difficult, even demanding, and thought his fee much too high. In fact, Inverclyde was of the opinion that Peto should simply not be considered and that Cunard should look elsewhere. Peto stated that he would do all of the designs for both ships for a fee of £6,000. Another option he offered to the Cunard Board was that he would act in a solely advisory capacity for £2,000 for one ship or £3,500 for both. Cunard rightly decided that they would not consider giving Peto the commission for both ships until Miller had at least submitted preliminary designs to the company for their consideration.

Cunard found Miller quite accommodating, and his quoted fee for all the design work of *Lusitania*'s first-class public rooms, including about fifty of the special staterooms, was £2,000. If commissioned for the project, Miller stated that he would hire more staff and do all work in-house himself. He also offered Cunard the option of having him work solely in an advisory capacity. The fee for his consulting services would be £1,000 plus travelling expenses. He wrote that, if Cunard chose this option, he would consult on all first- and second-class public rooms as well as fifty of the best staterooms. All designing and draftsmanship, subject to Miller's criticism, would be done at John Brown. As an incentive to give him the commission, Miller also lowered his fee from 5 per cent to 3 per cent of the actual cost of the decoration.

Lord Inverclyde was insistent that the two ships not be designed by the same man. Miller's qualifications and the high quality of work must have impressed the Cunard Board because on 26 August 1905 they wrote and offered Miller the position of consulting architect for *Lusitania*. He quickly replied and accepted their offer:

I am in receipt of your favor of the 26th inst. and I hereby agree to act in an advisory capacity in connection with the preparation of designs of the interiors, etc., of the New Steamer (No. 367) all in terms of your letter, for a fee of one thousand guineas and all my travel expenses.

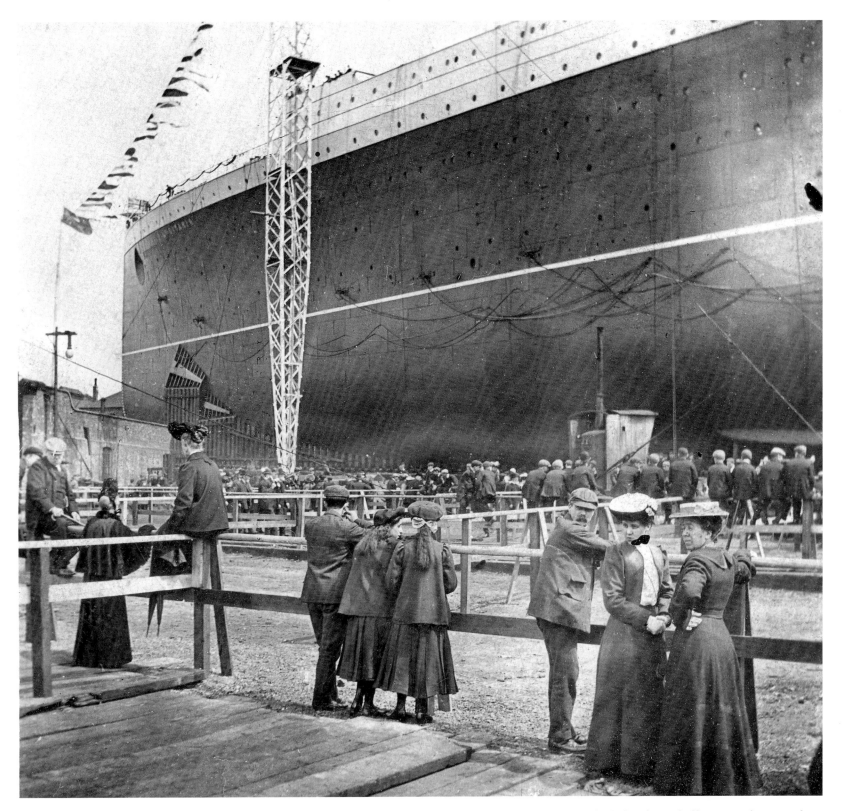

A snapshot taken on launch day as crowds begin to gather to find the best viewing location for the ceremony. Just under the bow, stands for the launch party had been erected at a cost of £1,100 5s 3d.

I desire to thank the Directors of the Cunard Company for placing this work in my hands. I need hardly say I full [sic] appreciate the honour of being associated with this great undertaking, and your Directors may rest assured that I will give the work my best attention and do everything in my power to make it a success.

The question of what to offer Peto, if anything, was put off for the time being. In the end, however, Cunard decided to give the *Mauretania* commission to him. He received 5 per cent of the 'total amount expended on the work ... not to exceed £4,000,' and in any case, his fee could not be less than £3,500. Under his direction fell all the designs for first-class public rooms, about fifty of the best staterooms and baths, and he acted in an advisory capacity for the second-class spaces. The actual design work for second class was carried out by Swan Hunter.

In the very early stages of designing the new liner, the Board of Directors at Cunard turned to about three dozen of their longest-serving senior sea staff for input on what design points could make the liner better – for

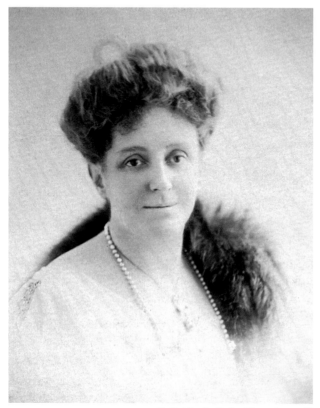

Mary, Lady Inverclyde, wife of the late Cunard Chairman. Despite still being in mourning for her husband, who had died the previous October, she graciously consented to launch *Lusitania*.

The King's Own Royal Regiment Museum, Lancaster, UK

both passengers and crew. Since the names of the ships were not yet known, the were referred to in memos simply as the 'New Fast Ships'.

One of the most frequent suggestions that the officers had was that water closets and bathrooms on the ships should be kept separate. Another was that the dining-room tables should be arranged for fewer people and seat no more than 8–10 passengers, rather than the old style of dormitory seating on the older ships. The chairs, it was thought, should also be bolted closer to the tables.

The reports from the pursers and captains were usually the lengthiest and ran to multiple pages. The suggestions submitted by Purser James McCubbin (who was later lost on *Lusitania*) was the longest at ten pages, and most of his suggestions came directly from complaints of passengers. On the other hand, the chief engineers had very little to say, most of their suggestions being limited to a single page. One engineer was quite upfront about his lack of suggestions because 'turbine engines are entirely new to me.'

The ships' surgeons generally wanted several small hospitals rather than one large one to avoid any cross-contamination among patients, and at least two wanted a small padded cell to hold 'alcoholic maniacs'.

Cunard's Chairman, Lord Inverclyde, became ill and passed away on 8 October 1905. Before his death, he had been in correspondence since the previous March with a Professor Ramsey of Glasgow University about choosing the names for the liners. The final decision to name the ships *Lusitania* and *Mauretania* came on 15 February 1906, and the following day, Cunard cabled the news to their New York office and asked that the information be forwarded to the Boston and Chicago offices. The cable was sent in code so it could not be intercepted and read. Cunard informed John Brown and Swan Hunter of the decision on 22 February.

Now that the names had been chosen, Professor Ramsey was again consulted by Cunard. At the time, there was some disagreement about how the name given to the English-built ship should be spelled – *Mauretania* or *Mauritania*. Ramsey wrote that, although both spellings were correct, because the liner was being named after an ancient province it should be spelled with an 'e' not an 'i'. Just to be certain, however, Ramsey

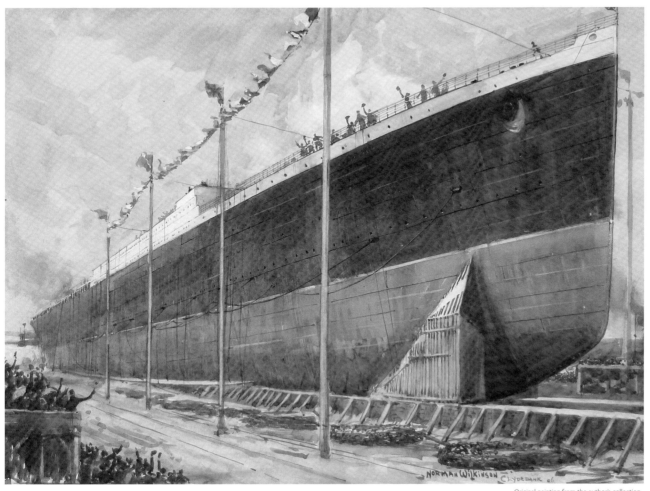

Original painting from the author's collection

Shortly before the launch, famed maritime artist Charles Dixon wrote to Cunard to inquire if they would consider allowing him to paint the official portrait of the launch. Ultimately, that honour went to the equally famous Norman Wilkinson, who produced this work of the new liner sliding into the Clyde. The painting was given to Mary, Lady Inverclyde, and the inscription on the matte reads: 'To Lady Inverclyde – With kindest regards, Norman Wilkinson.'

had consulted with several experts, including the staff at the British Museum.

For reasons that are still not clear, the final decision about one of the more important public-relations matters concerning the christening of *Lusitania* was put off until just a few weeks before the scheduled launch date. Initial thought had been given to who would name the liners a year earlier when Cunard considered asking the Princess of Wales (later Her Majesty Queen Mary) to launch *Mauretania* because the Prince of Wales (later King George V) was going to be in Newcastle around the anticipated launch date. Nothing came of this, and with other more urgent matters taking precedence, the matter was forgotten. By April 1906, however, Cunard realised that they had

no one to christen *Lusitania*. One of the first names suggested as a possibility was Her Royal Highness Princess Louise, daughter of Queen Victoria.

On 19 April 1906, just seven weeks before *Lusitania*'s scheduled launch date, Cunard wrote to Captain W.G. Probert, equerry to Princess Louise, to request that the Princess consent to launch their new ship:

The Directors of the Cunard Steamship Co. Ltd are very desirous that Her Royal Highness The Princess Louise should do the Cunard Company the honour of christening their new Quadruple Screw Turbine Steamer 'Lusitania', now being built for the Company by Messrs John Brown & Co. Ltd at Clydebank for their Passenger and Mail Service between Liverpool

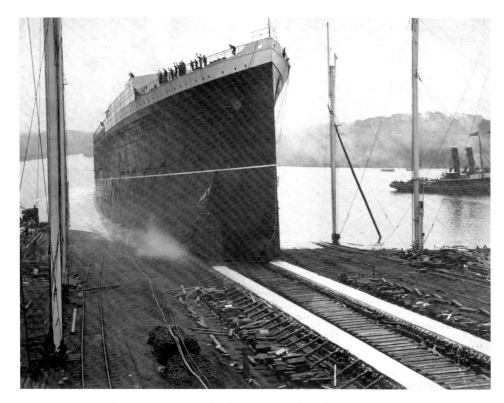

Over the course of a few months, £14,141 7s 11d had been spent dredging the Clyde and the River Cart in anticipation of *Lusitania*'s launch to ensure that everything went off without a hitch. John Brown employees were given the day off in celebration of the event, one paper stating that 'Clydebank public houses were well patronised' that day.

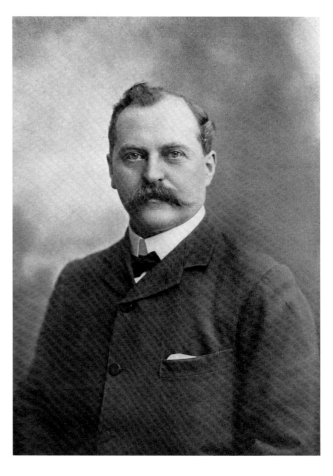

Leonard Adolphus Peskett was born to Edwin and Henrietta Peskett on 13 April 1859. He joined Cunard in 1885 and stayed with the company for the rest of his career, designing some of their most famous vessels. Peskett was awarded the OBE on 4 June 1918 for his services during the war. Despite becoming Cunard's Chief Naval Architect, he only travelled to the United States on a handful of occasions, the last being on board *Berengaria* a few months before his death on 7 March 1924.

and New York, on the occasion of the launching of the vessel on the 7th of June next.

I am informed by Lord Inverclyde that he has also written you today in regard to this matter and I am therefore sending you this letter of formal invitation in order that you may place the matter before Her Royal Highness.

The 'Lusitania' is one of the two Steamers which are being built under an arrangement with His Majesty's Government, and will be armed as Auxiliary Cruisers. The Steamers when complete will be the largest and fastest Passenger Steamers in the World. Under the circumstances it is felt that the Christening Ceremony of the 'Lusitania', which will be the first of the two Steamers launched, is one of great and even National importance, and it is sincerely hoped that Her Royal Highness may be pleased to favourably view the request, which if acceded to would, without doubt, give the liveliest

satisfaction to all concerned and the public of Great Britain at large.

Unfortunately, as written by Probert, previous obligations made it impossible for Princess Louise to alter her schedule:

The Princess Louise desires me to express her great regret that owing to arrangements for June already made, which it has been found impossible now to alter, she will be unable to accede to your Directors' request that she should perform the ceremony of christening the new Turbine Steamer 'Lusitania.'

Her Royal Highness desires me to intimate that it is a personal disappointment that circumstances have prevented her assisting on an occasion which she regards as of national interest.

Immediately after Princess Louise declined the invitation, Cunard turned to Lady Inverclyde, widow of the former

company Chairman. On 11 May 1906, Cunard Liverpool informed Cunard's office in Clydebank of the positive news that Lady Inverclyde had consented to perform the naming ceremony, despite the fact that she was still in mourning. Cunard Clydebank passed along the information to John Brown.

Now that the matter of who was to launch the ship had been settled, attention turned to who should receive official invitations from Cunard and John Brown to attend the ceremony. Lists were quickly made by both companies and invitations sent out. A large number of people were forced to decline because of the short notice although many of them then asked to be included on any trial trip the ship undertook. Not surprisingly, souvenir hunters came out of the woodwork, and Cunard received hundreds of letters requesting launch invitations as souvenirs as well as for tickets to the launch.

Thursday, 7 June 1906 was a lovely day. Guests and observers started gathering several hours before the launch to ensure the best possible vantage point. All through the shipyard and across the river, noises could be heard as workers removed the supports that had held the hull to land for so long. Punctually at 12.30 p.m., Mary, Lady Inverclyde, stepped up to the button that would send the ship on her first voyage. In front of 600 invited guests, she said a few words, pressed the button, and, after a brief delay, the liner slid effortlessly into the river.

Anticipation was running high throughout the world for news of the launch, and despite rumours that *Lusitania* had stuck on the ways before beginning her journey, everything went off without a hitch. So anxious, in fact, was the Cunard office in New York that they cabled Liverpool asking for a full report of the day's events. Liverpool's reply was short and to the point:

About a year was spent fitting out the ship to make her ready for passenger service. The large Titan crane just above the liner's fourth funnel was commissioned in 1905 and completed in 1907. It was constructed by the same firm that had built the Arrol Gantry at Harland & Wolff under which *Olympic* and *Titanic* were built. The total cost for *Lusitania* came to £1,651,870 16s 1d, about £350,000 more than the original 1903 estimate.

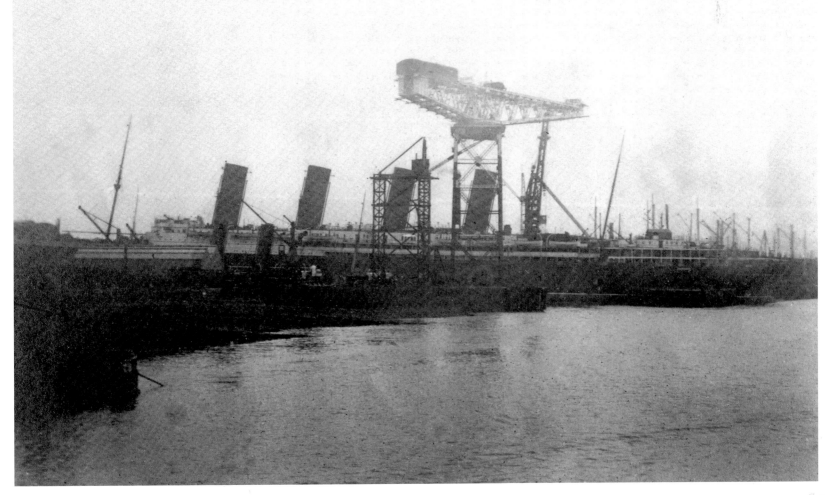

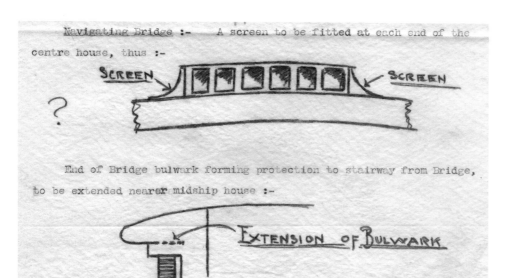

Navigating Bridge :- A screen to be fitted at each end of the centre house, thus :-

End of Bridge bulwark forming protection to stairway from Bridge, to be extended nearer midship house :-

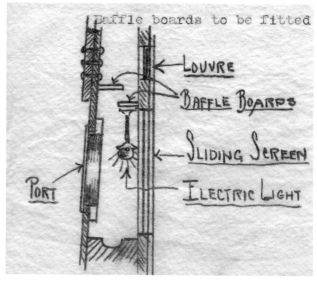

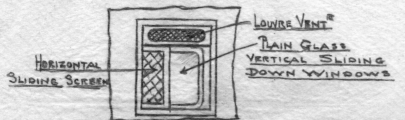

In the "Lusitania", the windows are without astrigals, fitted with plain glass and a sliding screen in front, thus :-

It was decided to leave the windows fitted with plain clear glass as it would be more cheerful for passengers dining to be able to see outside. The 3rd class have plenty of promenade at the fore side of the Restaurant, a collapsible gate to be fitted in an approved position to mark the boundary of the deck area allotted to them for promenade.

Archway to Stateroom Corridor at foot of Main Stairway on Upper Deck :- This as fitted on the ship is out of line with the corridor. It was decided to fit the arch at the corner of the after stateroom on corridor, leaving the web of the arch nearest the ship's side to screen the after state room doorway, thus :-

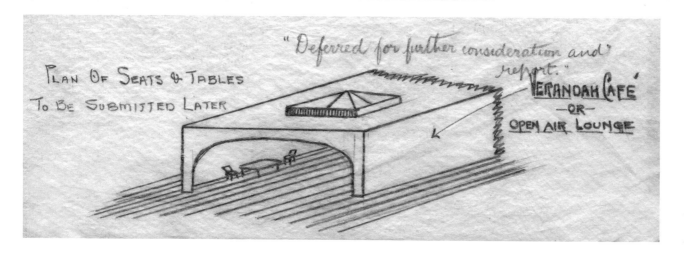

A sample of drawings which illustrate the various changes and alterations during construction.

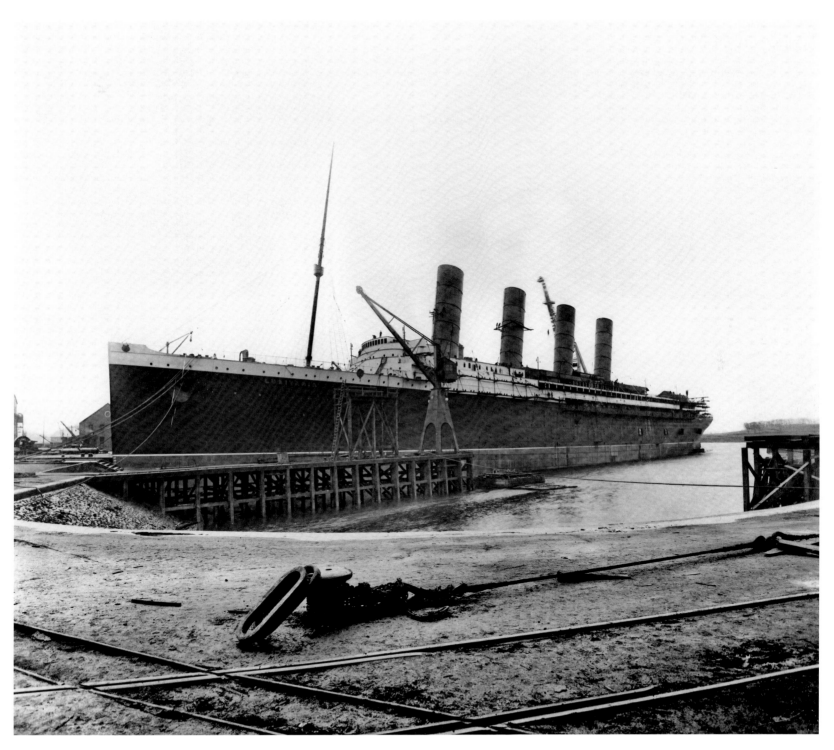

In the fitting-out basin at John Brown in early 1907.

Replying your cable today. *Lusitania* now largest vessel afloat. Successfully launched twelve thirty today. Glorious weather. Great enthusiasm. Christening ceremony performed by Mary, Lady Inverclyde. Distinguished guests included Directors Cunard, John Brown, Representatives British Admiralty, American and Foreign Governments, Lloyds Register, Lloyd's Underwriters, Presidents leading British and American Commercial Institutions. No special incident.

Everything carried out marvelous precision without slightest hitch. Immediately after launch, vessel placed under crane in outfitting dock to receive boilers, machinery. Graceful lines and noble proportions universally admired.

To celebrate the event, selected guests attended a multi-course luncheon in the yard's moulding loft, which had been transformed into a dining room. Cunard and John Brown spared no expense for the luncheon, the total cost of the event being £1,412 17s 8d a not-insignificant figure in those days.

During the construction of *Lusitania* and *Mauretania*, John Brown and Swan Hunter were each paid monthly for the completed work. So that Cunard did not have to put up large amounts of cash, regular payments were made by the Admiralty to the shipping line, and the funds were then disbursed. For example, on 21 September 1906 Cunard wrote to Barclay's Bank telling them that the Admiralty had paid into 'this Company's No. 3 Account, the sum of £155,641 5s 11d,' and that they should make out cheques as follows: '£64,548 2s 2d to John Brown & Co., Ltd, Clydebank, on account of 'Lusitania', as per Auditors Certificate No. 17, for the month of August 1906; Swan Hunter £90,833 10s 10d; Cunard £259 12s 11d.'

Regular reports about the progress of the liner were made by James Bain. After his inspection of the liner on 16 January 1907, he wrote to the Cunard Board:

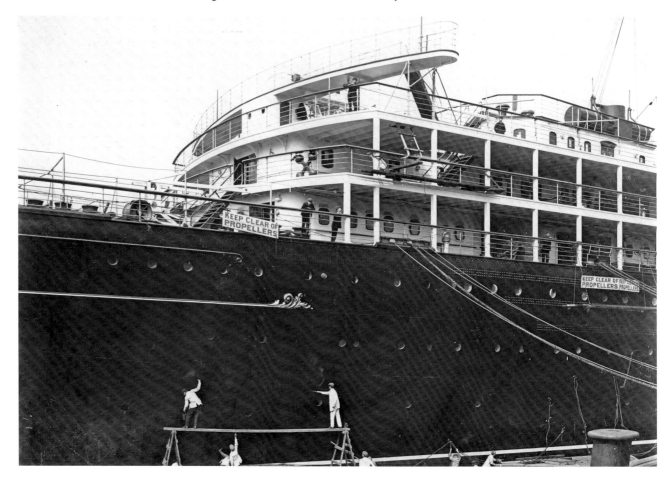

As fitting-out continued, saving money wherever possible was always a consideration. For example, it was decided to reduce the number of lights in the public rooms throughout the ship by 650. For this one alteration, the savings totaled around £3,000.

On the 14th and 15th instant, visited S.S. 'Lusitania' at Clydebank. Good progress is being made with the work to both ship and machinery. Two bottom portions of High Pressure Turbine Casings and one High Pressure Rotor are now in place on board.

It is probable the ship may be able to be taken down the Clyde about the first week of June when it is expected the tides will be most suitable. The ship may not be quite completed by that date, and a certain amount of work will have to be done at the Tail of the Bank.

Alterations were constantly being made to the design as details for the ship were finalised. For example, on 22 January 1907, the position of the lifeboat winches was changed. The original design had called for them to be located on Boat Deck, but because of the limited amount of space on deck, they were mounted up on Top of House, away from promenading passengers.

On 9 February, several Cunard Directors, naval architect Leonard Peskett, and designer James Miller travelled to Clydebank to inspect the progress on *Lusitania*. Following the visit, a memo was submitted to the Shipbuilding Committee. This extract gives some insight into how far along the liner was.

A part of the panelling at sides, and a part of the roof of the 1st class Dining Room on Upper Deck, had been prepared for their inspection. The panelling on sides and the roof was finished in white enamel. The mouldings, capitals, etc., on the sides have been gilded in accordance with the designs prepared by the Architect and were approved.

The ceiling was in plain white enamel; Mr. Millar [*sic*] explained to the Directors the various curved mouldings on the ceiling he intended to have gilded. It was decided that the amount of gilding to be done to the ceiling was to be left to the discretion of the Architect.

While the ship was under construction at Clydebank, a large model and case were commissioned for display at Cunard's office on Cockspur Street, London. As designed, the length of the model was 14 feet 6 inches. The case

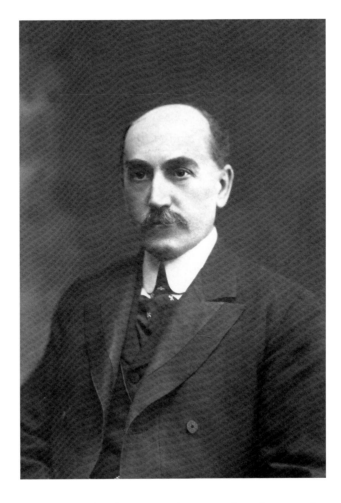

Andrew Daniel Mearns was born in Belfast, Ireland in 1857, and by 1871 his family had moved to Liverpool. After joining Cunard, his superb business skills allowed him to become Company Secretary in 1898, and he was made General Manager of the company on 27 May 1907 at a salary of £1,500 per year. He was the first General Manager of Cunard to be elected to a seat on the Board of Directors. Mearns died on 6 December 1925.

was made of mahogany and gunmetal, and was to be airtight. Because of its size and weight, the model ran on rollers within the case, and both ends of the cabinet were removable so that the model could be taken out from either end. The model makers guaranteed the work for five years, and any defect arising during that time, either through quality of material or workmanship, was to be made good by the makers at their expense.

Just a few weeks before the ship began her first set of trials, a memo was sent to Cunard's General Manager with a report of a recent visit to *Lusitania*, finding 'generally speaking ... matters satisfactory.' There were still a number of issues that had to be resolved, including the lack of good ventilation in some cabins and the poor hot and cold water supplies to first-class staterooms on A and B decks. More worrying to Cunard and John Brown were the up-coming trials. It was nearly time to find out if Cunard's huge gamble had paid off.

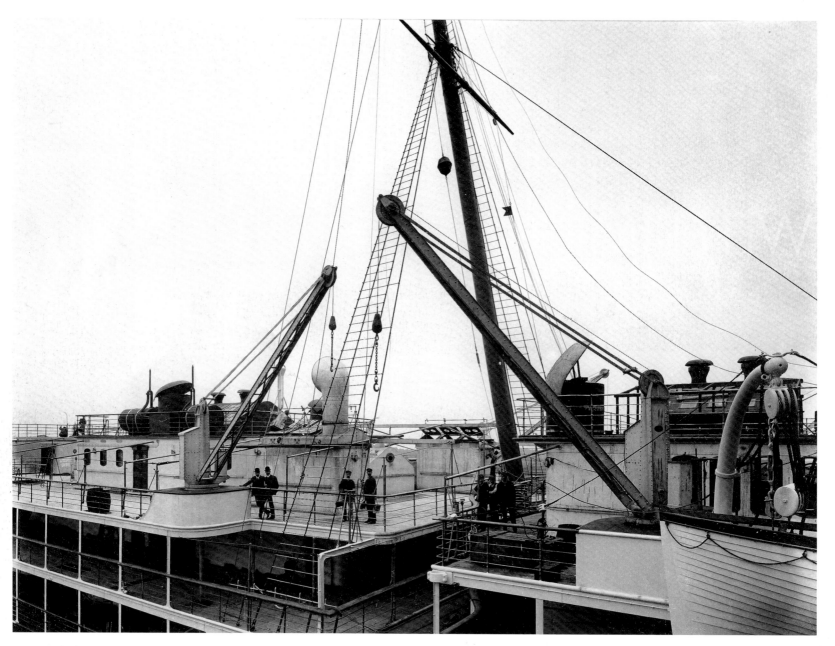

A view overlooking the second-class deck house. At the peak of *Lusitania*'s fitting-out, over 1,400 carpenters and joiners were employed by John Brown. At times during her construction, up to 5,000 men worked at the yard.

2

'SHE IS ENGLAND WITH IMPROVEMENTS ...'

Sir William S. Gilbert, *Utopia (Limited)*, Act 2

The morning of 27 June 1907 was a busy one at John Brown. The largest liner in the world was about to depart. At 11.50 a.m., with the help of six tugs, *Lusitania* slowly backed out of the fitting-out basin, turned to port, and began her nearly 20-mile journey downriver to Greenock. Drawing 29½ feet, the liner proceeded carefully even though the river had been dredged by the Clyde Trust to a uniform depth of 34 feet. Her speed on her first voyage varied between 5–10 knots, and after an incident-free passage, she arrived at Greenock at 1.45 p.m.

After a few days at anchor and some last-minute preparations, on 2 and 3 July, her progressive trials were held. Everything on the liner worked perfectly and she fully realised expectations, but there was one noticeable issue – vibration.

The vibration that became all too apparent on *Lusitania*'s trials was extremely worrying to Cunard and John Brown. Immediately afterwards, the companies' engineers and naval architects met to draw up a list of alterations that they hoped would reduce, if not eliminate, the problem. On 6 July 1907, A.B. Harris of John Brown sent a memo to James Bain at Cunard specifying the extensive changes that needed to be made right away. The weight of the additional stiffening was a serious consideration, and to assuage Cunard's concern John Brown quickly wrote to William Watson, who was now Cunard's Chairman, to advise him that the proposed alterations would add only 30 tons to the ship.

Anchored at Tail of the Bank, additional work was done to complete the liner while the stiffening was introduced. At 5 p.m. on 15 July, *Lusitania* departed for Liverpool and crossed the Mersey Bar at 5 o'clock the next morning. By 7 a.m. she had anchored just off the Landing Stage. A report about the passage from Scotland to the Cunard head office read:

At the commencement of the passage the ship was run at a speed of about 23 knots for the purpose of observing the result of stiffening the superstructure aft, where vibration was manifest on the progressive trials made on the 2nd and 3rd Instant. There was considerable improvement, although the result is not all that might be desired, and the Builders intend fitting additional webs to the structure on the way of the forward propellers. In addition to these webs the water service tanks will be removed from the top of the Lounge, and the after baggage cranes dispensed with. It is intended to carry out this work on the Clyde, on the return of the ship after being dry-docked in Liverpool, when some alteration will be made in pitch and diameter of blades.

During the passage from the Clyde all the turbines, auxiliary machinery, steering gear &c, worked satisfactorily.

The ship will go into Huskisson Dock to-day prior to being placed in the Graving Dock, possibly to-morrow.

James Birnie Watt was born in Montrose, Scotland on 12 February 1843. Starting his career as a cabin boy on a sailing vessel, he joined Cunard in 1873. Climbing through the ranks, he eventually commanded most of the company's largest ships, including *Umbria*, *Etruria*, *Campania*, and *Lucania*. At the height of his career, as first master of *Lusitania*, he received a salary of £900 per year, plus a £100 bonus as Commodore if there were no incidents to any ship under his command. He retired from Cunard service and died on 8 June 1920 at Las Palmas in the Grand Canary Islands.

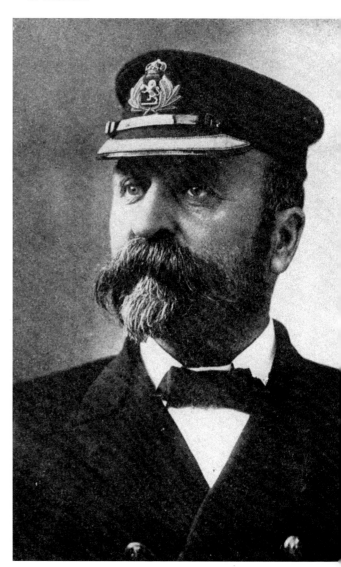

The dry-docking proceeded as planned, but there were some anxious moments as the water was pumped out of the dry dock. This excerpt from a report by Leonard Peskett and James Bain explains:

The [Lusitania] was put into the Canada Graving Dock on the 17th July and placed on blocks.

When the water was pumped down to the ship's 25 feet waterline, the after shores commenced to vibrate and crack, and one shore forward of amidships on the Starboard Side jumped out of position. It was thought that part of the launching gear might have adhered to the ship's bottom and displaced some of the bilge or keel blocks, and in order to ensure perfect safety it was decided to refloat the ship and examine the blocks.

The ship was floated out into the Canada Basin on the morning of 18th July, the Graving Dock pumped out, and the blocks examined; everything was found to be in order and the ship was again brought into the dock and placed on the blocks, this time without any hitch.

It is evident that the first time the ship was placed on the blocks the shores were set up too quickly before the ship had time to settle on the soft wood blocks.

After being taken out of the dry dock on the 22nd, the new liner anchored in the Mersey for several days before she sailed for the Clyde on Friday, 26 July, to embark the passengers for her trial trip around Ireland.

William Watson wrote to Ernest Cunard on 22 July to let him know that John Brown intended to make some speed trials during the trip to Greenock from Liverpool, and that John Brown did not want any passengers on board 'in case running at full speed makes her vibrate as

27 June 1907. *Lusitania* begins her first voyage down the Clyde to Tail of the Bank. The passage down the river went without a hitch; however, there was some concern that the liner might run aground despite it having been dredged to a uniform depth of 34 feet. When the ship was opened to the public in Scotland, £763 2s was collected for charity.

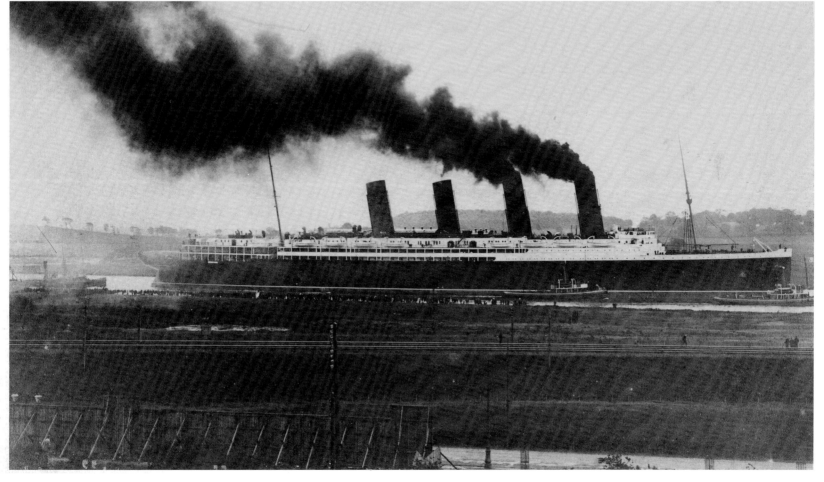

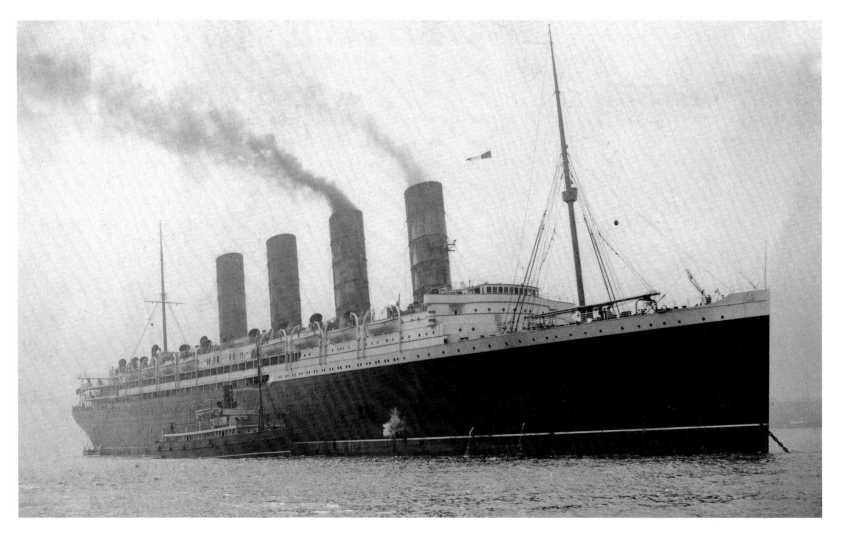

Lusitania at anchor in the Sloyne during her first visit to Liverpool. Unfortunately, the following memo is not dated, but it was sent to the Registrar of Shipping, Liverpool: 'We, the Cunard Steamship Company Limited, request that the new steamer *Lusitania* may be registered at the Port of Liverpool, and we hereby appoint Mr Andrew Daniel Mearns, of 8, Water Street, Liverpool, as the person to whom the management of the above named is entrusted by, and on behalf of, the Owners.'

before' and that the cruise around Ireland should start in Greenock and not Liverpool.

In order to limit the number of people on board for her first voyage with passengers, each Cunard Director was allowed to invite only five people. As the date for the trial trip approached, Cunard was having doubts about whether they should have taken part at all. Lord Inverclyde (brother of the deceased Chairman) stated candidly: 'We shall have a great deal of trouble before all the Guests are settled, and a deal of jealousy. I wish we had never joined [in planning the trial trip], but let John Brown & Co. issue the invitations themselves.'

The cost for the trip around Ireland was split by John Brown and Cunard. Lord Inverclyde wrote: 'From what I hear there are a great many refusals ... I presume that it will be possible to arrange for each person having a room

to themselves, at all events, Lady Inverclyde and I would each wish a room to ourselves. Lady Inverclyde will have her maid with her. I presume a good number of the party can be located in the second cabin.'

Among the invited guests were Charles Parsons; Gerald Balfour; Lord and Lady Pirrie of Harland and Wolff; Mary, Lady Inverclyde; Lord Stalbridge; Owen Philipps; and many Members of Parliament who had helped make the two new ships possible. Winston Churchill had been sent an invitation also. Unfortunately, he was not able to attend, as he cabled Ernest Cunard on 26 July: 'Very disappointed not able to accept your kind invitation on board *Lusitania*. Many thanks. Churchill.'

The liner left Tail of the Bank on Saturday, 27 July at 8.50 p.m. According to the first newspaper printed on board, her daily runs on the trip were as follows:

July 27, Up to midnight = 58 miles
July 28, Sunday = 488 miles
July 29, Monday = 194 miles

During the voyage, Captain Dow, in command of *Campania*, cabled Captain Watt: "Hearty greetings from captain, officers, and passengers of 'Campania.' Wish 'Lusitania' all success and her guests a pleasant time."

An anonymous source on board for the voyage, composed this amusing limerick:

A smart little ship 'Lusitania,'
For speed developed a mania,
Since they put in a turbine
To lighten the burden,
Mal de mer is no longer a bane in her.

After a successful jaunt around Ireland, *Lusitania* arrived at the Liverpool Bar Lightship at 9.37 a.m. on 29 July. She slowly made her way up the Mersey and anchored. Her guests landed by the tender *Skirmisher*, and *Lusitania* left once again for the Clyde to carry out additional speed trials and to have some final work completed before she entered service.

Security on the vessel and secrecy of the work to reduce the vibration had been a worry to Cunard, but more so now on her return to Greenock with even more stiffening work being done. Lord Inverclyde wrote to W. Dranfield, Cunard's Secretary, on 13 August 1907 about the question of unauthorised visits to the liner:

With reference to your letter about Lord Charles Beresford wishing to see the *Lusitania*, H.M.S. *Hindustan* was lying here and on Sunday some of her officers went on board the *Lusitania* and being in uniform no one stopped them.

They were here last night and were able to tell me all about the strengthening work going on. I think this is rather a pity and ought not to be allowed. If the Chairman thinks proper without mentioning my name he can use the information with Messrs John Brown & Co. as he likes.

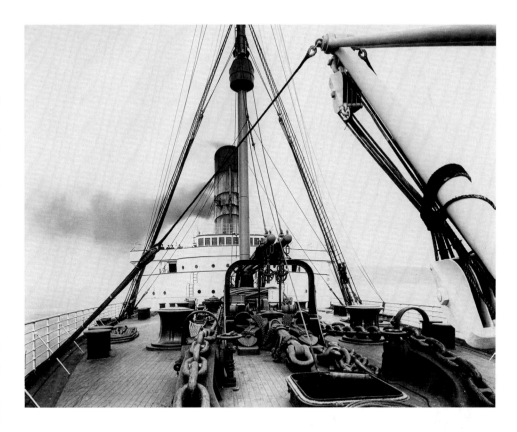

Cunard was obviously very concerned about the public finding out about the extensive alterations that were necessary after *Lusitania*'s trial runs – and with good cause. She was being built with government loans and any bad publicity might fuel a certain segment of the public which was already against government money being used for private enterprise.

Along with the vibration issues, there were still numerous small issues to take care of so the ship would be ready before her maiden voyage, including the installation of two additional watertight doors. On 14 August, James Bain wrote to Dranfield:

Visited Clydebank on the 12–13 inst. and saw the Builders with reference to the stiffening being fitted at the after end of Lusitania. Also inspected the work on the ship and found all to be going on satisfactorily.

The Builders propose to put 1500 tons of coal on board the Lusitania at the Tail of the Bank, and to run at full speed for a portion of the time on the passage from the Clyde to Liverpool to ascertain the effect of the extra stiffening.

Three bells were fitted on *Lusitania* – a 20-inch bell in the crow's nest, a 16-inch bell on Shelter Deck aft, and a 10-inch bell just outside the windows of the navigating bridge. Two of these are visible in this photo.

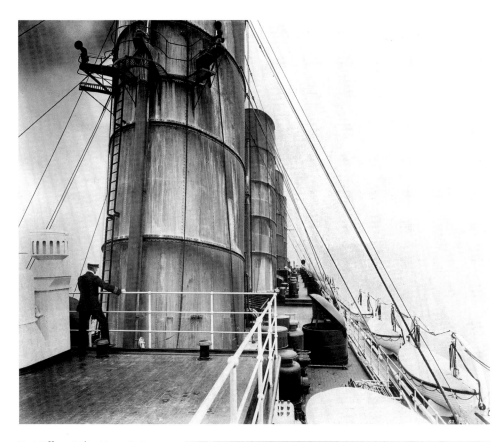

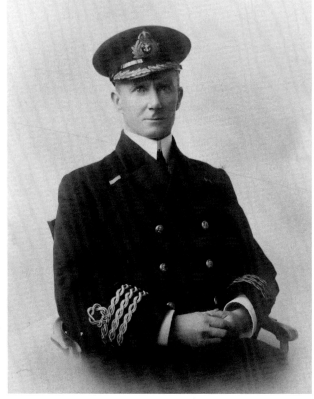

First Officer Arthur Henry Rostron on *Lusitania* during her trials. He achieved his greatest fame as the captain of the Cunarder *Carpathia* when she rescued the survivors of the *Titanic* disaster. Rostron was born on 14 May 1869 in Lancashire, England. He began his career with Cunard in 1895 as fourth officer on board *Umbria*, eventually achieving the rank of Commodore. He died on 4 November 1940.

A 1916 portrait of Arthur Rostron in his Royal Navy uniform.

Two W.T. Doors are being fitted at the after end of cross bunker to admit of coal being easily trimmed to fires at after end of forward section of boilers, as already approved.

It has been arranged to fit the Stone Lloyd gear to these doors, and the fittings are being made by Messrs. Stone & Co., as the time is limited these fittings may not be ready when the ship leaves the Clyde, but they will be fitted on the first opportunity that may afterwards be afforded. Meantime the doors will be operated by the ordinary hand gear in the usual way.

Lusitania left Tail of the Bank on 26 August and proceeded down the Clyde to carry out her steering gear and turning tests. When the ship was between Pladda and Ailsa Craig, two complete circles were made, one to port and one to starboard. Then the stopping test was performed off Skelmorlie, and from a speed of 22½ knots with engines reversed, the ship came to a dead stop in three minutes and fifty-five seconds.

She then proceeded to Gourock to embark some Cunard Directors and other passengers and departed for Liverpool at 8.30 p.m., where the passengers were landed at the Liverpool Bar by *Skirmisher* the following morning. She did not make her way up the Mersey but rather departed for a final set of trials to determine the effect of the stiffening and to conduct the full steering trials required by the Admiralty. About the vibration during these trials, it was written, '... it was found that there was a marked improvement, and that the vibration, although still perceptible, was not likely to interfere to any appreciable extent with the comfort of the passengers.'

Upon arrival back in Liverpool, a few last-minute details were taken care of, and *Lusitania* was officially handed over to Cunard. A company memo records the event:

The 'Lusitania' was safely moored to the moorings in the River Mersey, about 3 p.m. on August 27th 1907. After obtaining the usual Certificate from the General Supt., the Marine Supt., and the Supt. Engineer, that she has been completed in accordance with all the requirements of the Contract with the Builders and the Agreement with

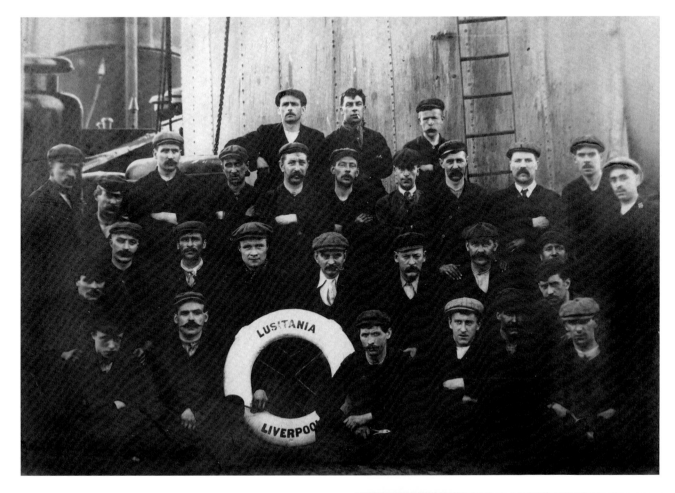

Workers from John Brown pose for a group photo during the trials. Because not all work had been completed before the liner left the shipyard, many of John Brown's workers accompanied the ship on her trials and voyage to Liverpool to finish the liner. In fact, work on the ship continued until the day she sailed on her maiden voyage.

'The Lusitania has just completed the most thorough speed trial which has ever been undertaken by a merchant steamer. Under somewhat stormy and unfavourable conditions she has steamed at full speed for 48 hours between the Lands End & the mouth of the Clyde, making the journey twice in each direction. The total distance covered was 1200 miles, and the average speed of all the runs was well over 25¼ knots.'

His Majesty's Government, she was taken delivery of at 5 p.m. on August 27th, 1907.

Her career with Cunard had begun.

On Tuesday, 3 September, just four days before her maiden voyage, *Lusitania* was opened to the general public at a cost of 2*s* 6*d* per person with the proceeds going to charity. Thousands boarded to look around Cunard's new greyhound via the tender *Skirmisher*, and what they saw was impressive. *Lusitania*'s gross tonnage was 20 per cent larger than White Star's *Adriatic*, the largest ship in the world before *Lusitania*.

Early in the afternoon of 7 September, the Cunarder *Lucania* tied up to the Landing Stage to begin embarking her passengers. As soon as she cleared the stage and began her voyage to New York, it was *Lusitania*'s turn. The Cunarders *Caronia* and *Sylvania* were in Liverpool that day to bid farewell to their new fleetmate.

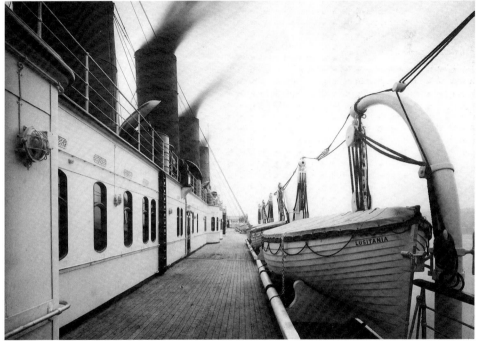

Between the time of *Lusitania*'s first trial voyage and departing on her maiden voyage, the aft set of cargo cranes on the second-class Boat Deck was removed. Many believe they were taken off simply because they were found to be superfluous; however, this is not the case. As with so many other changes to the liner before her entry into service, the cranes were removed in an attempt to reduce the vibration that plagued the aft end of the ship.

On 20 September 1907, John Brown wrote to Cunard asking what should be done with the two cranes that had been removed. The shipyard had already written to Stothert & Pitt, the company that had manufactured them, to ask if they would take them back and at what price. According to John Brown, the crane manufacturer did not offer a reasonable amount for them; so the shipyard wanted to return them to Cunard so that they could be fitted onto another vessel.

A few days later, James Bain of Cunard wrote: 'I beg to state that the after superstructure has now been stiffened, and the cranes which were removed on account of vibration, might be put back and tried again in original position on the first opportunity ... In the meantime a temporary derrick has been fitted as a substitute for the cranes.'

Despite the suggestion from Bain that they be put back on board, the cranes were not replaced right away. They were, however, eventually returned to the ship and remained with her for the rest of her career.

THE SHIP IN RARE ILLUSTRATIONS

An excellent view of some of the stiffening installed on the second-class deck house to reduce the ship's vibration. As the first vessel of Cunard's pair of 'new fast steamers', *Lusitania* has received all the bad press about her shaking problems. As John Brown made alterations to her, they stayed in constant contact with Swan Hunter to advise the British shipbuilder what changes had been made to *Lusitania* so that the same changes could be made to *Mauretania*. As a result, the English-built ship had fewer vibration problems.

In a memo to the head office, Cunard's James Bain reported that *Lusitania* came alongside the Prince's Landing Stage at about 6.45 p.m. and began embarking passengers. She sailed at 9.10 p.m. and slowly made her way down the Mersey and out to sea. As *Lusitania* passed between Holyhead and Tuskar, fog closed in, and Captain Watt reduced speed for over two hours. Once the fog cleared, the engines were gradually opened up, and the highest revolutions obtained during the run to Queenstown were 162 per minute, giving a speed of about 22 knots. After a brief stop in Queenstown to pick up additional passengers and mail, she turned her bow seaward.

Among the numerous reports sent back to Cunard's office about the ship and the voyage to New York was a confidential one written by Board member Ernest Cunard to the Chairman, William Watson. His comments on vibration are especially interesting because he heard no complaints from first-class passengers about vibration, even though 'they all came on board primed with the idea that it would be very great.' He said that there was still slight vibration in the first-class Library and the forward section of the Smoking Room, 'but in neither case is it sufficient to cause any real inconvenience. The two Dining Saloons are virtually quite free from it ... Speaking generally, I think we may rest content that the stiffening which has been added has taken away most of it, and what little remains must be expected in a ship of such power as this. With regard to second-class there is, of course, still some vibration remaining and it is more apparent in the drawing room and saloon.'

One error made while loading baggage in Liverpool caused a great deal of inconvenience for a number of first-class passengers because the luggage that they needed for the crossing was mistakenly put into the

Anchored at Tail of the Bank, *Lusitania* awaits her second set of trials. Notice that the cranes on the second-class Boat Deck have been removed.

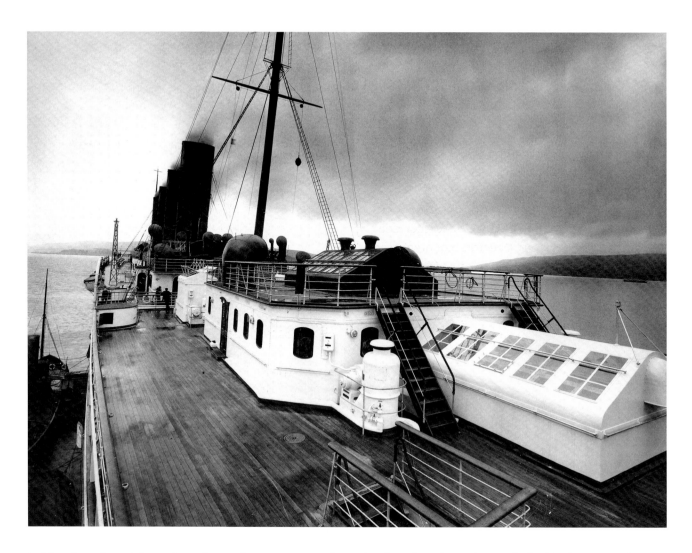

hold rather than delivered to their cabins. Because of the hundreds of trunks in the hold, there was no way the required baggage could be found; so it was inaccessible for the entire trip.

Ernest Cunard also wrote that there were still a number of issues with the hot water supply on A and B Decks, as well as some ventilation issues, and found that some of the cabins were nearly unlivable because of the heat. In two cabins, E-14 and E-15, the heat was radiating through the floor and would 'have to be properly insulated' when the ship arrived back in Liverpool.

Two other items that Ernest Cunard mentioned are of particular interest. He wrote that '... the upper dining room had the unfortunate problem of third-class passengers being able to look into the room while first-class passengers were dining.' He also brought up

the fact that the indicator bells for the stewards were 'too highly pitched, and the passengers within earshot are being woken up every time a bell is sounded.' Both of these issues were promptly remedied.

Cunard found that passengers were extremely pleased with the accommodation, and he heard one man state: 'What is the use of taking a trip on a ship, where search as you may, you can find nothing to grumble about?'

After a crossing of five days and fifty-four minutes, *Lusitania* arrived in New York on the morning of 13 September. As she made her way up the North River to Pier 54, she was escorted by about 200 small vessels, whistling all the way. Although the new liner didn't take the Blue Riband on this crossing, she won the honour on her second round-trip voyage, crossing the Atlantic for the first time in history in under five days, at a speed of 24.002 knots.

About a month after the maiden voyage, James Miller submitted his final invoice to Cunard, and on 29 November, he sent the following:

It is very gratifying indeed to me, to know that your Directors are pleased with the work I did on the *Lusitania*. The spontaneous manner in which they expressed their appreciation comes to me as an unexpected and welcome compliment.

The work was most interesting, and rendered particularly pleasing by the kindly and courteous manner in which your Directors countenanced my efforts.

I shall always feel proud of having been associated with the *Lusitania*, and grateful for the courtesy extended to me by the gentlemen representing your Company.

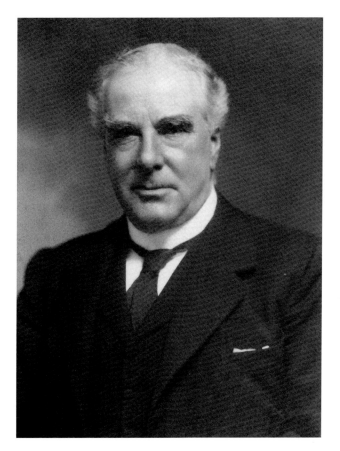

William Watson was born in Charleston, South Carolina, in 1843. After moving to England he made his fortune in the cotton trade and became a Director of Cunard in the early 1890s. Watson was elected Chairman upon the death of Lord Inverclyde in October 1905. He remained Chairman until his death on 4 October 1909 and was succeeded by Alfred Booth.

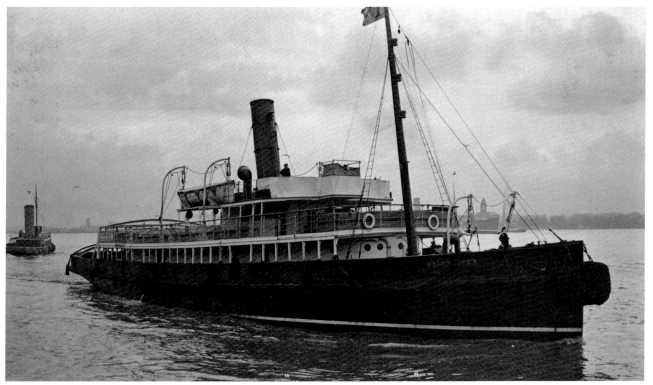

Built in 1884, *Skirmisher* was Cunard's Liverpool tender. She was withdrawn from service in October 1945 and scrapped after sixty-one years of service.

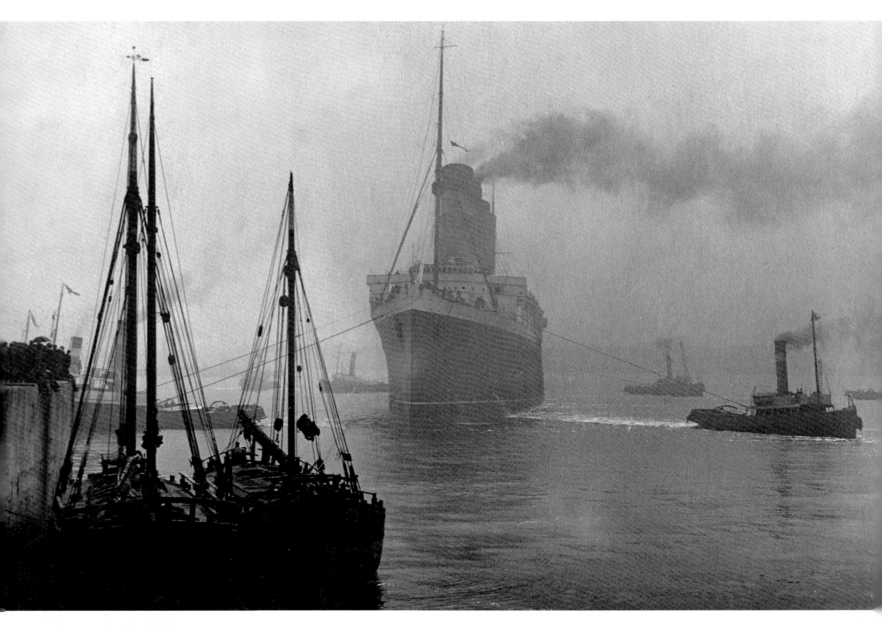

Lusitania in Liverpool just before her first dry-docking on 17 July 1907. Note the white-painted stripe under the forecastle, which had been painted black by the time she left the dry dock on 22 July.

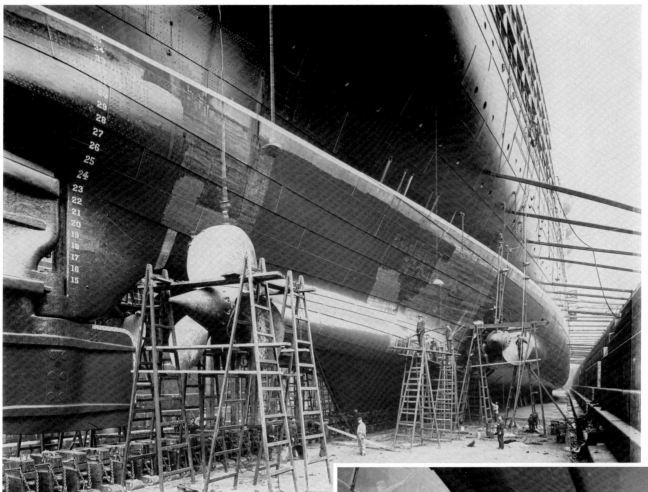

Above: During her first dry-docking in the Canada Graving Dock in Liverpool, Leonard Peskett and James Bain sent the following report to Cunard:

After the ship was dry, the bottom was examined and found to be in good condition, with the exception of some slight damage to one or two of the blades on the forward propellers.

Before the ship entered the graving dock the ship was sighted on the port side of Shelter Deck. After the ship was dry on the blocks in the graving dock she was again sighted with satisfactory results, there being very little movement on the fore and aft lines, and none athwartships.

The blades of the two forward propellers were taken off and replaced by other propellers 18 inches less in diameter and of slightly increased pitch. The pitch of the blades on the two after propellers was increased in order to make the revolutions of forward and after propellers run nearly equal.

Below: Before the advent of stabilisers, many ships depended on bilge keels to help minimise rolling. During her dry-docking from 17 to 22 July 1907, the ship's bottom was cleaned and coated with 'one coat of Suter Hartmann's anti-corrosive and one coat of the same firm's anti-fouling compositions.'

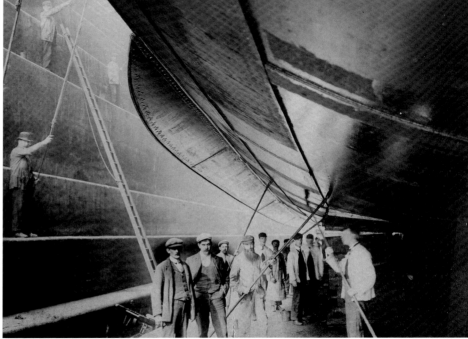

For her trip around Ireland, *Lusitania* departed Greenock on the afternoon of 27 July and arrived in Liverpool on the morning of 29 July. A lucky few received one of these gold-edged invitations.

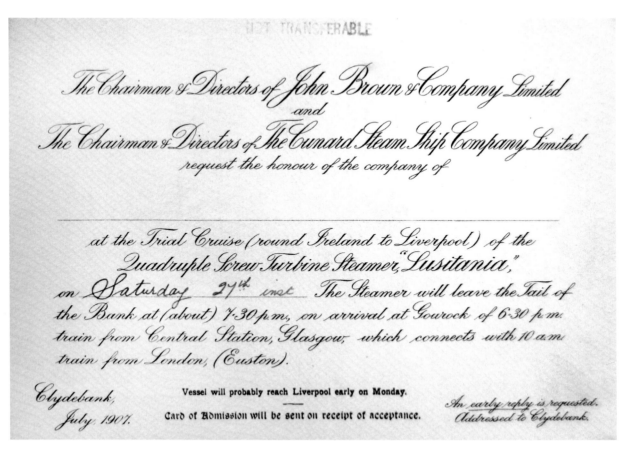

NOT TRANSFERABLE

The Chairman & Directors of John Brown & Company Limited
and
The Chairman & Directors of The Cunard Steam Ship Company Limited
request the honour of the company of

at the Trial Cruise (round Ireland to Liverpool) of the Quadruple Screw Turbine Steamer "Lusitania," on Saturday 27th inst. The Steamer will leave the Tail of the Bank at (about) 7·30 p.m., on arrival at Gourock of 6·30 p.m. train from Central Station, Glasgow, which connects with 10 a.m. train from London, (Euston).

Clydebank, July, 1907.

Vessel will probably reach Liverpool early on Monday.
Card of Admission will be sent on receipt of acceptance.

An early reply is requested. Addressed to Clydebank.

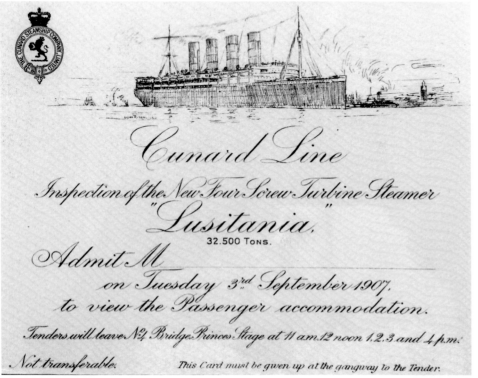

Cunard Line

Inspection of the New Four Screw Turbine Steamer "Lusitania,"
32,500 Tons.

Admit M

on Tuesday 3rd September 1907, to view the Passenger accommodation.

Tenders will leave N4 Bridge Princes Stage at 11 am. 12 noon. 1. 2. 3. and 4 p.m.

Not transferable. This Card must be given up at the gangway to the Tender.

A few days before she left for New York on her maiden voyage, visitors were allowed on board *Lusitania*. In a letter to shareholders, Cunard's Secretary, W. Dranfield, wrote:

My Directors have decided to throw the Company's New Steamer 'Lusitania' open for public inspection in the River Mersey on Tuesday, September 3rd, at a charge of 2s. 6d. per head, the proceeds being devoted to Charities. No charge will, however, be made to the Shareholders of the Company, and a Permit available for the inspection in question is sent herewith, in the hope that you may be able to use it. Tenders will leave the Prince's Landing Stage for the Vessel at 11 a.m., noon, 1, 2, 3 and 4 p.m. for the purpose of conveying visitors to the Steamer. The tenders will return at convenient intervals.

The day was an immense success with about 10,000 people paying to tour the liner.

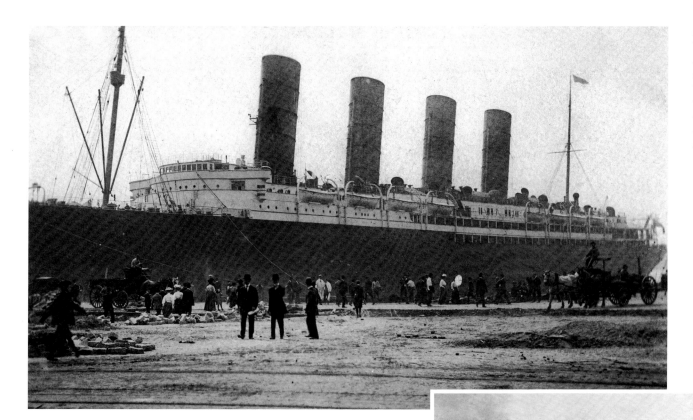

A private snapshot taken on 15 September 1907 in New York. *Lusitania* had arrived on her maiden voyage two days earlier. Thousands of curious New Yorkers came to see and tour the ship. All money collected from their admission fees went to charity.

'If ever a ship deserves to be called a floating palace, the *Lusitania* does.'

Arriving in New York on her maiden voyage, *Lusitania* prepares to dock at Pier 54. Because of the tidal conditions when she arrived, Captain Watt sailed the liner upriver past her berth, turned around, and used the force of the ebbing tide to turn in between the piers.

On 12 September, the day before her arrival, Harland & Wolff, the Belfast shipbuilder, announced that they were to build two new ships for Cunard's rival, the White Star Line. These ships became *Olympic* and *Titanic*.

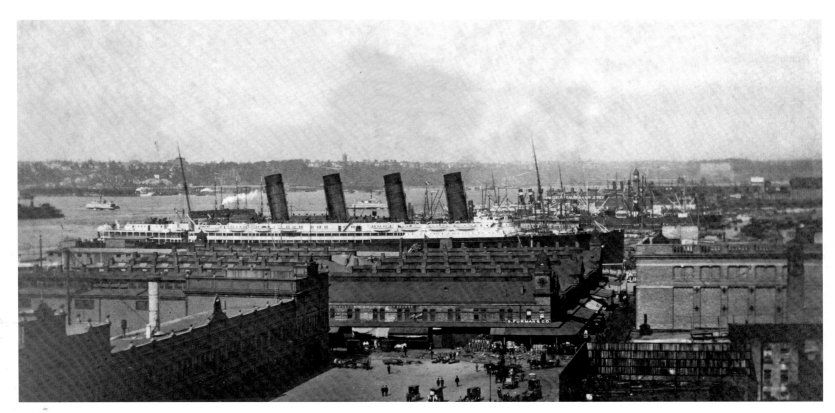

A privately published image of *Lusitania* docked at Pier 54 after taking the Blue Riband on her second westbound crossing. She also captured the coveted prize on her return voyage to England.

Born on 17 September 1872, Alfred Booth joined Cunard's Board of Directors in 1901. Upon the death of William Watson, Booth became Chairman of Cunard on 7 October 1909, a position he kept until 1921 when he resigned because of poor health, although he did remain a Director of the company. During his chairmanship of Cunard he received a peerage in January 1916. He retired completely for health reasons on 30 June 1945. Sir Alfred died on 13 March 1948.

'NO WORDS ... CAN ADEQUATELY DESCRIBE THIS MAGNIFICENT VESSEL'

Palmer Langdon, *Lusitania* passenger

FIRST CLASS

The design for the bronze-and-gilt Cunard crest that was to be placed over the forward fireplace in the first-class Lounge.

Born at Auchtergaven, Perthshire on 11 July 1860, James Miller was educated at the Perth Academy and trained in architecture and design. In 1893, he opened a small architectural firm and became one of Scotland's most prominent architects, designing many of Glasgow's most famous buildings as well as acting as consulting architect for many of *Lusitania*'s interiors. He lived in Stirling, Scotland, and died on 28 November 1947.

Even as the date of the trials approached in July 1907, details about the interior design of the ship were being rethought. One example concerns a bronze and electro-gilt Cunard lion in low relief that was being considered for placement over the forward fireplace in the first-class Lounge, seen here. Sketches were submitted to Cunard, and the work was to be carried out by the Bromsgrove Guild, one of the founders of which was Walter Gilbert, who later did work for Cunard on board the *Queen Mary*.

Some internal discussion ensued at the company's office in Liverpool, and the result was that Cunard needed more information from John Brown with regard to the crest, specifically its exact placement above the fireplace. It was also discussed whether both fireplaces should have the same treatment 'for the sake of uniformity ...'

By 24 July, John Brown had received word from James Miller that Cunard did not completely approve of the idea of the crest and that it had been arranged to fit a simple green marble centrepiece over the forward fireplace. In the corresponding position on the aft fireplace, a clock was fitted.

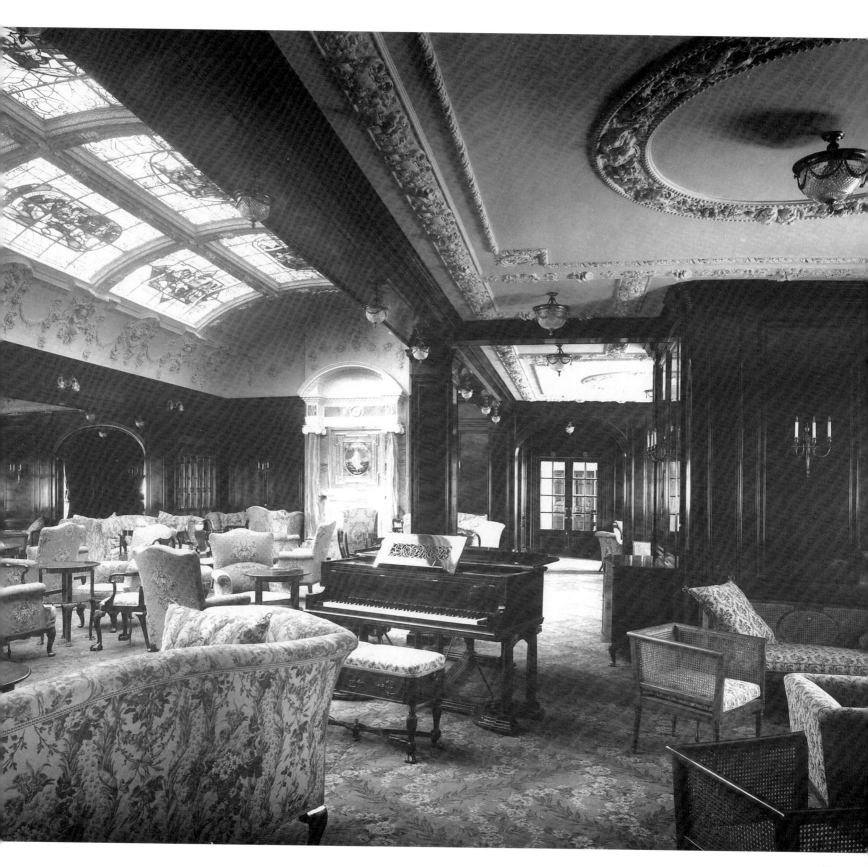

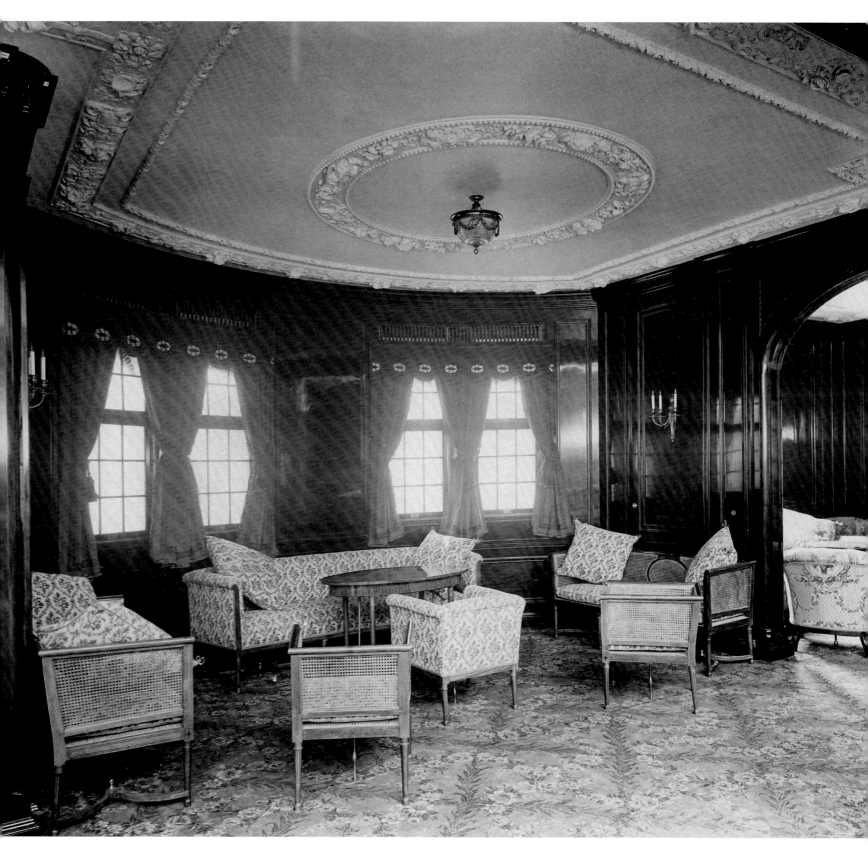

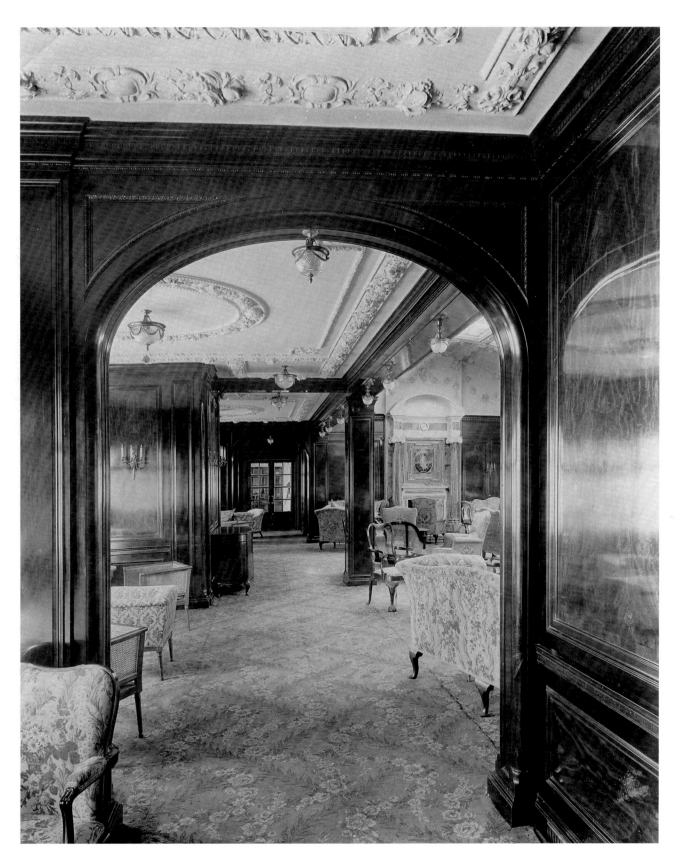

Among the most impressive features of *Lusitania*'s design were the magnificent vistas obtained through the first-class public spaces. This image, taken from the forward starboard corner of the Lounge, looks through to the Smoking Room.

Opposite page: Much of the plasterwork on board *Lusitania* was designed by the Bromsgrove Guild. Of his work in the Lounge, Walter Gilbert wrote:
'The Lounge is the resort of daintily-dressed women: the playful tricks of the Amorini upsetting the emblems of time, represented by the signs of the Zodiac, are a delicate satire on their womanly caprices.' The theme of the plasterwork in the Lounge was 'The Music of the Sea and of the Wind'.

The fireplace just forward of the first-class staircase on Boat Deck set up as a rendezvous point. In October 1914, a serious fire took place very near here because of deteriorated insulation. Cunard was concerned enough about the issue to remove all the panelling and replace the wiring.

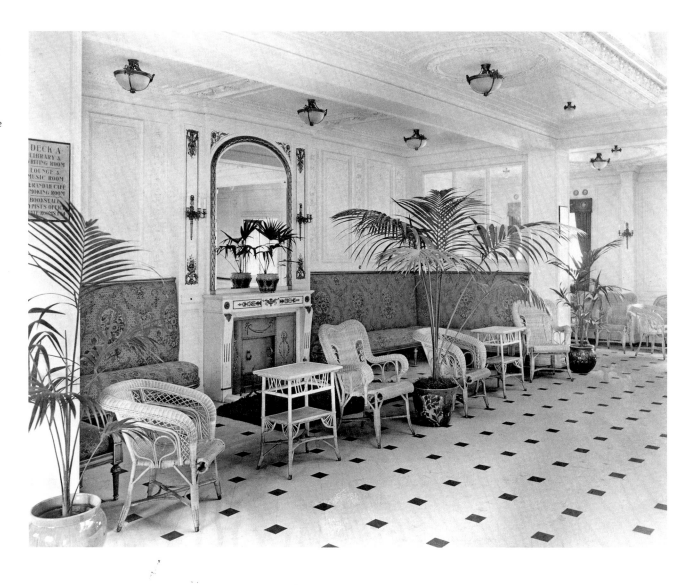

At about the same time the discussion was going on about installing a Cunard crest over the fireplace in the Lounge, another discussion along similar lines took place between Cunard's Furnishing Department and the company's Secretary.

Replying to your memo dated July 12 enclosing a copy of letter from Messrs John Brown & Co. with sketch & price for additional metal-work to top of Lift Enclosure. The sketch submitted is quite in keeping with the remainder of the metal work and would be a decided improvement to the Lift Enclosure on the Boat Deck.

There appears perhaps to be too much repetition of the Company's Crest, and it is submitted that it would be an improvement if there were one crest in the centre of the additional metal-work with a shield on each side as indicated on enclosed tracing.

Unfortunately, no additional correspondence on this issue seems to survive, but in the end, no crest was installed.

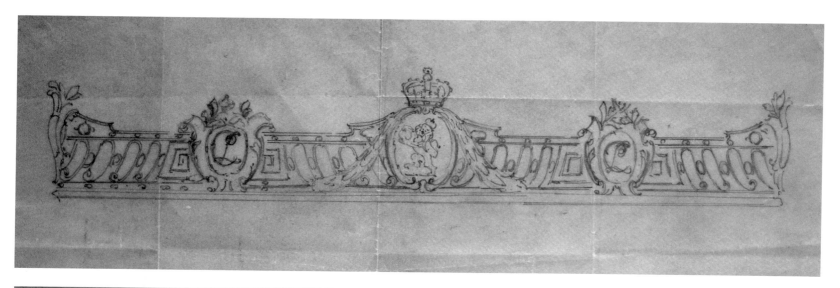

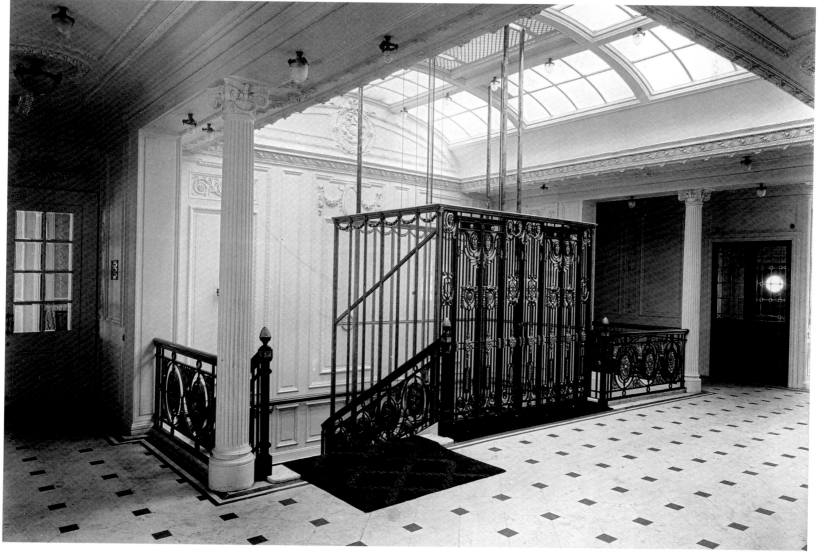

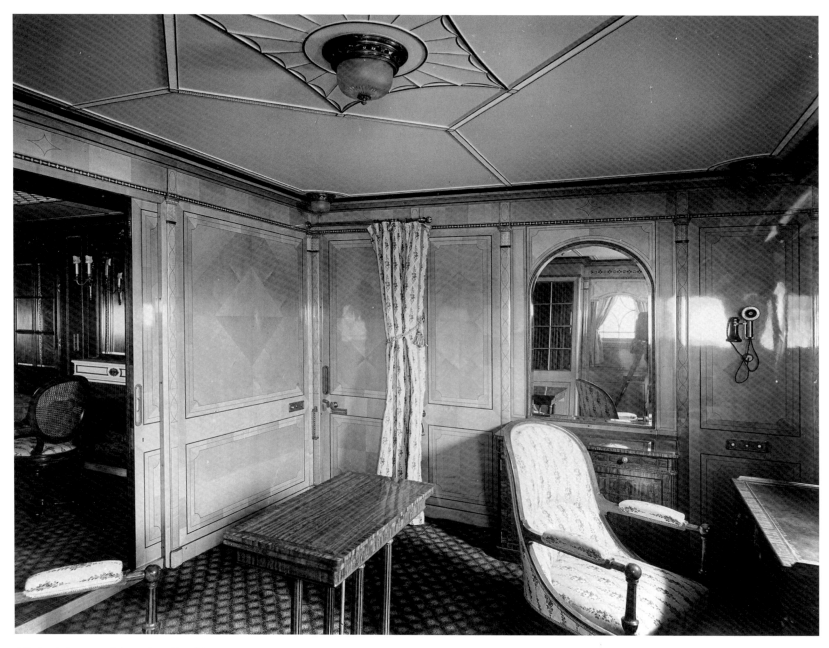

B-51, the sitting room of the starboard Regal Suite.

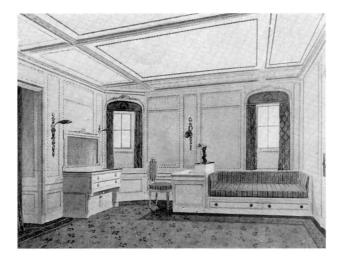

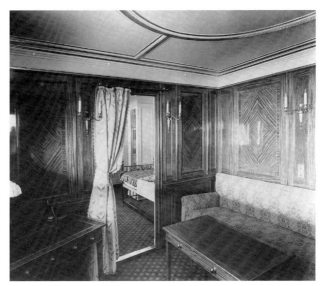

Far left: A preliminary rendering of a first-class suite.

Left: B-78 looking into B-76.

Below: B-88 looking into B-86.

The largest staterooms on *Lusitania* were the dining rooms to the Regal Suites, cabins B-53 and B-54 at about 159 square feet. The smallest first-class staterooms were B-83 and B-84 at about 29 square feet. These two small B Deck cabins were nestled in around the dome of the first-class Dining Room and were sold as first-class accommodations for the first few years of service. They were later removed from the published fare lists although they continued to appear on the ship's deck plans and were most likely used as servants' accommodation. The passage rate for servants was the minimum winter fare.

Among the changes made to the suites during construction was a reduction in the number of lights in those rooms on *Mauretania*:

> The number of lights in the Regal and En-Suite rooms of the 'Mauretania' is 298 against 180 in the same rooms on the 'Lusitania.' It is suggested, therefore that 100 lights be dispensed with in these rooms on the 'Mauretania,' so as to bring the number of lights in both ships about equal.

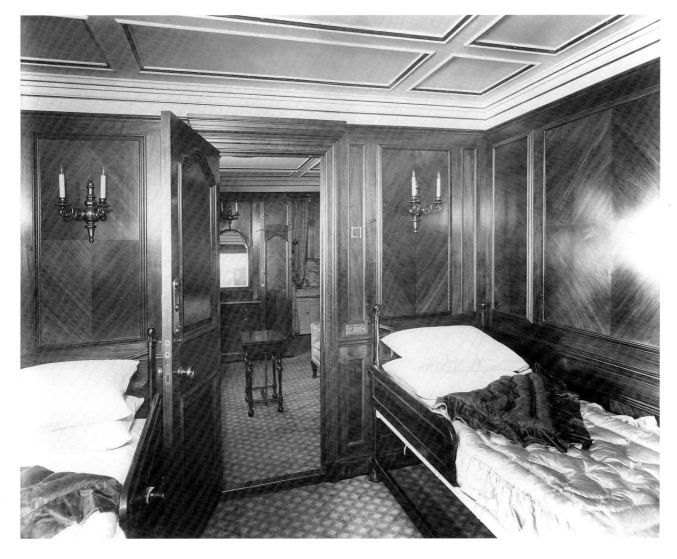

One of the most costly issues to resolve on most pre-war liners was the lack of private toilets attached to cabins. Two were added to *Lusitania*'s first-class accommodation before she sank, and these were attached to cabins D-20 and D-23 by removing the middle stateroom of the triple bank of cabins just forward and adding a door. Many more were installed on *Mauretania* during various refits after the First World War, and the same, no doubt, would have been done to *Lusitania* had she survived the war.

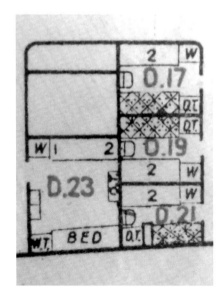

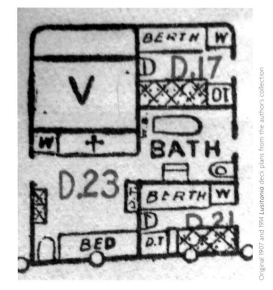

Original 1907 and 1914 *Lusitania* deck plans from the author's collection

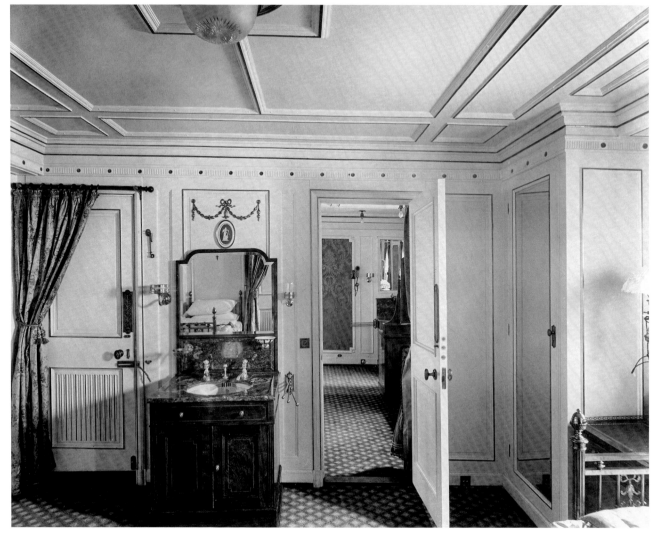

B-48, a bedroom of the port Regal Suite.

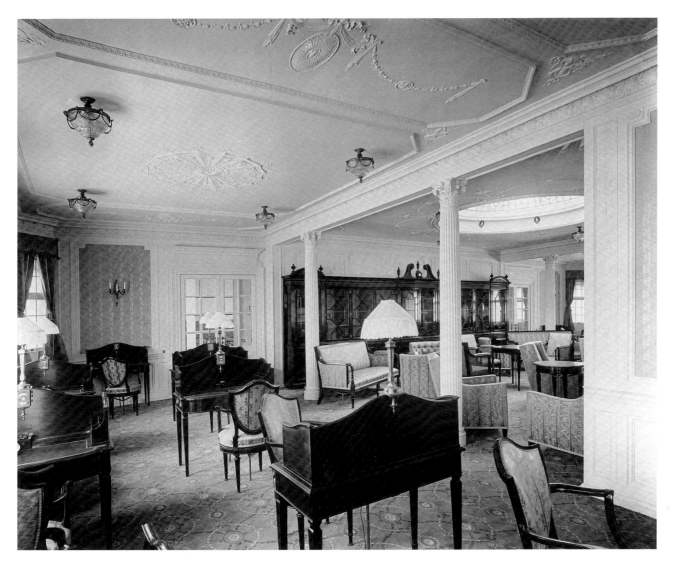

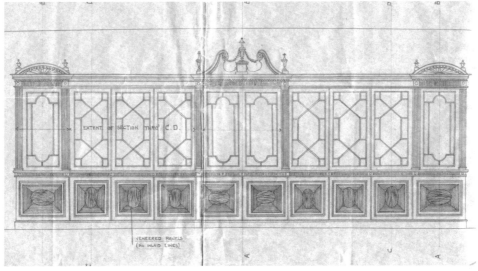

Designed as a quiet spot to write postcards and letters to friends back home, the Writing Room and Library was a popular room in the days when letter writing and reading were the major forms of communication and entertainment. The designs for the bookcases in both the first-class Writing Room and the second-class Drawing Room were approved on 16 January 1907. Several of the windows from this room are still identifiable on the wreck.

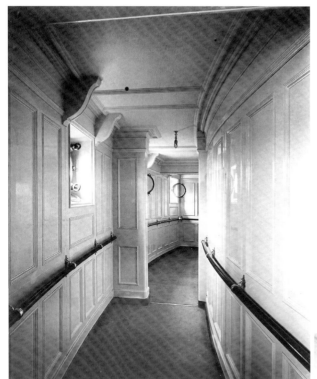

This forward-facing corridor was originally designed as an observation room, but as the design of the liner progressed, it was decided to add more cabins in the space that had been allocated to the room, leaving just this hallway. One suggestion made during the ship's fitting-out was to provide first-class inside cabins B-5 and B-6 with portholes that would look forward. This idea was ultimately rejected, but this would have been an easy alteration to make. Although this would have necessitated changing the layout of two nearby linen lockers, it would have had the advantage of making these two staterooms outside cabins, for which higher fares could have been charged.

Cunard had originally intended that the Verandah Café be an open-air seating area with a covered overhead but no enclosure on either side. After much deliberation, on 9 February 1907 they decided that an open-air café would not work because of the weather on the Atlantic and obtained a quote from John Brown for various options of enclosing the space. Several ideas were proposed, including folding teak screens, but the decision was made to install steel bulkheads.

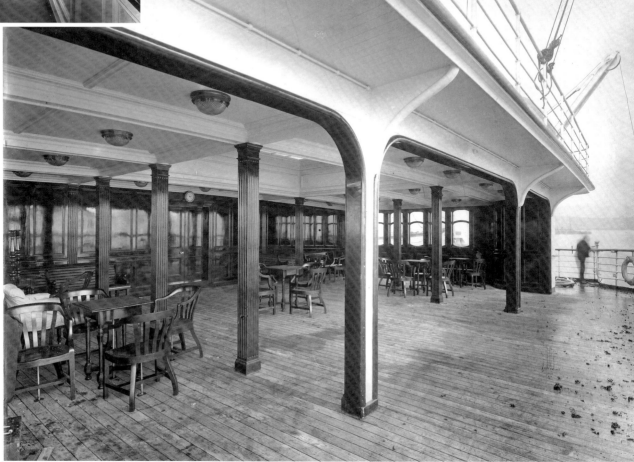

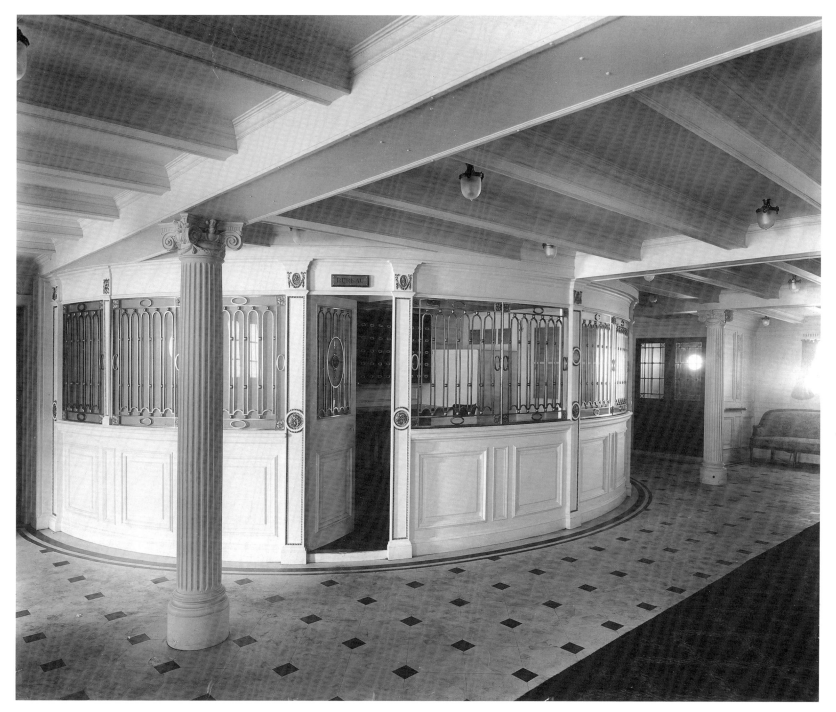

Located on B Deck, the Bureau was the centre of passenger interaction with the Purser's staff. Valuables could be left in the safe deposit boxes, money could be exchanged, railway tickets purchased, etc. Because passengers were charged by the word to send a telegram, to save money, passengers were encouraged to use a special code to reduce the number of words required. Books containing various codes were available on the ship and could be referred to 'on application to the Purser'.

Decorated in the Louis XVI style, *Lusitania*'s first-class Dining Room was one of the most beautiful ever to put to sea. As originally conceived, the upper level of the room was to serve as an à la carte restaurant, but as designing the liner progressed, Cunard reconsidered this as they did not want a 'superior class' of first-class passenger.

One suggestion made early in *Lusitania*'s design by several of Cunard's chief stewards was that passengers would appreciate smaller tables rather than the long dormitory-style seating found on older ships. On the upper level of the room, Cunard took the advice and installed tables for two to five people. On the lower level, however, long bench-like tables were still used, which could seat up to twelve. As time went on, the arrangement of tables and chairs in the Dining Room changed, and in many instances smaller tables were installed on the lower level as well for more intimate seating. Reservations for a table of a specific size could be made at any of Cunard's main company offices or on application to the Second Steward upon embarkation.

During 1914, an experiment was tried in the Dining Room. Dancing was becoming popular; so at night the tables and chairs under the dome were unbolted from the deck, and the centre of the room became a dance floor. A purser reported to his superiors that 'a dance was held in the Saloon Dining-room on the outward voyage, and notwithstanding the brass plates on the deck, the passengers managed to dance round them and spend an enjoyable evening.'

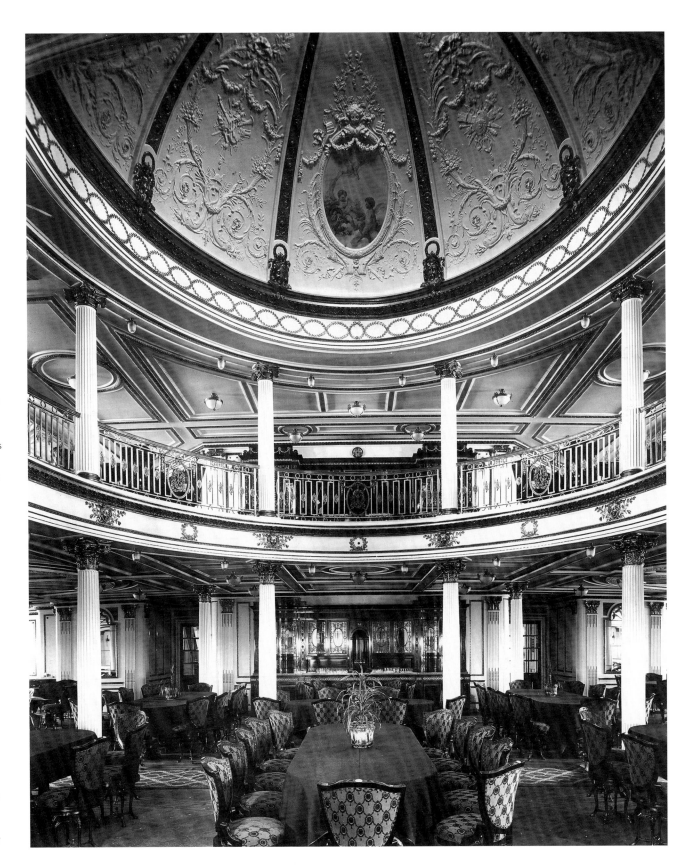

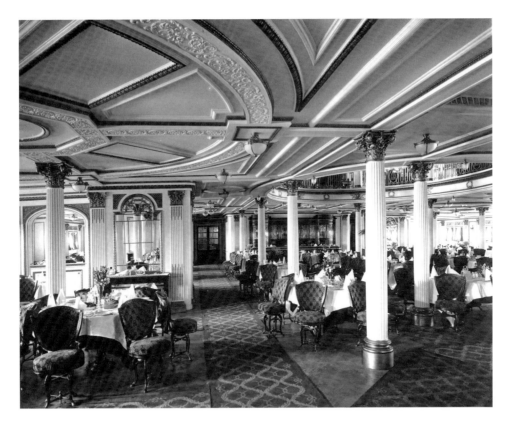

To help with airflow in the Dining Room, a number of fans were supposed to be fitted throughout the room. To reduce costs during construction, it was decided not to install the fans, even though the wiring had been run. Shortly after *Lusitania* entered service, however, it was realised that the fans were needed. On 3 March 1908, James Bain wrote the following to the Cunard Upholstery and Furnishing Department in preparation for their installation: 'With reference to the question of fitting Electric Punkah Fans to the Upper & Lower Dining Saloon on the *Lusitania*. There are 9 positions wired for in the Lower Dining Saloon and 4 in the Upper Saloon. It is estimated that the cost of each fan including the starting switch and the man's time fixing etc. will be £6.10.0. each or £84.10.0. for the complete set.'

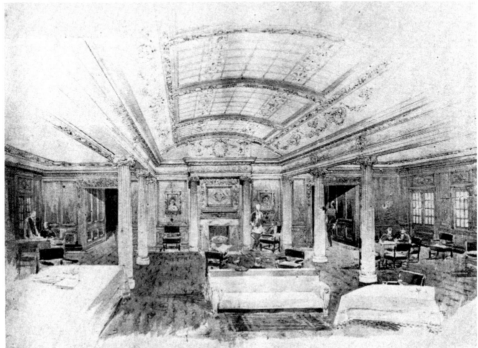

James Miller's original design for the first-class Smoking Room was rejected by Cunard as not 'sufficiently attractive'. After some reworking, he resubmitted plans, which Cunard approved. This is his reworked design.

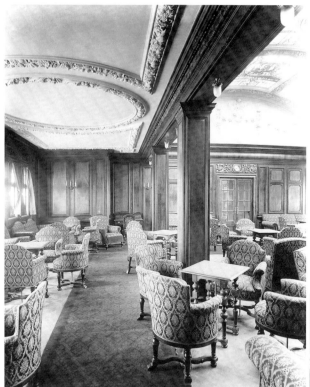

Suggestions were solicited from some of Cunard's senior sea staff to improve the design of the new liners. One of the more forward-thinking suggestions that was not taken came from *Lucania*'s Chief Steward Clark, who thought that there should be a Smoking Room that catered to both men and women in addition to one just for men. As he wrote: 'A room of this description is provided on the latest ships (German). From information gained this room gives great satisfaction.'

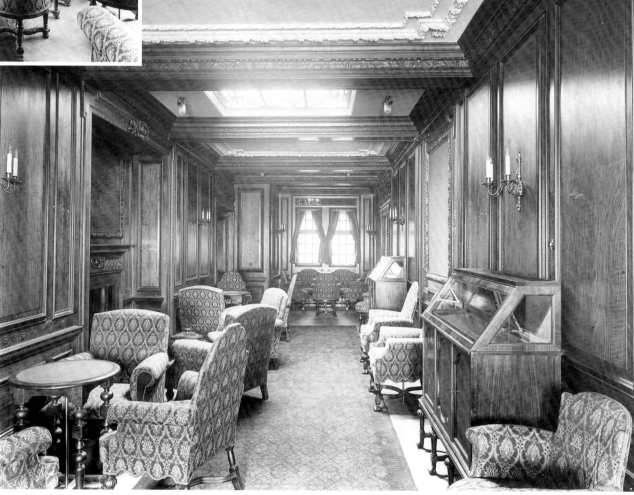

SECOND CLASS

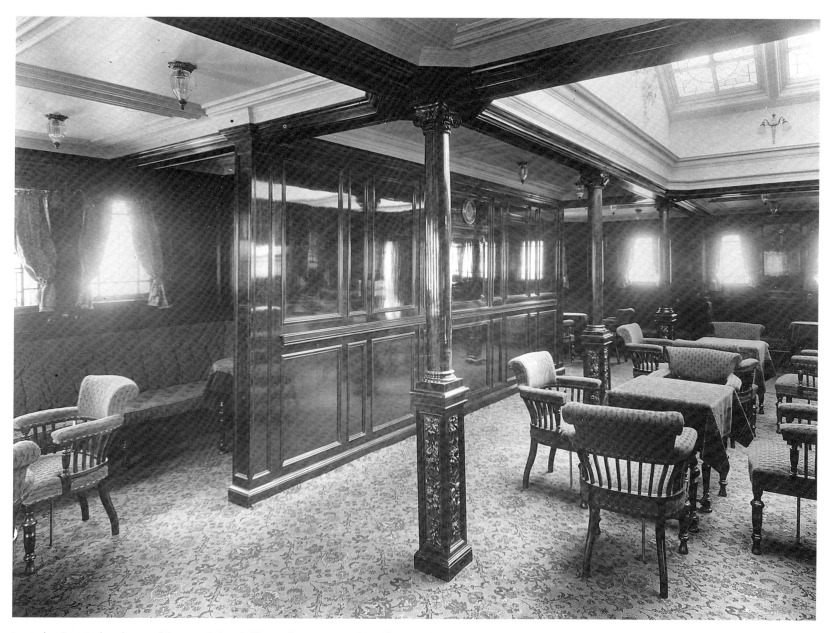

Located on Boat Deck at the top of the second-class deckhouse, the Lounge was the public room that was most heavily modified to reduce the ship's vibration. Originally designed as a completely open space with a staircase descending from the centre to the other second-class accommodations below, the room became somewhat closed-in because of all the stiffening modifications. Behind the mahogany panelling seen here was the serving pantry for the room.

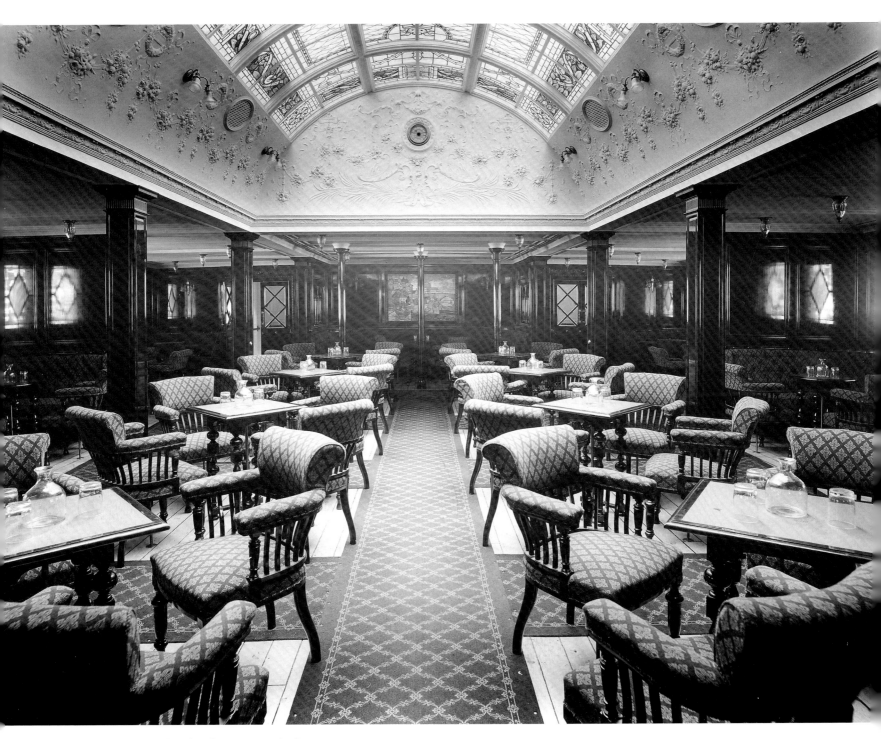

The Smoking Room was an exclusively male preserve. Much of
the furniture that was used in first class on earlier Cunarders was
'downgraded,' and the designs found their way into second class on
Lusitania.

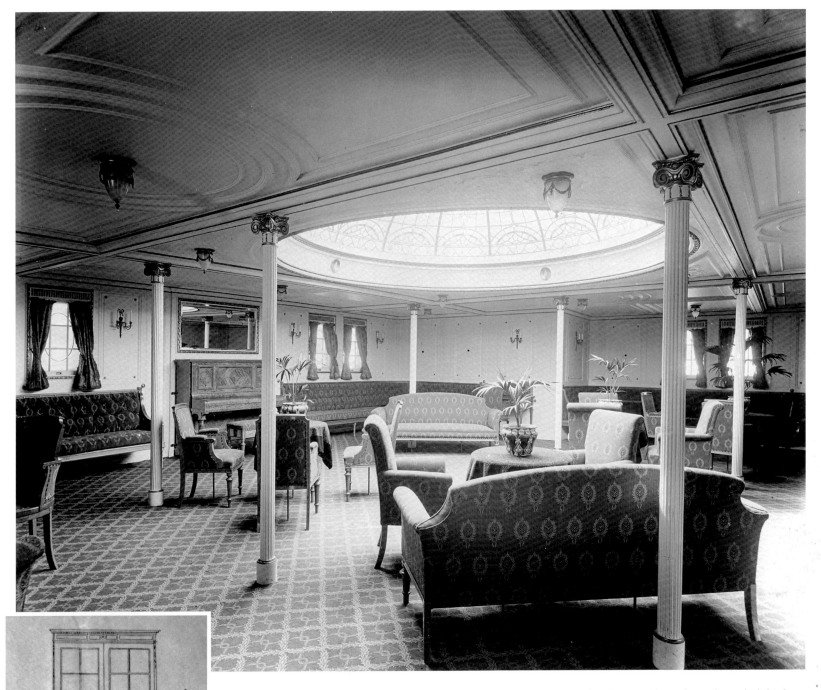

All of the second-class public spaces on *Lusitania* were conceived by John Brown's resident designer Robert Whyte, who worked closely with James Miller, Cunard's consulting architect. Although less money was spent on the decor than in first class, second class had many of the same amenities.

The design for the two bookcases at the aft end of the Drawing Room.

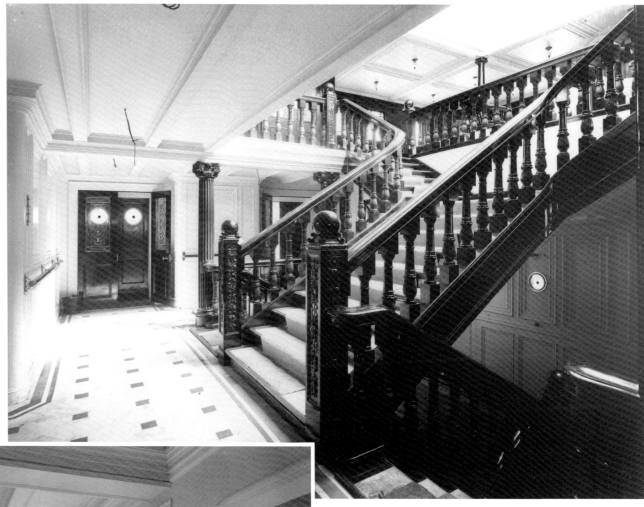

Both of these photos were taken from the same location in the second-class deckhouse on B Deck (Promenade Deck) looking to starboard. The Drawing Room is to the left, and the Smoke Room is to the right. Up the stairs is the Lounge. The photo at right shows the staircase as originally built. The photo below shows the staircase after adding the necessary stiffening.

We are very fortunate that a few photos survive of the interiors both before and after the stiffening was added. These give us a better idea of the massive amounts of work that had to be carried out to reduce the ship's vibration.

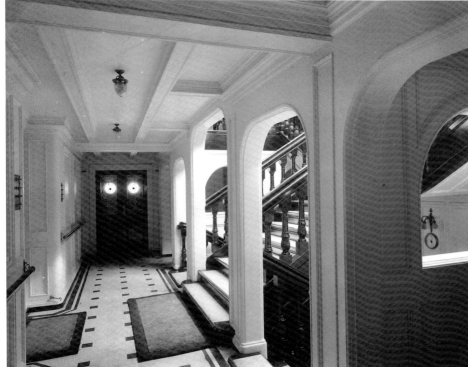

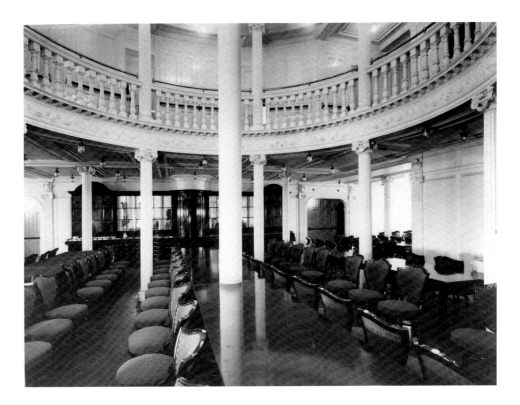

This view looks forward in the second-class Dining Room. The arched opening on the right-hand side led to the second-class pantry and galley. Each chair in the room was spring loaded to turn it away from the table when its occupant stood up, saving the stewards the nuisance of having to keep them neat.

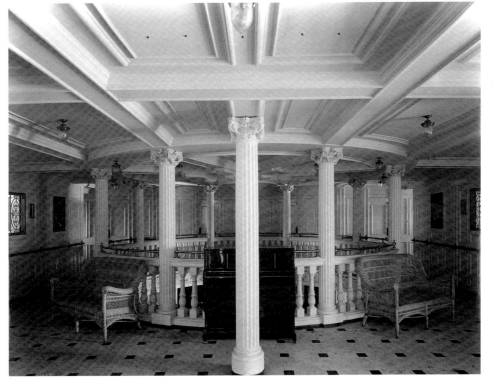

Normally used as an entrance hall, this balcony over the second-class Dining Room on Upper Deck was used an auxiliary dining room on the final voyage because second class was overbooked. The doors on the far bulkhead lead to second-class cabins that open directly into the space. The decorative filigrees to starboard and port lead to light-and-air shafts to the machinery spaces below. In one of *Mauretania*'s later refits, part of the well was decked over and a Purser's office was installed.

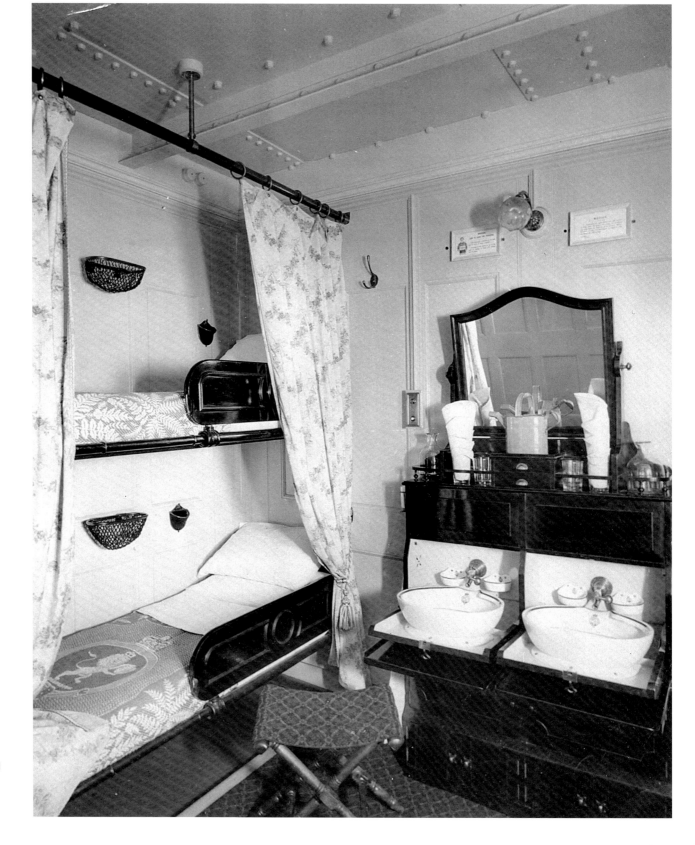

One oddity in the design of *Lusitania*'s cabin arrangement was that two second-class cabins on Shelter Deck measured about 138 square feet, which made them larger than almost all first-class staterooms on board. They were also about double the size of the largest second-class cabins. A change made to most first- and second-class staterooms during construction was the elimination of electric heaters, as well as the plugs and wiring for them, because 'these rooms will be heated by the Thermotank system …'

THIRD CLASS

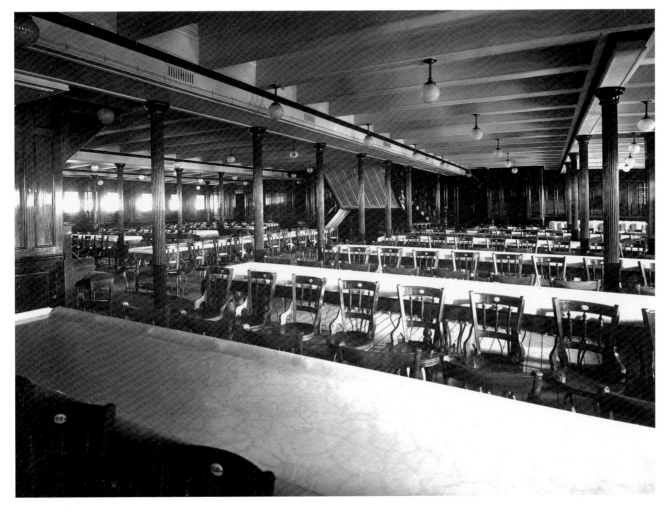

Located on Upper Deck all the way forward where the motion of the ship could be felt the most, the third-class Dining Room could serve 332 passengers at one sitting. This view looks aft. The oval plaques on the back of each chair were numbered to make finding your seat easier. The third-class and crew galley was on the deck above, just aft of the staircase.

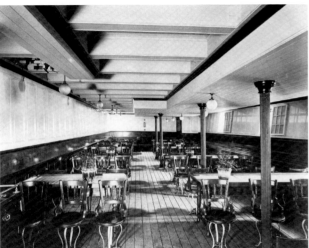

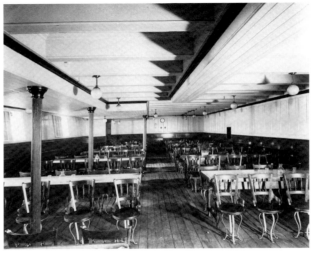

Far left: The third-class General Room seated seventy-six passengers and was located on the starboard side of Shelter Deck forward, just under the forecastle. If the ship were carrying a large number of third-class passengers, both the General Room and the Smoking Room could be converted to auxiliary dining rooms.

Left: On the port side, just across from the General Room, was the slightly larger third-class Smoking Room with seating for 108. When the wreck collapsed, much of the overhead for this room pulled away from the hull, and the forward end of the room is now completely open.

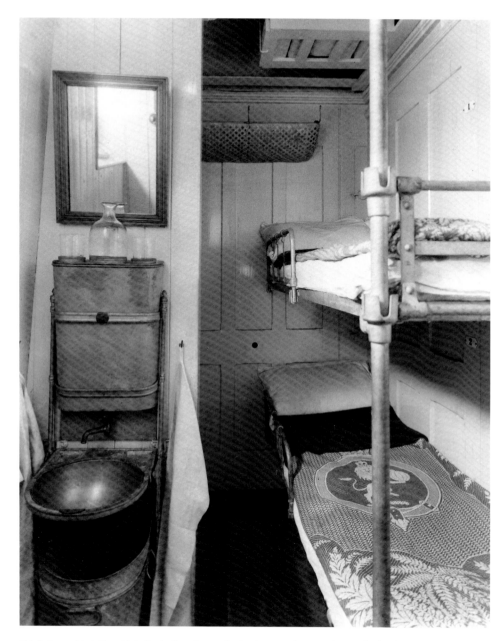

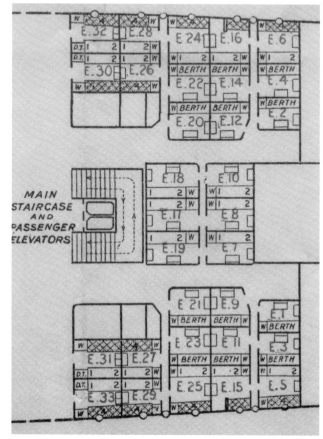

Third-class cabin J-41 on Main Deck. First class on *Lusitania* proved extremely popular for the first few years of service; so in July of 1910, Cunard decided to increase her first-class capacity. To achieve this, the aftermost third-class accommodations on E Deck were gutted and converted into first-class staterooms. In all, third-class capacity was lowered by 136, but this was more than made up for by the addition of fifty-two new first-class berths. The cabin shown here was replaced during the conversion with slightly larger first-class stateroom E-15.

Because second class was oversold on the final voyage, a number of second-class passengers were accommodated in first-class cabins on E Deck forward. The second-class passengers were allocated to the area that used to be occupied by third-class cabins. First-class passengers were accommodated aft of the main staircase.

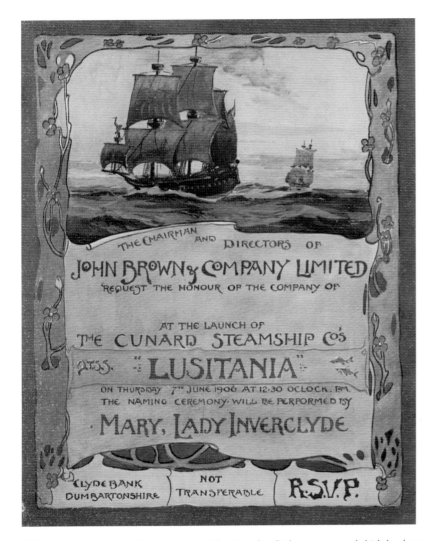

THE CHAIRMAN AND DIRECTORS OF

JOHN BROWN & COMPANY LIMITED
REQUEST THE HONOUR OF THE COMPANY OF

AT THE LAUNCH OF
THE CUNARD STEAMSHIP CO'S
Q.T.S.S. "LUSITANIA"
ON THURSDAY 7TH JUNE 1906 AT 12.30 OCLOCK. PM.
THE NAMING CEREMONY WILL BE PERFORMED BY

MARY, LADY INVERCLYDE

CLYDE BANK
DUMBARTONSHIRE | NOT
TRANSFERABLE | R.S.V.P.

THE FIRST CUNARD LINER
"BRITANNIA"
BUILT 1840
TONNAGE 1154 · SPEED 8½ KNOTS.
THE SKETCH IS ON THE SAME SCALE AS THE ENGRAVING OF
THE "LUSITANIA"

Six hundred guests were invited to the launch by Cunard and John Brown, mostly high-level government officials and people of importance throughout the transportation industry. Among those asked to attend was a 'visitation committee' from Lloyd's of London.

MENU.

Mayonnaise de Saumon Froid, Salade de Concombres.

Paupiettes de Sole à la Princesse.

Aspic de Crevettes à la Victoria.

Cailles en Caisse. Soufflé de Volaille à la Marie Louise.

Aspic de Foie Gras aux Truffles. Chaudfroid de Côtelettes d'Agneau.

Pâté de Pigeon Bordeaux.

Hure de Sanglier à la St. Hubert.

Quartiers d'Agneau Rôti, Sauce Menthe. Bœuf Braise à la Benoist.

Aloyau de Bœuf Rôti. Dinde Rôtis aux Cresson.

Galantine de Capon aux Pistaches. Langue de Bœuf à l'Ecarlate.

Jambon de York Decoré.

Salade de Homard. Salade de Tomate.

Trifle à l'Ecossaise. Meringue Monté aux Apricot.

Baba au Rhum. Charlotte Russe au Chocolat.

Crême à la Duchesse. Gelées Variées.

Gâteau Breton.

Fraises à la Crême.

Fruits. Glacés Variée.

Bonbons.

Caramels. Petits Fours.

Café Noir.

The menu for the special-invitation luncheon held at the shipyard after the launch of hull 367.

A 1907 advertising poster for the new Cunard sisters. This image was also made into a large wall calendar to ammounce the addition of *Lusitania* and *Mauretania* to the fleet.

BY THE FIRESIDE ON A CUNARDER.

The first-class Lounge as seen on the cover of a special 1909 supplement to the *Cunard Daily Bulletin*.

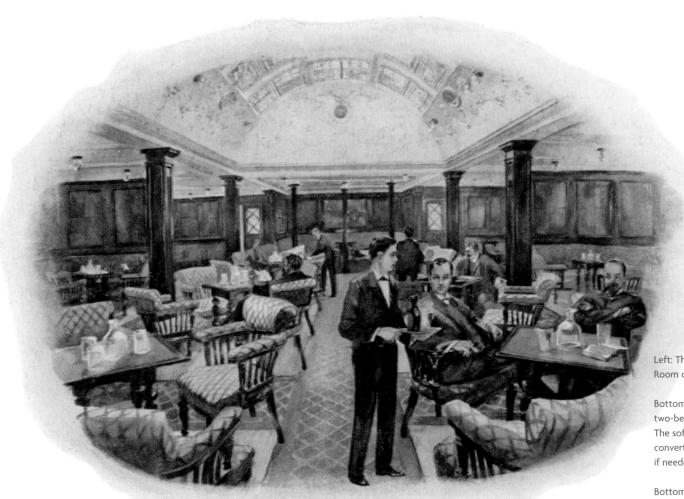

Left: The second-class Smoking Room on B Deck aft.

Bottom left: A standard two-berth second-class cabin. The sofa on the right could be converted to an additional bed if needed.

Bottom right: A four-berth third-class cabin. These were located in the bow of the ship.

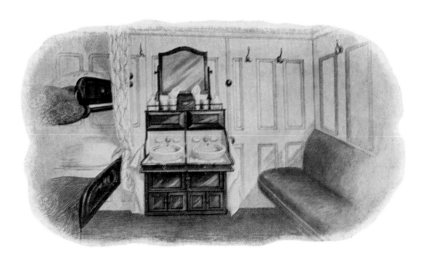

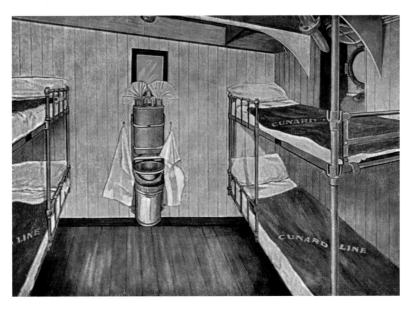

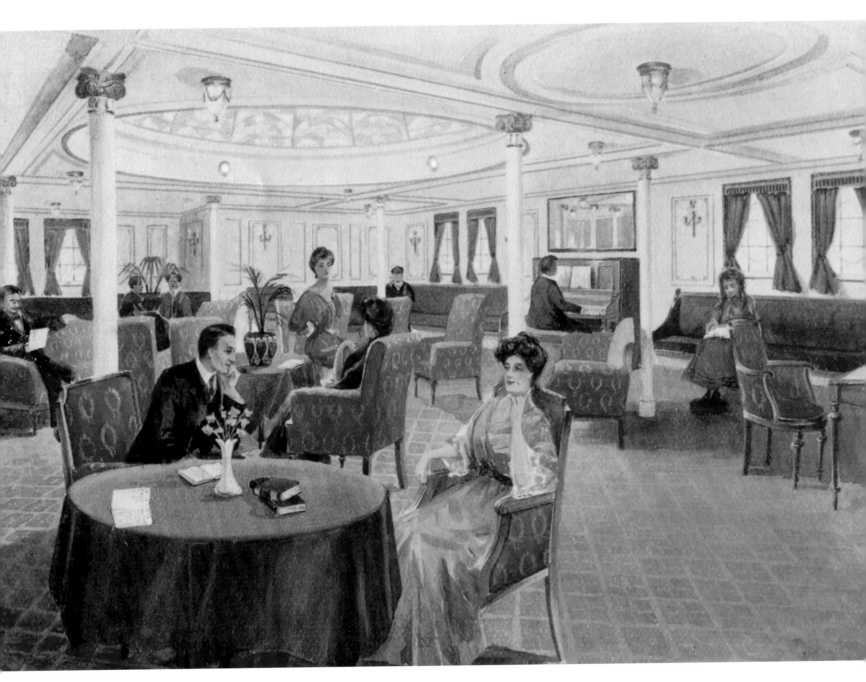

The second-class Drawing Room in colour from a Swedish brochure.

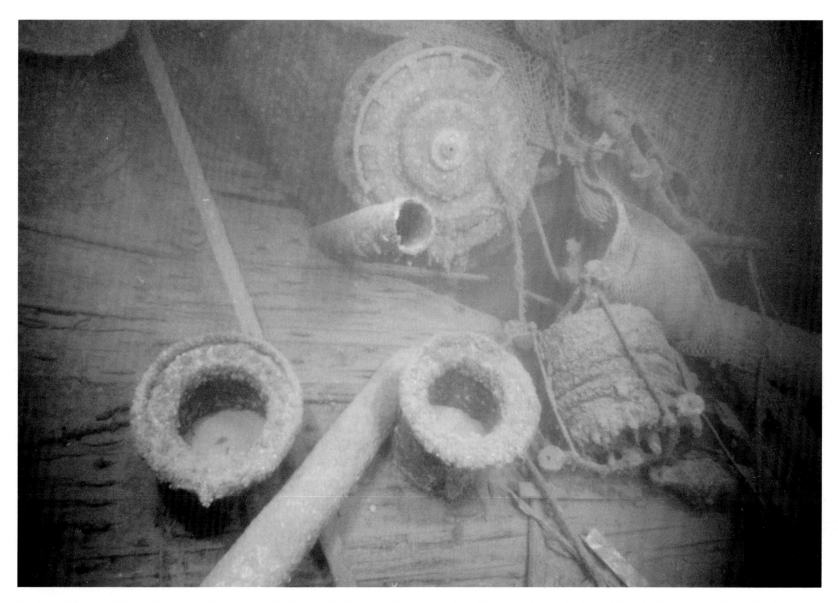

The forecastle is one of the very few areas on the wreck that is still easily identifiable. In this photo, a wire reel lies upside down in the lower right, and in the upper left, the outline of a capstan can be seen. The starboard windlass has begun to fall through to Shelter Deck below.

The opening in the foremast to enter the crow's nest. In 1982, the bell from the crow's nest was recovered from this area. At some point during the ship's career, it seems that this bell had been replaced because originally it was inscribed with the ship's name, but the one recovered from the wreckage in 1982 is not.

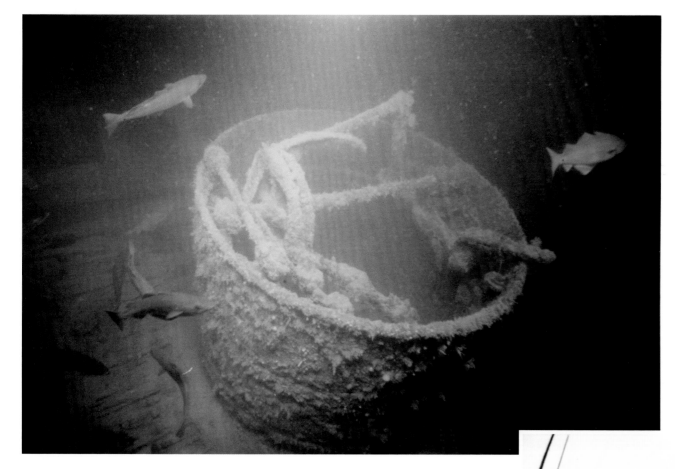

One of *Lusitania*'s most distinctive features was the hinge-topped ventilators John Brown chose to install rather than the cowl vents used on *Mauretania*. Although these gave *Lusitania* a much sleeker and less-cluttered appearance than her sister, they had a difficult time standing up to the rigors of service. As they failed and needed replacing, regular cowl vents were installed. Many of the original vents can be seen scattered throughout the wreck site.

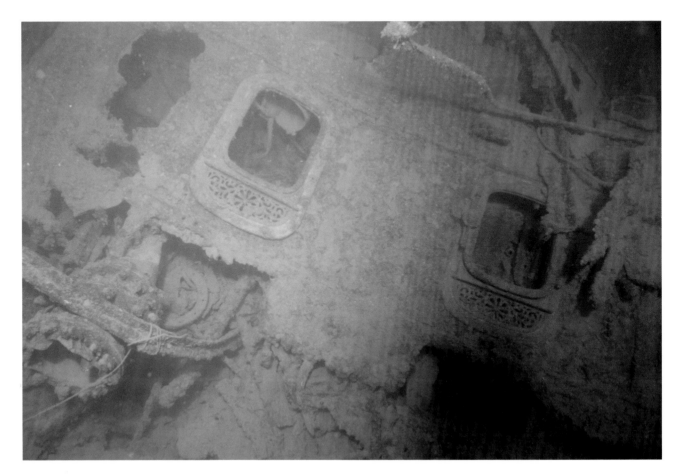

One of the only identifiable pieces of superstructure left on the wreck. These windows originally looked into a pantry and a ladies' bathroom on the port side of Shelter Deck, just aft of the first-class Dining Room.

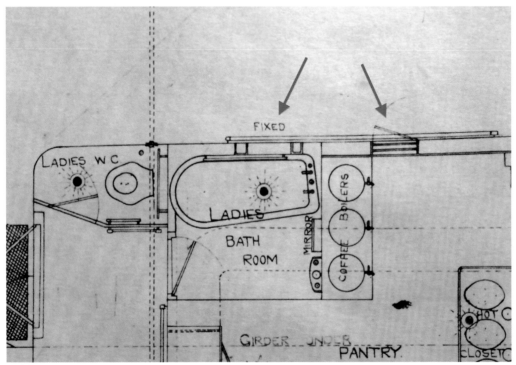

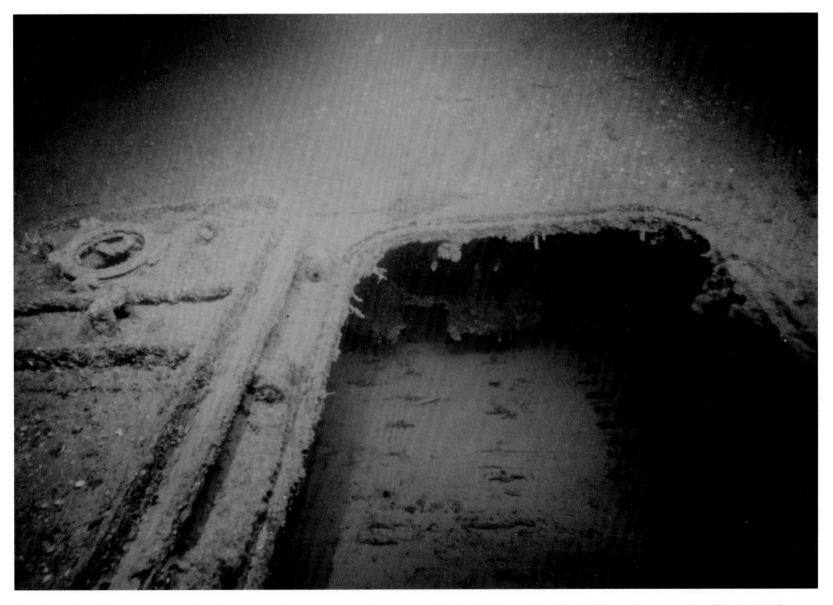

The collapse of the hull is evident in this photo of the port shell door for the firemen's entrance on Main Deck aft. The deck inside has folded up and is now nearly parallel with the hull.

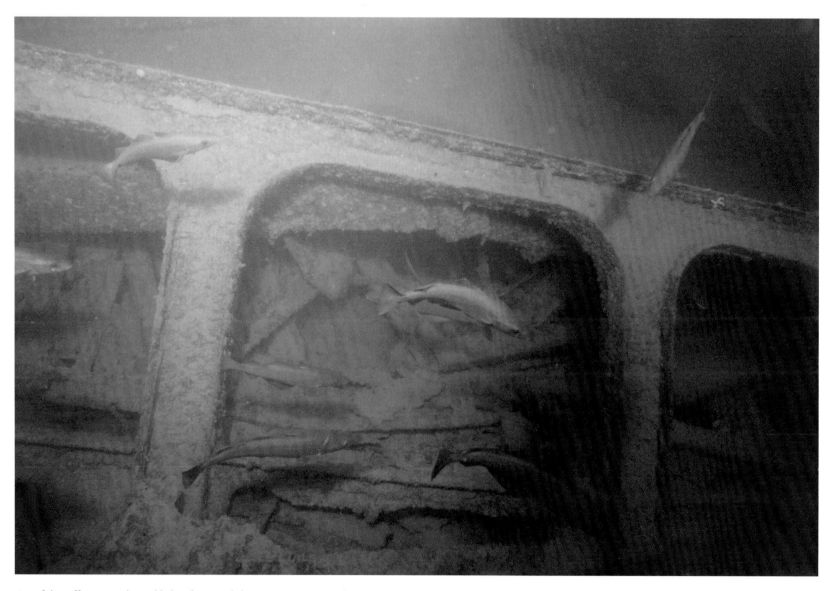

One of the stiffening members added to the second-class Lounge on Boat Deck to help arrest the ship's vibration now lying in the debris of the second-class superstructure (above), and an archival photo of the same stiffeners just after installation (opposite).

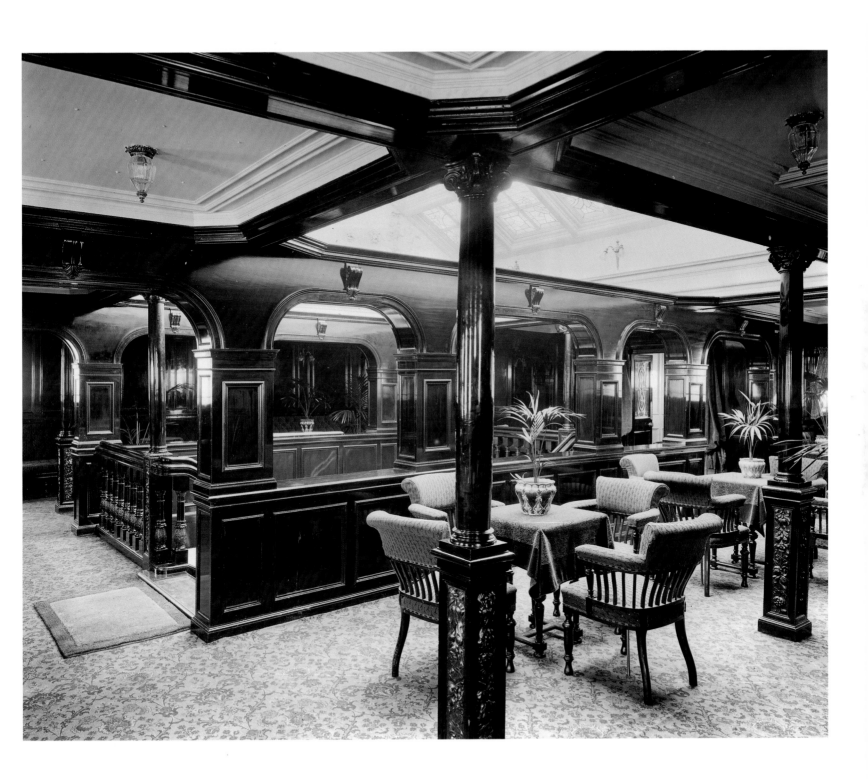

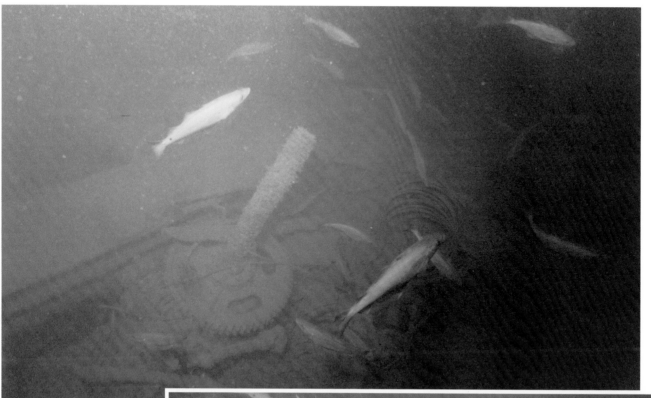

Part of the port-side turbine lifting gear. An identical piece of equipment can be seen in the engine room photo on page 66.

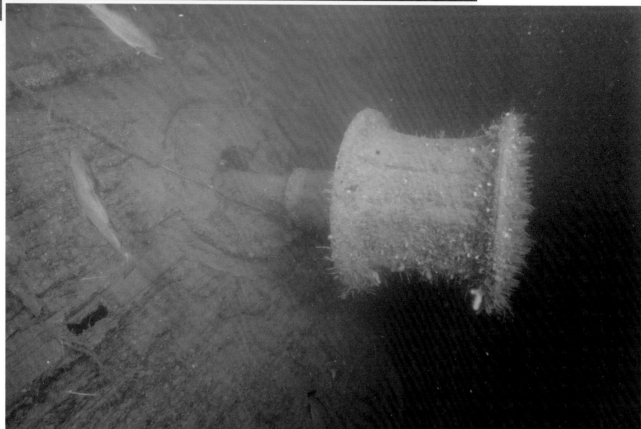

The starboard capstan from the recess in the second-class deckhouse on Shelter Deck aft. The flattening of the ship is easily seen from the way the capstan protrudes above the deck.

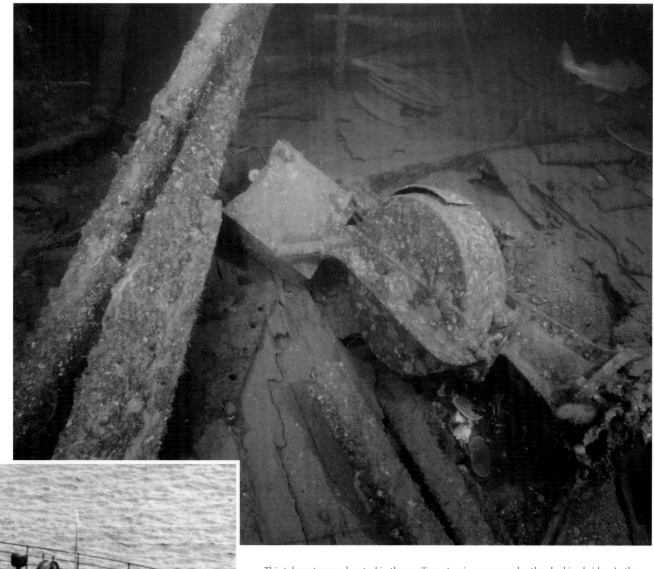

This telemotor was located in the auxiliary steering room under the docking bridge. In the distance is the telegraph from the docking bridge, and just out of frame at the top of the photo is the docking bridge, which landed upside down when the wreck collapsed.

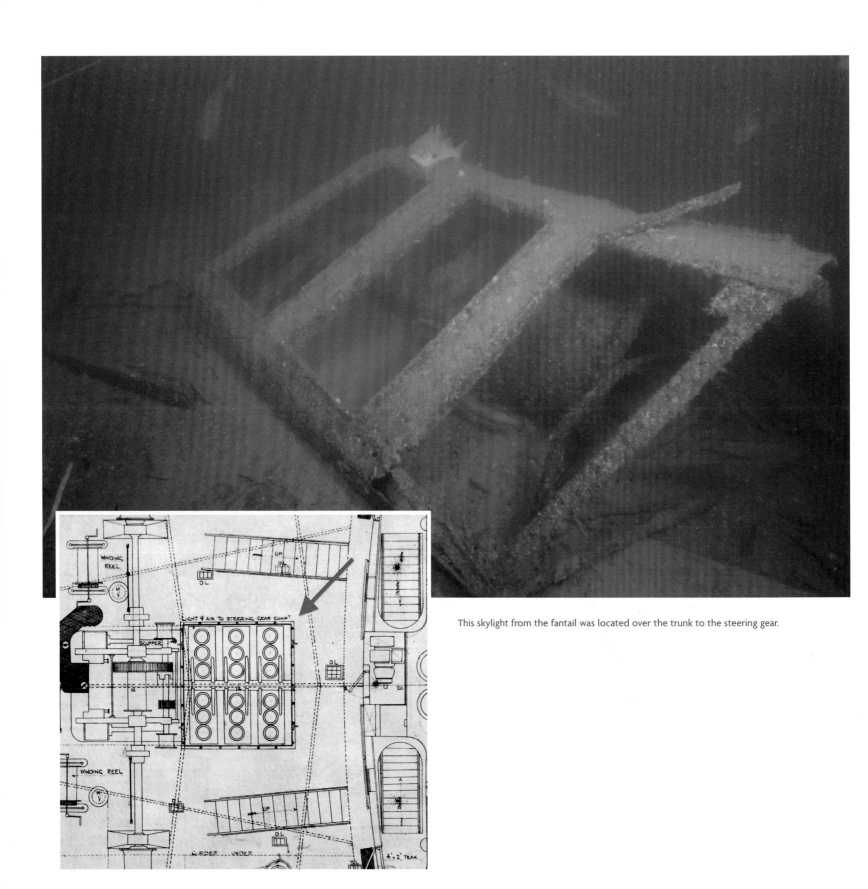

This skylight from the fantail was located over the trunk to the steering gear.

CREW SPACES

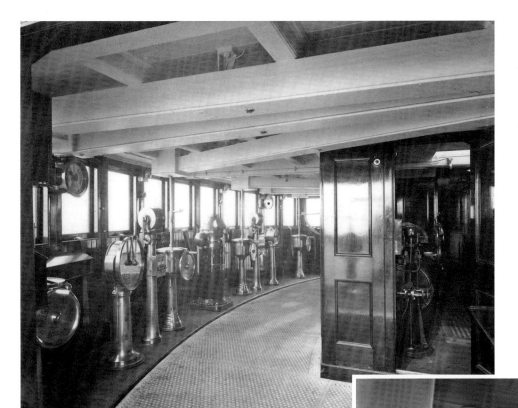

Because of their potential use as auxiliary cruisers, the bridge equipment on *Lusitania* and *Mauretania* was of a higher standard than on most other liners of the day. For example, rather than use a pulley-and-chain-type telegraph system which was preferred by Cunard because it was less expensive, the Admiralty insisted under the terms of the government loan that the more-reliable type operated by rods and miter wheels be used. During an expedition to the wreck in 2011, one of the engine telltales and a telemotor were salvaged.

A rare photo of the Officers' Smoke Room located just aft of the bridge. The two doors on the aft bulkhead – one open and one closed – lead to cabins for the second officers. Just off to the right of centre through the open door, is a cabin shared by two third officers. The chairs are identical to those in the second-class Lounge and the Smoking Room.

Right: The aft half of the main galley on Upper Deck looking to port toward the Bakehouse and Bakers' Shop.

Far right: *Lusitania*'s engine room was divided into three distinct spaces – one each for the high-pressure turbines (port and starboard) and one for the low-pressure turbines. This view looks aft on the starboard side in the area over the low-pressure turbine engine room. The portholes above on the right allow light into the Firemen and Trimmers Dining Saloon.

To drive *Lusitania* across the Atlantic at record speeds, her boilers consumed about 1,000 tons of coal per day or about 1,500lb per minute. In the distance are two watertight doors that led to the longitudinal coalbunkers. There were some questions asked at the British *Titanic* Inquiry about whether the watertight doors on *Lusitania* would close if they had been blocked by lumps of coal or a build-up of coal dust. Leonard Peskett testified that, even if coal had come to rest in the opening of a watertight door on *Lusitania*, it could still be closed and function as designed.

The wreck is split from top to bottom through the first-class Lounge and Dining Room down through boiler room No. 4. One boiler still inside the wreck was seen during the 1993 expedition.

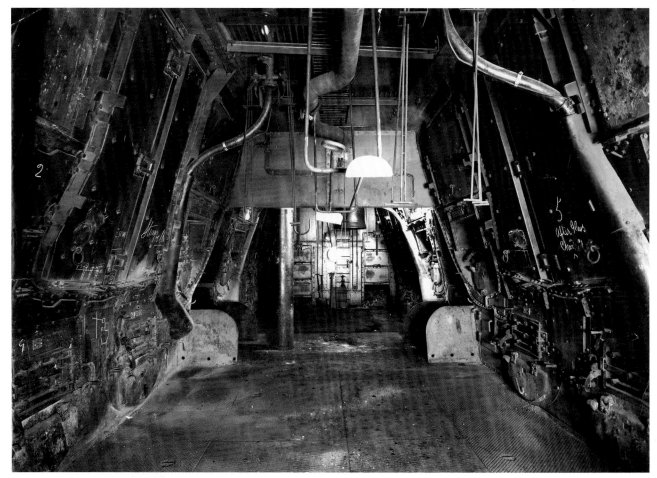

UPON THE FACE OF THE WATERS ...

So proud was Cunard of *Lusitania* and *Mauretania* that, several months after the ships entered service, the company produced a small brochure consisting of complimentary letters that had been received from grateful passengers. Mr. T.H. Worsnop wrote:

I consider the *Lusitania* as near perfection as possible from a passenger's point of view. Her appointments for the comfort of those travelling by her are without doubt equal to those to be found in the most luxurious hotel, and the rooms are lofty and roomy. With respect to the vibration, this has been certainly greatly exaggerated in reports that I have heard – I do not see how it would be possible to diminish it beyond what is now felt with the speed that is being maintained.

James Thomas Walter Charles was born on 2 August 1865. Charles first went to sea in 1880 as an apprentice in sailing ships, and he joined Cunard as Fourth Officer of the *Lucania* in 1895. In a very rapid assent, by 1900 he had become Chief Officer of *Etruria*. The following year he received his first command, the 2,057-ton *Aleppo*. He went on to captain *Mauretania*, *Saxonia*, *Carmania*, and *Lusitania* among others. He first assumed command of *Aquitania* in 1918 when she was still a transport on government service. He died on her bridge ten years later on 15 July 1928 upon his last arrival in Southampton before his announced retirement.

Palmer H. Langdon's thoughts on the vibration are typical of the comments of many other passengers:

Regarding the vibration, before I left New York, my friends told me that 'if you go on one of these high-power vessels you will have your head shaken off.' I have been all over the vessel and have taken particular pains to look for vibration, and am pleased to say that I could find very little of it, and what there is is far pleasanter than the hum of a reciprocating engine.

Running aground or scraping a submerged object is always a concern to any ship's master, and one of the first incidents of this in *Lusitania*'s career was upon arrival in Queenstown on 29 December 1907. As she approached the harbour, she 'touched bottom'. An immediate inspection of the hull was made, and since no serious damage could be found and there was no flooding anywhere in the ship, she proceeded to New York and continued in service until her regular overhaul in the Canada Graving Dock on 16 February. During her time in dry dock, the hull was closely examined, and it was discovered that the damage, although slight, extended 'for a distance of about 330 feet.' Sufficient repairs were made to the ship to make her 'fit and efficient for the service ... by renewing rivets in the damaged floors and fitting partial straps at the back of the floors and riveting same to both floor and angle bar. This work was carried out without removing or disturbing any of the damaged shell plates.' This was Captain Watt's second incident with grounding during his career with Cunard; so he was called in front of the company's Chairman, William Watson, and 'spoken to and cautioned.'

To complete this repair cost £1,658 10s 8d and on 12 March 1908, Cunard received an estimate for the cost of carrying out the work necessary to put the ship back in the same condition as before the grounding. The total would be about £14,000 for the ship repairs only, not including the cost of dry-docking, coal, etc. These extra expenses totaled an additional £3,000, and the time needed to effect complete the work was given as about ten weeks. No definitive record of this work being carried out has been found yet, so it may not have been done because of the cost.

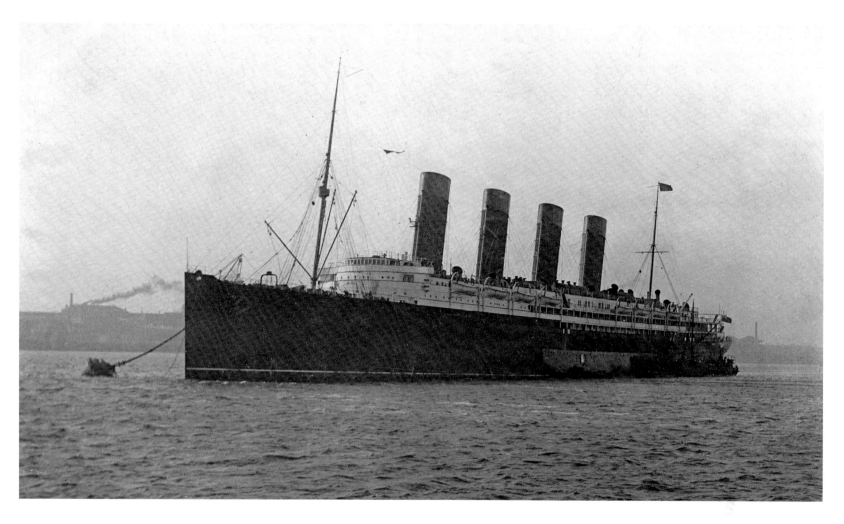

Although the stiffening introduced before the maiden voyage greatly reduced the vibration, it was still an ongoing problem, and additional modifications continued to be made. On 30 March 1908, James Bain submitted the following report to Cunard:

On the 26th instant the Writer and Ship Designer [Leonard Peskett] joined the 'Lusitania' at Queenstown on her last voyage to note the effect of the additional stiffening that had been put into the ship before she left Liverpool [during her dry-docking of 16–29 February 1908].

The effect of the stiffening could not be accurately determined owing to two wing propellers 16'6" diameter x 15'9" pitch having been substituted for the propellers 15' diameter x 16'6" pitch which have been in use since the ship ran her trials. These new propellers were fitted at the same time as the stiffening was added.

The draft of the ship leaving Liverpool on her last outward voyage was 34'8 mean, equal to 39500 tons displacement, and on her homeward voyage from Queenstown 31'3½", equal to 35200 tons displacement, which is a difference of 4300 tons.

In a report from the Ship Designer who went to Queenstown on the outward passage it is stated that at the great displacement there was a general improvement throughout the ship, but that there was slight vibration at the forward and after ends of the 2nd class Lounge and a disagreeable hum from the propellers in the 2nd class Entrance.

At the smaller displacement, on the homeward passage from Queenstown it was found that there was less vibration in the 2nd cabin lounge,

Lusitania tied up to one of the Cunard buoys in the Mersey. Because pier space in Liverpool was at a premium, ships were required to anchor in the Mersey to take on coal and prepare for their next voyage. When time came for passengers to embark, the liner would move to the Landing Stage.

Lusitania at the Prince's Landing Stage in Liverpool.

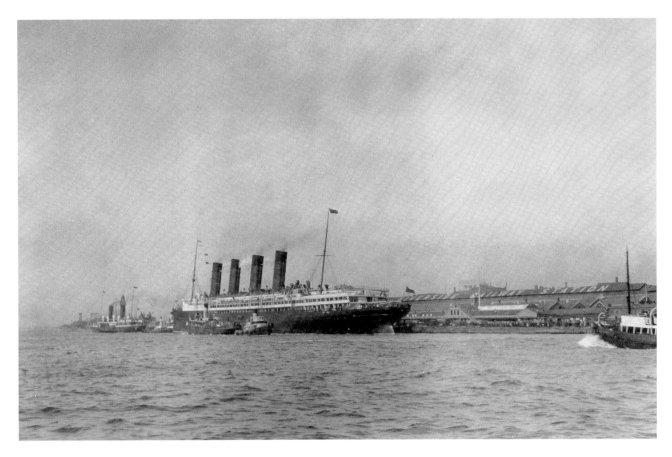

A group photo in front of one of *Lusitania*'s lifeboats. Note that the name on the lifeboat is painted on and is not a brass plaque as on most other liners.

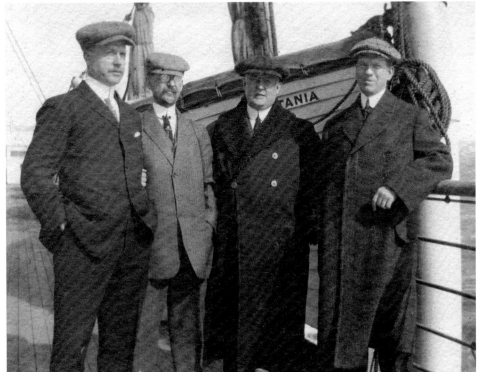

principally confined to the neighborhood of the Lounge bar, and that the hum from the propellers had practically disappeared.

It was noticeable also on the homeward passage that some vibration had developed in the after alleyways on B Deck between the main entrance and the engine room hatch, and vibration was also more perceptible in the after end of Upper Dining Saloon, Smoke Room, and in the Lounge than on the outward passage.

From this it is to be inferred that the locality of the vibration varies with the displacement.

Plans are attached showing where it is proposed to fit some partial bulkheads and pillars before the ship sails on Saturday, the 4th prox.

It is suggested that on the vessel's return to Liverpool weights should be placed in the first and second class Lounge and in the 2nd Class Drawing Room as was done in the 'Mauretania' with good effect.

John Brown had given Cunard a one-year 'guarantee period' for any defects on the ship. As the first anniversary of the turnover to Cunard approached, Cunard began submitting a number of claims so that the cost of repair could be charged to John Brown, including worn carpets, more issues with the hot water supply, and shrinking woodwork. The woodwork issue seemed to be the most serious problem because it was already an issue when the ship had been in service only four months. Two reports were written by Cunard representatives in January 1908:

> ... the Supt. Upholsterer reported that the woodwork in various parts of the ship shows signs of shrinking, and suggests that this be made good and that the cost, together with the necessary re-painting, be charged against the Builders ...

> [It was] reported that the Woodwork to the Writing Room, Entrance, Alleyways, Ceilings, and Upper and Lower Dining Saloons had shrunk very considerably in many places, and was much worse than when the ship left Liverpool on her last voyage; that several ceilings of rooms fitted by Messrs. Waring & Gillow had also shrunk, and suggested that Messrs. John Brown & Co. be asked to send a representative to inspect this woodwork, and to ask Messrs Waring & Gillow to send someone to inspect their portion of the work, so that arrangements might be made for putting the work right.

On the first anniversary of the ship being turned over to Cunard, John Brown sent a friendly reminder to the steamship company that the 'guarantee period under the Contract for the above vessel has now expired ...'.

As time went on, it was realised that, like most other major liners, alterations needed to be made to *Lusitania*'s design. One of the most costly issues to resolve on most pre-war liners was the lack of private toilets attached to cabins. Two were added to *Lusitania* before she sank, and these were attached to cabins D-20 and D-23 by removing the middle stateroom of the triple bank of cabins just forward and adding a door. Many more were installed on *Mauretania* during various refits after the First World War, and the same, no doubt, would have been done to *Lusitania*.

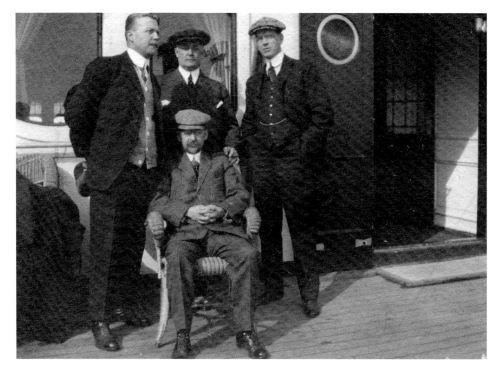

Taken just outside of the first-class entrance on Boat Deck, this is one of the only known photos to show part of the interior of a Boat Deck vestibule.

Taken from cabin A-20 looking aft into cabin A-22, this is the only known snapshot of a passenger in a cabin. A-22 was one of only two cabins on A Deck to have an attached bath.

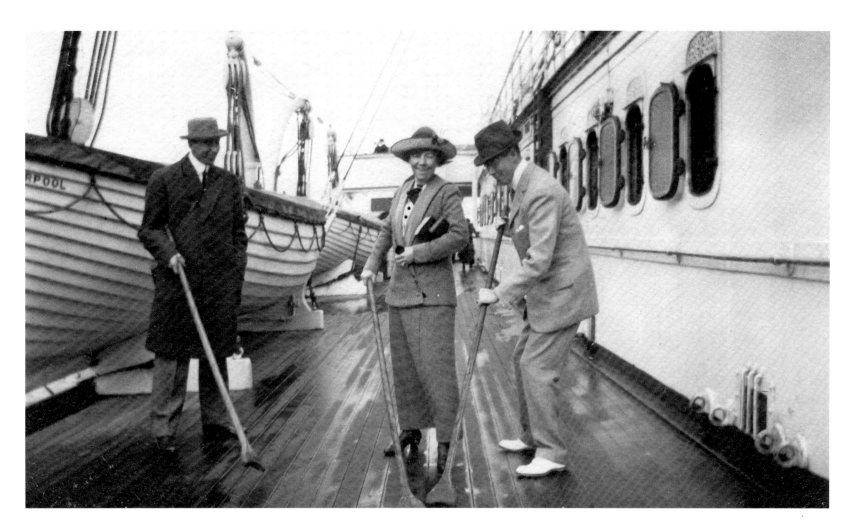

The windows on the right looked into cabins A-20 and A-22. The skid light at deck level allowed natural light into interior spaces, and today these are still identifiable in the remains of Boat Deck. The one pictured here led into the bathroom of the Regal Suite below.

Because of the high first-class passenger loads the ship was carrying, the suggestion was made to increase *Lusitania*'s first-class capacity. This was a significant change with the addition of twenty-eight new staterooms on E Deck forward. To achieve this, the thirty-six aftermost third-class cabins on the same deck, which were just forward of the first-class staircase, were gutted and converted into first class.

After the loss of *Titanic*, one of the changes Cunard made to the hierarchy of officers on *Lusitania* and *Mauretania* was the addition of a staff captain, immediately under the captain. The staff captain was responsible mostly 'for the discipline and efficiency of the ship.' He was given former first-class cabin A-2, overlooking the bow and right next to the Captain's quarters.

The new staff captain position '... was decided upon by the Cunard Directors to insure the safety of passengers by having lifeboat drills and the general working of the ship under one responsible official who had no watch to keep on the bridge. The Staff Captain will arrange the officers' watches, order the boat drills, and enter them in the log book.'

Only *Lusitania* and *Mauretania* (and later *Aquitania*) would carry staff captains. *Caronia* and *Carmania* would not, but 'their officers [were] increased to seven, out of which one will be the relief officer to carry out any extra duties that may occur on the voyage, and relieve the Chief Officer on the bridge when necessary.'

Various problems also arose with *Lusitania*'s turbines. After some work on them that kept the ship out of service from mid-October to mid-December 1912, *Lusitania* had only made one round-trip voyage before the next incident. On 30 December 1912, as she arrived in Fishguard Harbor, the officer on the bridge saw a steamer

in their way. He ordered the quartermaster to port the helm, but the telemotor jammed. To avoid a collision, the turbines were immediately ordered to full astern. The collision was prevented, but it was soon discovered that upon the full-astern order some blades on the starboard low-pressure and high-pressure turbines had been damaged, as had many of the blades on the port low-pressure turbine, which had only been installed the month before. Upon examination of the telemotor to find out why it had malfunctioned, it was discovered that a small piece of marline had fallen into it and prevented it from working.

Although Cunard considered a less expensive option, the company decided to keep the ship out of service for more than half of 1913 and repair her properly. For nearly eight months, she was shuttled between several berths in Liverpool while the repair work was performed. Finally, on 20 August, she left Liverpool for her successful two-day trials and departed on 23 August for her first transatlantic crossing of 1913. Between October 1912 and August 1913, Lusitania made only one round-trip voyage.

During Lusitania's call in New York in mid-January 1914, the temperature was below zero, and when she sailed, it was still below freezing. Because of this, water service on the liner was 'greatly impaired' because of frozen pipes and scuppers. The engineers worked continuously on the problem, but 'the thaw caused numerous bursts, which further inconvenienced passengers ...'

As Lusitania began to age, problems cropped up that were, for the most part, not unexpected. Many had to do with her plumbing. On her next westward voyage from Liverpool at the beginning of February, the hot water in the first-class staterooms on D Deck did not work. On the following passage from New York, the chief steward reported that the hot saltwater supply was irregular, and at times, no water came from the tap at all, only steam. He went on to say that 'nearly all the Bath Taps are leaking, and on turning the handle for cold water, hot water comes through, which is likely to scald'.

Rescues at sea were also a common occurrence. Lusitania departed New York on a cold winter crossing early on the morning of 15 January 1914 bound for

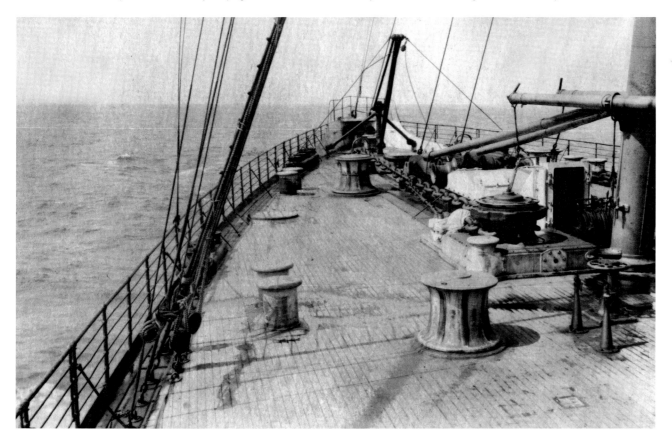

In a memo to Cunard on 30 November 1905, the Admiralty stipulated that the guns to be 'fitted to Lusitania should be 6" B.L. Mark VII not 6" Q.F.' The Admiralty also required that the gun rings be installed and approved by them before laying of the decking began.

As work proceeded on the design of the ship, on 7 December 1905, Cunard asked the Admiralty for permission to move the placement of the guns from frames 171–172 to frames 169–170 because 'the gun supports as at present arranged [interfere] materially with the cabin accommodation on deck below.' The Controller of the Navy approved the request on 23 December 1905 after reviewing the redrawn plans submitted by Cunard. This is one of the few images to show a gun ring installed on Lusitania. It is the raised area in the left centre of the photo.

Liverpool under the command of Daniel Dow. At 2 a.m. on the 16th, the officer on watch sighted distress signals to the north. The liner made for the rockets and stopped her engines around 2.40 a.m. They found the schooner *Mayflower* in distress because of the storm. Her mainsail had been lost and another was damaged, as were her rudder and sternpost. By Morse lamp, Captain Halfyard of the *Mayflower* asked that a lifeboat be sent so they could abandon ship. Around 3 a.m. First Officer Alexander of *Lusitania* and a volunteer crew lowered a boat with great difficulty because of the high seas and slowly made their way to the immobilised schooner.

Upon reaching the *Mayflower*, Alexander found that he could not bring his boat alongside because of the sea conditions; so each man from the schooner had to jump into the turbulent sea and be pulled to the lifeboat by a rope. Because of the cold conditions – the water was 32 °F and the air was 26 °F – Captain Dow was concerned about leaving his boat crew out in the frigid weather too long; so another lifeboat was standing by to relieve them.

After the loss of *Titanic* in April 1912, steamship lines were required to put additional lifeboats on their entire fleet to ensure that every soul on board had a seat. Until the time of *Lusitania*'s loss, Cunard kept altering the arrangement, and here we see the one from August of 1913. Boat No. 2 is in the foreground and is being inspected by the crew. According to a report to Cunard shareholders, in the two and a half years following *Titanic*'s sinking, the company spent over £76,700 'in order to comply with the varying government regulations in force from time to time. Under the new life-saving regulations as approved by the International Convention a large part of this expenditure will prove to have been a pure waste of money.'

25 August 1913, Liverpool to New York. Boat 10 is swung out for inspection. Once the new additional lifeboats had been placed on the ship, Boat Deck became almost unusable. The forward bay window of the first-class Lounge is in the foreground.

It took about two and a half hours to rescue everyone from the schooner, and just before leaving the vessel, Captain Halfyard set fire to the *Mayflower* 'as a safeguard to shipping.' Alexander had everyone safely on board *Lusitania* by 5.30 a.m., and each crewman of the *Mayflower* was treated by *Lusitania*'s surgeon, James Pointon. Captain Halfyard even managed to save the ship's cat. Unfortunately, the poor animal died from exposure shortly after reaching safety.

A committee was set up among *Lusitania*'s passengers to raise money for the lifeboat crew and the shipwrecked sailors from the *Mayflower*, and £354 was collected. The money was presented to Captain Dow in the first-class Lounge at 11.45 a.m., and the entire crew of the rescue boat was present. It was also decided to present Captain Dow with an illuminated certificate, and a gold watch was to be presented to each officer of the lifeboat, thanking them for putting their own lives at risk in coming to the aid of fellow sailors.

When word reached Liverpool of the rescue, the Lord Mayor decided to make the presentation to Captain Dow of his illuminated certificate on 29 January. First Officer Alexander and Extra Third Officer Foden were also honoured at the ceremony. Cunard management requested that as many of their office staff as possible attend.

Small fires also became a problem throughout the ship. One broke out in the drying room in February 1914 and fortunately did not cause much damage. Another fire occurred in the Verandah Café as a result of rats 'eating away the insulation of the wires, thereby allowing contact between two live wires.' A more serious one occurred in the first-class Entrance on Boat Deck, caused by deteriorated insulation. For the most part, each fire was small and quickly brought under control, but the results, if just one of these could not have been contained, could have been disastrous.

In March 1914, Staff Captain Wolff wrote a memo to Cunard's General Manager in Liverpool to let him know that passengers had been complaining about the noise from the 'typewriting office' on A Deck. First-class cabins surrounded it, and the clicking of the typewriter could be clearly heard. He suggested that it be moved to just off the first-class entrance as it was on *Mauretania*. It is unknown whether his suggestion was completed before *Lusitania* sank.

A snubbing chain, like the one seen here, was attached to each lifeboat and prevented them from moving as the ship rolled. In some cases, it was these chains that prevented lifeboats from being launched during the sinking.

Walter Lord, author's collection

On 19 July, the chief engineer reported to the home office that although they had fine weather for the entire passage, the ship did not make very good progress because 'we had a very poor class of Firemen and trimmers …' He also reported an explosion in a baker's oven, in which one of the copper pipes burst resulting in a broken 'bracket at the root of the funnel'. One of the bakers was injured, but it was reported that he was making good progress.

Another major incident with her turbines occurred in early August 1914 while the ship was docked in New York. In the words of Cunard's Superintendent Engineer, Alexander Galbraith, the reason for the catastrophic turbine failure was:

… that in testing the condenser at New York, the turbine drains were blanked off and this was primarily responsible for the damage, the rapid heating up of the turbine being a secondary matter.

After the condenser was tested, it was the duty of the Engineers to see that the turbine drains were

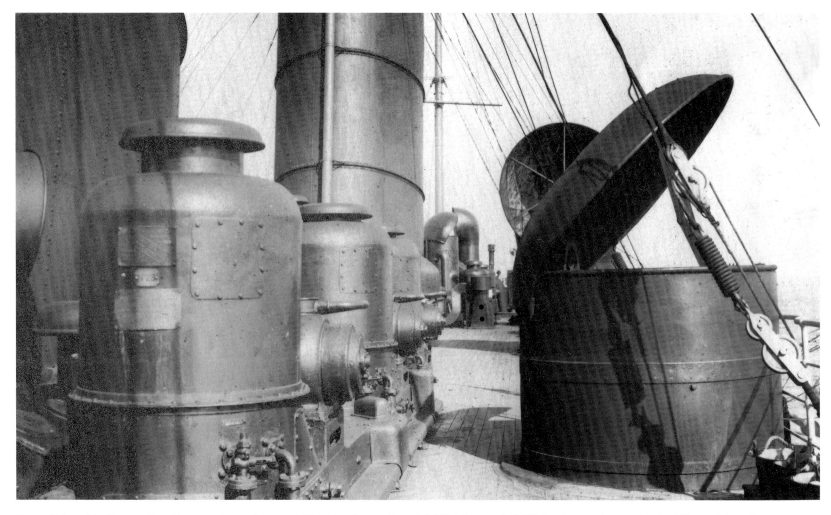

The ventilators of *Lusitania* and her sister were a topic of concern to Cunard as the two shipyards building the liners had differing views on the type that should be used. Swan Hunter was not enthusiastic about the style John Brown had selected for *Lusitania*, and there was a running correspondence between the builders and Cunard as to what course to take. On 11 December 1906, James Bain at Cunard wrote to Andrew Laing at Swan Hunter:

I have looked into the matter of ventilator tops for the *Mauretania*. If you are not perfectly satisfied that a sufficient volume of air can be obtained with the cap tops similar to those adopted for the *Lusitania*, there is no alternative but to fit ordinary bell-mounted cowls as you suggest.

Laing replied on 29 December 1906:

When we looked into this matter we took into consideration not only the weight, but cost, insofar as we can estimate the ordinary cowls with the style of turning gear which will be quite efficient, should work out at about 500 pounds less than the type of cowl that you are fitting to the other ship. I trust that you will be pleased to learn this, and shall be glad to learn by return of post that we are to proceed with the ordinary type of cowl.

Swan Hunter's reasoning apparently satisfied Bain because, in his memo of 2 January 1907 to Andrew Mearns at Cunard, he seemed satisfied to leave the question to each shipyard:

The appearance of the two ships, if Messrs Wallsend Slipway Company's suggestion be adopted, will be somewhat different. As it is considered by The Wallsend Slipway Company to be a matter of efficiency, and as they are responsible for the speed of the ship, it would be desirable to leave the matter in the hands of the builders.

left in their original condition. This was not done, for while the blank flange was removed, the jointing material was left in position. It would thus follow that an accumulation of water would take place, and while we should have expected the long blades in the last expansions to have suffered first, there can be no doubt that the fracturing of the smaller blading in the 3rd and 4th Expansions was due to the abnormal conditions prevailing.

The engineers responsible were C. Gray, Junior 2nd; J. Thompson, Junior 3rd; and W.H. Pollard, Junior 7th. All three, as well as Chief Engineer Allen, were removed from the ship, and several engineers from *Aquitania* were transferred to *Lusitania* to fill the now vacant positions, including Archibald Bryce and Alexander Duncan. Chief Engineer Bryce replaced Allen, who was given a shore-based position in Newcastle as Engineer Inspector for *Aurania*, which was under construction at

Swan Hunter. Allen was eventually demoted to a Senior 2nd Engineer, and Gray was put on shore duty and was 'reduced in rank when a suitable Seagoing vacancy' occurred. Thompson and Pollard were asked to resign.

This turbine incident had far-reaching and fatal implications for Duncan and Bryce, both of whom were aboard *Lusitania* for her final crossing nine months later. Although Duncan survived, Bryce died in the disaster.

Lusitania had been out of service for nearly a month while the turbines were repaired, but finally left Liverpool for her regular run on 12 September 1914. Once the frenzy of people fleeing Europe because of the war stopped, Cunard made the economic decision to keep only one fast liner in service. *Mauretania* was finally withdrawn from service and laid up at the end of October, leaving *Lusitania* on the Atlantic run by herself. Because of the reduced passenger traffic, in November 1914, the maximum speed of *Lusitania* was slowed from 24 to 21 knots after closing a boiler room

Known for her movement in even the mildest of seas, *Lusitania*'s Boat Deck is, not surprisingly, wet and completely void of passengers. In this pre-*Titanic* photo, the original boat arrangement can be seen.

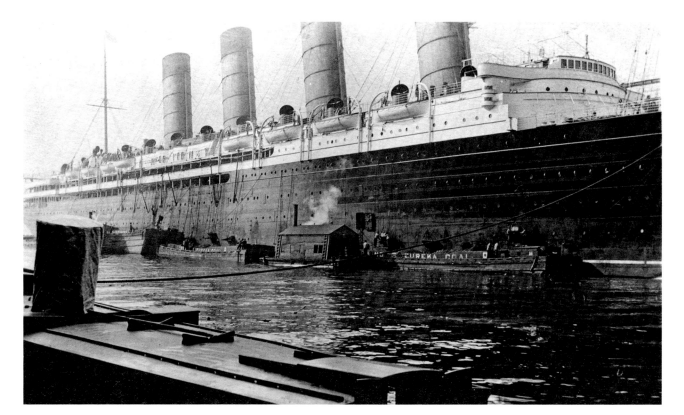

Lusitania docked at Pier 56 in New York. Because coaling was such a messy business, Cunard considered building *Lusitania* and *Mauretania* as oil burners. They decided against it because there was no way to guarantee a constant supply of fuel oil on two continents at a time when nearly all ships were coal-burning.

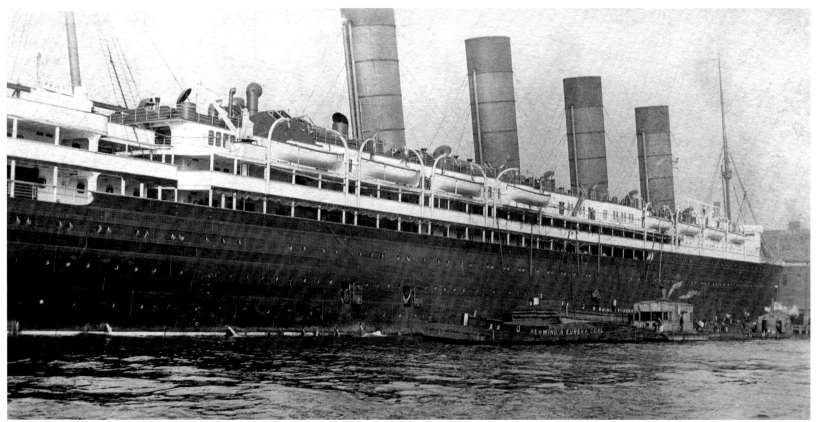

to reduce operating costs. As Booth explained at the British Inquiry into the sinking:

After the rush of homeward-bound American traffic was over, and that came to an end towards the end of October, it became a question as to whether we could continue running the two large steamers the 'Lusitania' and the 'Mauretania' at all or not. We went into the matter very carefully and we came to the conclusion that it would be possible to continue running one of them at a reduced speed, that is to say, that the traffic would be sufficient, but only sufficient to justify running one steamer a month if we reduced the expense.

He went on to say that with the reduction in speed, Cunard would simply be breaking even on the service and that they had expected no profit. Looking at the figures, on every voyage through the war, *Lusitania* made a profit, which averaged about £10,565 per round trip. The reduction in speed was obviously no great concern to the company because Booth also testified that 'no steamer so far as I know of over 14 knots had been caught by a submarine at all.'

For a few voyages before her sinking, submarines and torpedoing were a constant concern to passengers and crew. Rumour mills on both sides of the Atlantic were rife with talk of a submarine attack, but despite this the bookings for *Lusitania*'s next crossing home to Liverpool were the highest since the war began. The prior few months on the Atlantic had been fairly slow, but it seemed that things were beginning to look up for Cunard.

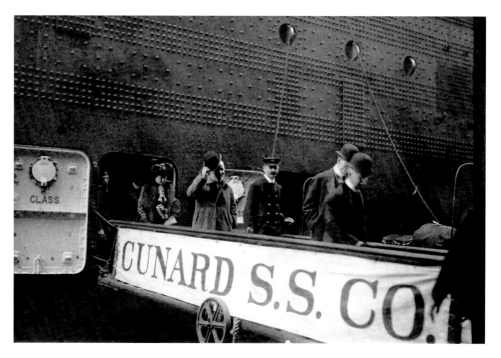

First-class passengers disembarking *Lusitania* at Pier 56 in New York. These double shell doors led into the Entrance on E Deck.

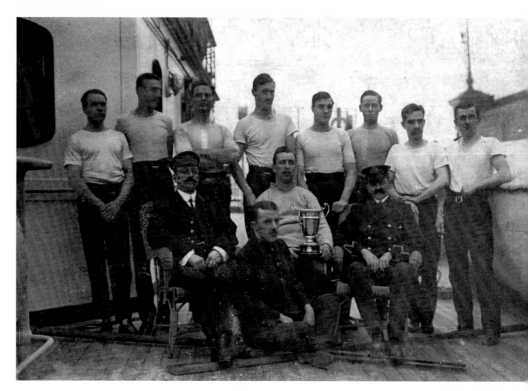

Because a layover in New York usually lasted several days, after passengers had disembarked, one of the most popular ways for crew to spend whatever free time they could find was to compete with men from other Cunarders in lifeboat races to find the best boat crew. This team from *Lusitania* poses with their trophy in this post-*Titanic* photo.

This photo was taken in New York after *Lusitania* had been hit by a rogue wave on 10 January 1910, one day out of Queenstown. Once back in Liverpool, repairing this damage kept the ship out of service for a month. Note the additional supports that had been added to the bridge front after the damage caused by a wave early in 1909. When the superstructure was repaired after the wave of 1910, even more supports were added just under the bridge windows.

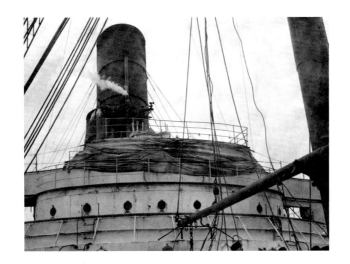

The same damage from inside the bridge. Compare this view to that of the bridge on page 65.

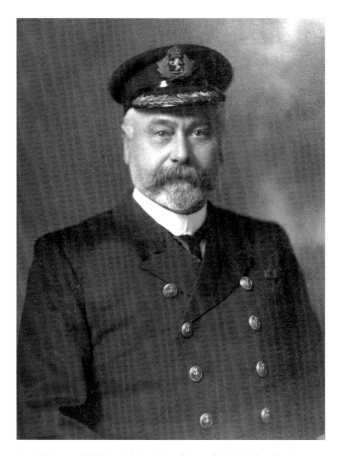

Born 18 January 1860, Daniel Dow joined Cunard in 1888 after having been at sea since 1876. His first Cunard command was *Sylvania* in 1903, and during his career he served on most of their large liners. He was promoted to captain of *Campania* on 16 May 1907, and while in command of her he received a salary of £600 per year. He commanded *Lusitania* during three separate tenures. He retired in January 1919, and died at his home in Blundellsands on 20 January 1931.

Turbine blades from the author's collection.

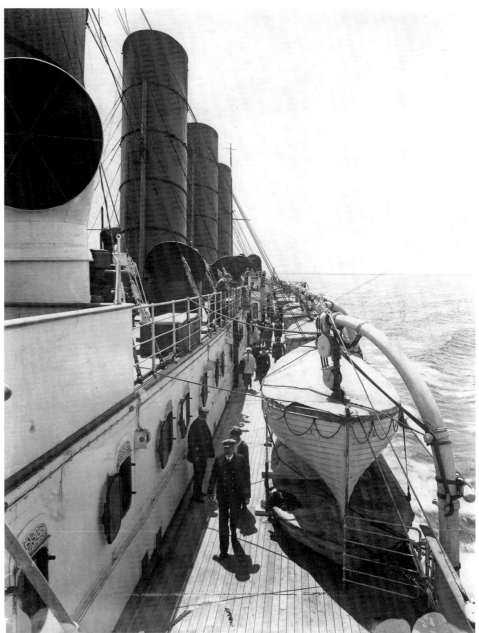

An unusually late view of *Lusitania*'s port Boat Deck taken from the bridge wing. Captain Daniel Dow is clearly visible in the foreground making his way toward the bridge.

A paperweight made from high-pressure turbine blades removed from *Lusitania* during the turbine replacement of 1913.

Captain Dow accepting an 'illuminated certificate' in thanks for his rescue of the survivors of the schooner *Mayflower* on 16 January 1914.

Lusitania in the Gladstone dry dock during her yearly overhaul from 20–30 January 1914. In the midships davits that were added a few years before are collapsible boats stacked three high.

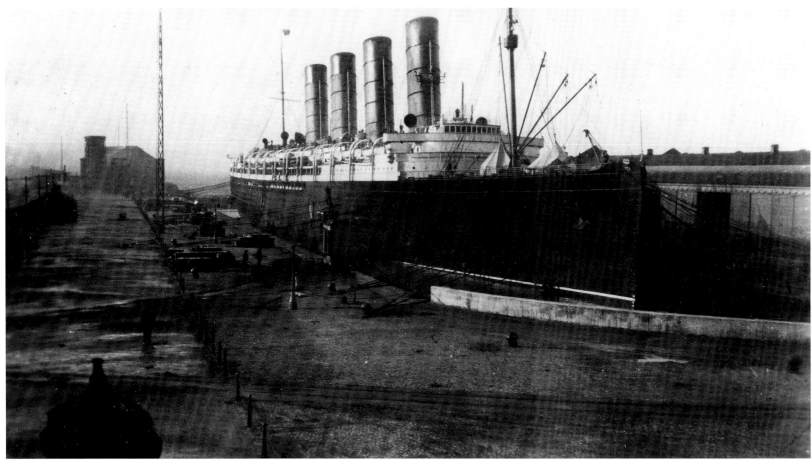

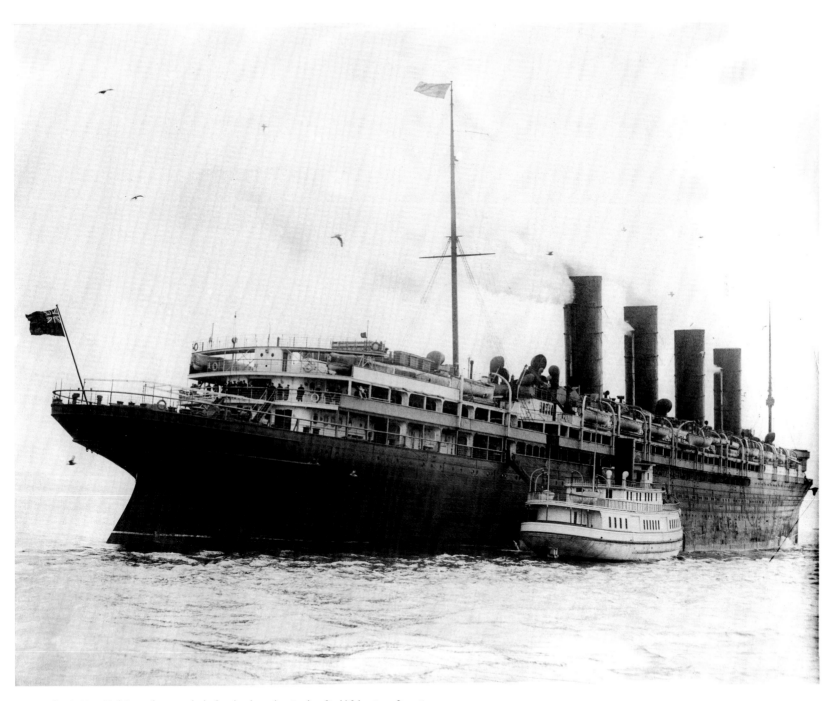

A view taken in New York just a few months before her loss, showing her final lifeboat configuration.

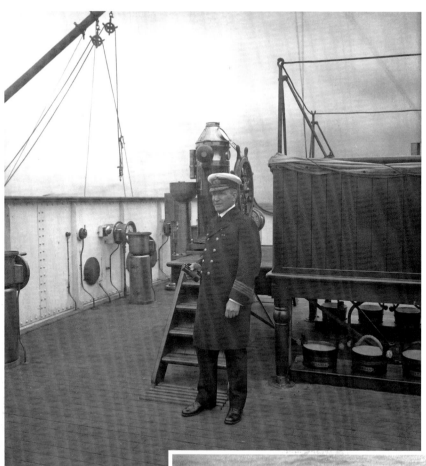

Captain William Thomas Turner on the upper bridge of Cunard's new *Aquitania* at the time of her maiden voyage in May 1914. Turner joined Cunard on 26 April 1883 and later commanded *Lusitania* on her final voyage. He survived the sinking and was given command of *Ivernia* in 1916. At 10.12 on the morning of January 1917, while steaming 58 miles off Cape Matapan, Greece, *Ivernia* was torpedoed by the UB-47 and sank within an hour, with the loss of around 120 lives. Turner again survived. *Ivernia* was the second ship to be torpedoed with Turner in command. Not surprisingly, he was never given another command.

An exceptionally rare photo taken during *Lusitania*'s final completed voyage to New York in April 1915. Lifeboat 14 is swung out and boat drill is under way. Considering the available evidence, the officer standing on the rail is almost certainly First Officer Arthur Rowland Jones.

'MURDER BY SAVAGES DRUNK WITH BLOOD'

A British newspaper

'WITH JOYFUL PRIDE WE CONTEMPLATE THIS LATEST DEED OF OUR NAVY'

A German Newspaper

Saturday, 1 May 1915. Scheduled to sail at 10 a.m., *Lusitania*'s departure from New York was delayed because of the requisitioning that morning of the Anchor Line steamer *Cameronia* and the subsequent transfer of passengers to *Lusitania*. Finally sailing over two hours late, *Lusitania* slowly backed out of Pier 54, turned her bow downstream, and began her 202nd crossing.

The morning of 7 May dawned foggy, but around 11 a.m., the weather cleared into a lovely spring afternoon. What no one on board knew was that, in the six days since *Lusitania* sailed from New York, twenty-two ships had been sunk by German submarines.

At 1.20 p.m. Kapitänleutnant Walther Schwieger, commander of the U-20, sighted the fast-approaching *Lusitania* about 13 miles away. As the liner drew nearer, Schwieger attempted in vain to get his submerged U-boat into position for a clean shot but soon realised that it was impossible because of the direction *Lusitania* was sailing. At 1.40 p.m., just as he was about to give up hope, *Lusitania* made a turn to starboard and would steam almost directly in front of the bow of the U-20. Schwieger couldn't believe his luck. Just before 2.10 p.m., Schwieger fired a single torpedo and watched as the deadly missile found its mark.

Mortally wounded, *Lusitania* had less than eighteen minutes to live.

No author can recount the terrifying experiences of the nearly 2,000 people on board *Lusitania* the day she sank better than those who were fortunate to live through the tragedy. With that in mind, the following two accounts from survivors of the disaster should give the reader an idea of the horrors of that terrible May afternoon which changed the lives of so many innocent people forever.

A proposal painting showing *Lusitania* departing on her final voyage from New York, 7 May 1915.

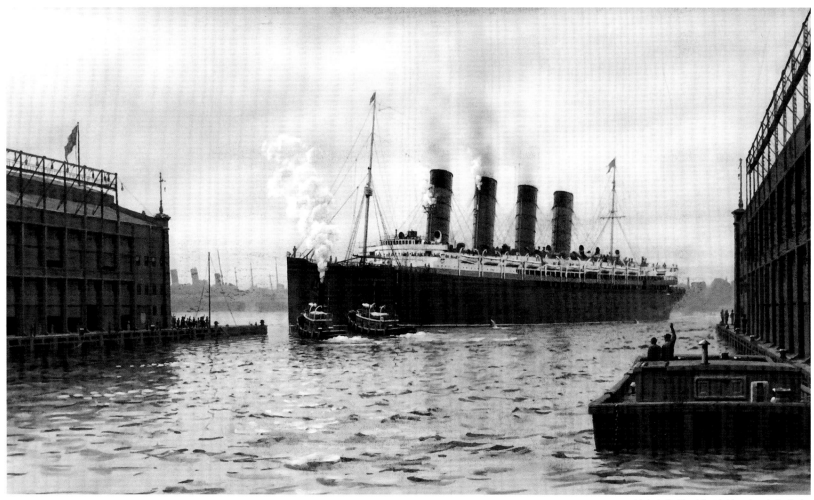

Painting by Ken Marschall, original from the author's collection

'MURDER BY SAVAGES DRUNK WITH BLOOD'

A British newspaper

'WITH JOYFUL PRIDE WE CONTEMPLATE THIS LATEST DEED OF OUR NAVY'

A German Newspaper

Saturday, 1 May 1915. Scheduled to sail at 10 a.m., *Lusitania*'s departure from New York was delayed because of the requisitioning that morning of the Anchor Line steamer *Cameronia* and the subsequent transfer of passengers to *Lusitania*. Finally sailing over two hours late, *Lusitania* slowly backed out of Pier 54, turned her bow downstream, and began her 202nd crossing.

The morning of 7 May dawned foggy, but around 11 a.m., the weather cleared into a lovely spring afternoon. What no one on board knew was that, in the six days since *Lusitania* sailed from New York, twenty-two ships had been sunk by German submarines.

At 1.20 p.m. Kapitänleutnant Walther Schwieger, commander of the U-20, sighted the fast-approaching *Lusitania* about 13 miles away. As the liner drew nearer, Schwieger attempted in vain to get his submerged U-boat into position for a clean shot but soon realised that it was impossible because of the direction *Lusitania* was sailing. At 1.40 p.m., just as he was about to give up hope, *Lusitania* made a turn to starboard and would steam almost directly in front of the bow of the U-20. Schwieger couldn't believe his luck. Just before 2.10 p.m., Schwieger fired a single torpedo and watched as the deadly missile found its mark.

Mortally wounded, *Lusitania* had less than eighteen minutes to live.

No author can recount the terrifying experiences of the nearly 2,000 people on board *Lusitania* the day she sank better than those who were fortunate to live through the tragedy. With that in mind, the following two accounts from survivors of the disaster should give the reader an idea of the horrors of that terrible May afternoon which changed the lives of so many innocent people forever.

A proposal painting showing *Lusitania* departing on her final voyage from New York, 7 May 1915.

Painting by Ken Marschall, original from the author's collection

Born on 7 April 1885, Kapitänleutnant Walther Schwieger sank over 183,000 tons of shipping during the war. He was awarded the Iron Cross (both 1st and 2nd class) as well as the Hausorden von Hohenzollern and the Pour le Mérite (Prussia's highest military award). He was lost on the U-88 in September 1917 in the North Sea.

Commissioned in 1913, the U-20 was one of four U-boats of this class. During her brief career, she had two captains, the second being Walther Schwieger of *Lusitania* fame. The U-20 survived until 4 November 1916 when she ran aground on the coast of Denmark near Vrist. After unsuccessful attempts to refloat the submarine, her crew detonated torpedoes in her tubes so she wouldn't fall into enemy hands. In 1925, some salvage work was done, and after this was completed, parts of her were blown up. There was additional salvage done in the 1950s and 1980s, and among the important pieces of her currently preserved are the conning tower, a propeller, and a deck gun.

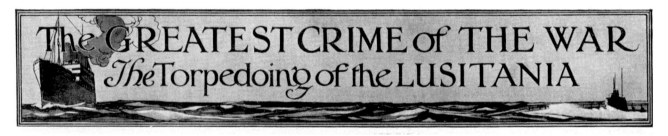

The GREATEST CRIME of THE WAR
The Torpedoing of the LUSITANIA

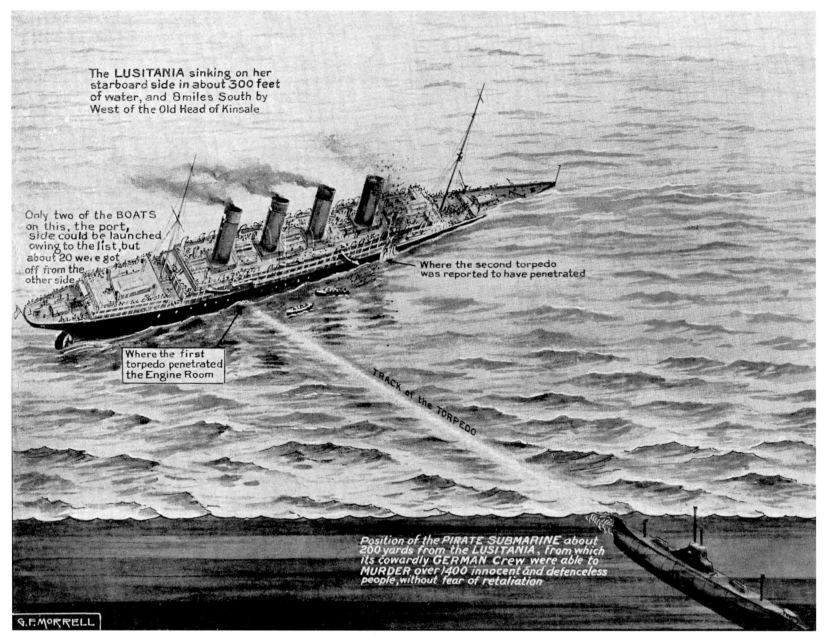

The LUSITANIA sinking on her starboard side in about 300 feet of water, and 8 miles South by West of the Old Head of Kinsale

Only two of the BOATS on this, the port, side could be launched owing to the list, but about 20 were got off from the other side

Where the second torpedo was reported to have penetrated

Where the first torpedo penetrated the Engine Room

TRACK of the TORPEDO

Position of the PIRATE SUBMARINE about 200 yards from the LUSITANIA, from which its cowardly GERMAN Crew were able to MURDER over 1400 innocent and defenceless people, without fear of retaliation

G.F. MORRELL

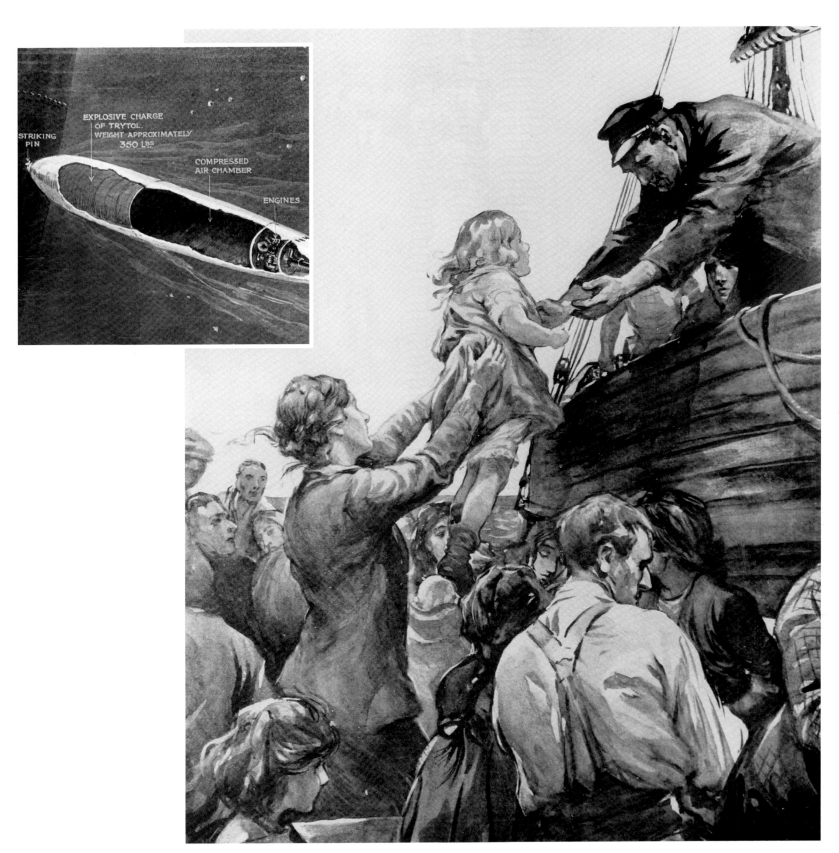

A Letter to Relatives
By Chrissie Aitken
(Originally published in
The Nicola Valley News)

Chrissie Aitken (front right) was travelling with her father James (back row, centre), brother James Jarvie Sr (back row, second right), and nephew James Jarvie Jr (back row, far right). They were booked on the Anchor Line's *Cameronia*, but her requisitioning by the Admiralty on the morning of 1 May 1915 forced the transfer of her passengers to *Lusitania*. Chrissie was the only member of her family to survive.

Photo courtesy Chrissie Aitken Barnett, original from the author's collection

I have just got sat down to write so as long as I'm in the mood I will write a few lines. This is about all I am able to do, as my left hand is out of action. I got it hurt on some wreckage and as it wasn't attended to for three days, dirt has got in and I fear it was poisoned. My knee is the same. But I have got off a lot better than some my life being spared.

Well, the cables you would get all right and would relieve your mind so far. Poor father there is no fear about him, as I identified his body before I left Queenstown but Jarvie and Jarrie I don't know. I fear they have had a similar fate, for as far as I know none of them had life belts. It happened about lunchtime. The girl who slept above me was waiting outside on me so I hurried my lunch, leaving the three sitting at theirs. We (the girl and I) went to our cabins and were just going to pack our grips to put them on deck as they were expecting to get in that night. We were standing laughing at something when the crash came. Instinct seems to tell us what it was. The boat gave a decided list to the right, and as best we could we made for the deck. Being in the first class, (this happened as the 2nd was all filled) we had to pass some boilers, smoke, steam, and so it were gushing here, and we had to run through them.

When we got on the deck, everybody was making for the stairs for the next deck, four, by this time, the first deck was enveloped in the water. The crash was awful. I must say I kept very calm. This girl friend who was with me got very excited, and in trying to calm her I forgot my own excitement. We managed to get on deck and made for the lifeboats. I've been remembered I had no life-belt, and turning back I went to the saloon to get one for my girl friend and one for myself. On reaching the saloon a steward turned me back and told me to go to my own cabin if I wanted a life belt. When I returned from the saloon my girl friend had disappeared. I could not see her in any of the boats so I don't know where she could have gone.

I was standing wondering, when a little fellow, one of the crew came up to me and took off his own belt and fix it around me. How I wish now I have got his name and address, but thank God I noticed him in the crowd at Queenstown, so I know he was saved. His self-sacrificing bravery, I am sure, saved me from a watery grave.

At the saddest times you can't help laughing; I did this and a steward turned round and said: 'Thank God there's one smiling face.'

Something has gone wrong with a lifeboat and men were pulling a rope to bring it nearer the ship. It was hard work, and I grabbed the rope to help. I was doing this when someone pulled me by the

shoulder and told me to get into a life boat. There was about 4 feet to jump. When the boat was full it was lowered. By this time the *Lusitania* was nearly under water. The little boat I was in having been lowered the men were doing there [*sic*] best to push away, but it seemed the fast sinking *Lusitania* was drawing us under. Hearing the remark of a steward that our boat was being swamped, I immediately jumped out. As I left the life boat the big boat sank; and I was carried down and down. It seemed ages before I came up. My bills brought me up, but I was severely knocked about among the wreckage.

When I got my head above the water the *Lusitania* was nowhere to be seen. Seagulls in hundreds were hovering around, but nothing but a few life boats and wreckage was to be seen. I heard someone close by say 'there's a woman,' and I saw three men on and upturned boat. They tried to get me, and I tried to get to them. Eventually they managed to pull me on to the boat, and we sat huddled together to keep each other warm, till another boat came along. After eight while another came along we got in and a half-dozen of us sailed around, picking people up till we had forty in our boat. I was next afraid maybe we would capsize with so many but we didn't. It was a sight I'll never forget, passing people who are crying for help, and not able to help or save them. We were in this boat for a long time while till we were picked up by a minesweeper.

The Marconi operator had sent out the 'S.O.S.' and I think about nine vessels came to our rescue, but it seemed ages before they came. When I got on board it was about half-past five, being after two when the *Lusitania* was struck. Standing on this mine sweeper were a big bunch of fellows – eight men – I went up and stood beside them. They were all smoking cigarettes and I had too. Half in the hopes to warm me and half-expecting them to make me sick, as I imagined I had swallowed an awful lot of sea water.

There is an idea that the Germans used those poisonous gases, as next morning when I awoke and I felt as though I were going to be choked and through the day I have always an inclination to cough, and I have got an awful cold. I have only got a slight touch of it, but something makes me think that lots died from the supposed gases.

When looking over the dead bodies nearly all had froth oozing out of their nose, ears, and mouth. Many had as large as your fist at their mouth just like a peice [*sic*] of white cotton wool, I think they had been choked. Father, I think has died of shock more than anything his heart being weak.

When we got to Queenstown the whole population had turned out. We were taken to a hotel. We had to get a change of clothes. I got a change of clothes but that was all. Next day we left for Kingston near Dublin. We sailed from there to Holyhead, and from there we went to Crewe. From Crewe we changed to the Glasgow train and then again I changed at Carstairs to the Edinburgh train and had to wait an hour and a quarter there for the Davidsons Mains train. I was tickled to death to get in the train on Sunday.

Of course I am the talk of Davidsons Mains. About a dozen reporters have been out. I told my experiences to the first (*The Scotsman*) but the rest I didn't see.

If you like you can let the 'News' and 'Herald' see this letter so that all my friends can see that I have got here safely and save me writing it over again.

I am about all in writing this letter and feel as though I could not be bothered lifting a pen again.

I had written four letters on the *Lusitania*, big letters too, of all my journey right to Friday and when we were in sight of land I had closed them, and I don't feel like writing them again.

I feel so tired and sick today, and I had such a rotten night. The night I was landed I slept a good sleep. I knew nothing till I awakened.

All my money and Father's and Jarvie's went down, all my lovely clothes too. I hadn't a cent to blow my fingers on.

Little did I think when I read Mr. Langley's personal experience of the sinking of the *Empress of Ireland* that I, myself, would have a similar one to tell.

The Death of the *Lusitania*
By Phoebe Amory

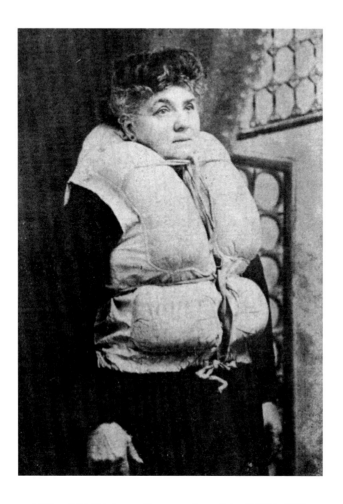

Second-class passenger Phoebe Amory wearing the lifejacket in which she was saved.

Little did I think, on the morning of April 27th, 1915, as I purchased my ticket for sunny England, that I was destined to endure the experience of being face to face with death before returning to my Canadian home. Neither could I have employed my imagination to conjure before me the terrible scenes that I was to witness in the most terrible disaster in the history of the British marine.

Now, as I sit in my home, surrounded by loving hearts and familiar faces, it seems to me that it must have been a dream, but I have only to recall the agonizing screams of the mothers and the children and the scenes of parting between husbands and wives; the husbands begging the wives to be saved, and the wives pleading tearfully for their men to come with them. But a law of the sea is 'women and children first,' and those brave men were doing their duty before their God, trusting that some help might arrive to save them at the last moment from a watery grave.

But to return to my starting and my reason for making the voyage when the fiendish piracy of the German was at its height. I am the mother of five boys, who have gone to serve their King and their country. Two of them were at the front in France, and the other three were training for the trenches. Realizing that a short vacation in England would place me near to them, and feeling it my duty to visit them, probably for the last time on earth, I decided to sever home ties for the time being, and in this case decision was action, for I immediately secured passage, and upon purchasing my ticket in Toronto was informed that I could sail on the *Lusitania* from New York on the 1st of May. It being the 27th of April, I made immediate preparations, and the morning of the first found me aboard that mighty empress of the seas, thrilled with the thought that a few days hence would find me with my soldier sons.

I had not bought any of the New York dailies, and was therefore unaware of the vague feeling that so many were experiencing regarding the safety of the *Lusitania* when she should enter the danger zone. Had I known that notices had been posted by the German Embassy at Washington, notifying passengers that they were taking their lives in their own hands if they departed on this particular ship, I would have been undeterred, as I would have taken the risk to be near my boys, and at any rate I have never had a fear of the sea. The men of my family, as far back as I can remember, have been naval officers in the service of the King, and I presume that I have inherited a natural fondness for a voyage on the ocean. I was born aboard ship, and much of my early life was spent on the water, so that I am almost as much a sailor as land-lubber, and it is only natural, and not to be attributed to desire to boast, that I should have made the voyage, warning or no warning.

Aboard the ship, the usual hustle and bustle was in evidence, and after being assigned to my cabin, and seeing to it that my luggage was safely deposited therein, I went on deck to enjoy what is always a pleasant experience to me – the sites of a great, busy port, and the making-ready for departure.

The dock was crowded with people, come to bid farewell to relatives and friends going abroad. Time passed quickly, all too quickly, for even though I was anxious to be on my way, yet the interest that one arouses in watching a great ship prepare for a voyage is so intense that the thoughts of my journey were, for the time being, thrust into the background. Smartly dressed officers were attending to their various duties, both aboard ship and on the dock. Great truck loads of luggage, and last-minute consignments of mail were being rushed aboard. Finally the rush subsided. Blue-coated officers were seen coming on the ship with their hands full of papers; these being the bills of landing and the consignment sheets for our cargo of express and baggage. Bells were ringing their signals for final preparation. The shrill blasts from tug-boats announced that they were ready to begin their labor of moving the great ship from her moorings, and the deep, throaty reply from the chimes of the *Lusitania* voiced her assent. Bridges were swung. Two more sharp exchanges of signals from the tugs, and we were moving. The mightiest vessel in the world had started on what was to be her last voyage.

We passed down the river and into the sea, and here our friendly tugs left us with many whistles of farewell. Such little boats they are, and so powerful. One often wonders where they keep the enormous strength that enables them to force the big ocean liners to do their bidding.

The *Lusitania* was now running under her own power, and the mighty engines were forcing us ahead rapidly into the open road that leads to dear old England and our loved ones, and I decided that I would go to my cabin. I was anxious to meet the two ladies whom I understood were to share the cabin with me; and, as the invigorating air, and the

interesting sites of the past few hours had given me a ravenous appetite, I anticipated an early dinner.

I found my room-mates to be very charming ladies. One, the younger of the two, was a handsome girl, with beautiful, fair hair. When I first saw her, she was wearing a perfect-fitting dress of black velvet, and I was so impressed with her beauty and her frank, straightforward manner of introducing herself to me, that I felt I had indeed been fortunate in having such a charming young lady for a voyage companion.

The other lady was older. I should judge her to be fifty years of age or more. She had been in the United States nursing an uncle until his death, which had occurred but a short time before our memorable voyage. This uncle had left her considerable property, and she was returning to her native land (England) to spend the remainder of her life among relatives and friends. I believe I have never known a more kindly woman, nor one who seemed to be more ready in a case of emergency to lend a helping hand. It seemed as though she had everything that was needed for sickness, and she spent much of her time relieving the cases of illness that most naturally occur during the first days aboard ship.

After we had become acquainted and had arranged our cabin to suit ourselves, my younger companion asked me if I was ready for dinner. I replied in the affirmative, and upon going below to the dining-room, we found that we were late for the first table, and had to await our turn. But I was permitted to get a view of the interior, and such a site it was! It would have gladdened the heart of anyone to gaze upon such a scene as was then before me. Such a beautiful dining-room I had never seen, either aboard ship, or in the magnificent hotels that I have visited on both sides of the ocean.

The pillars, extending from floor to ceiling, were as snowy white as the linen that covered the long tables. The walls and ceilings were frescoed in delicate tints, and in the centre there was a round, open balcony, which permitted one to stand above and gaze down upon a spectacle that I believe could not be duplicated elsewhere.

Finally our turn came, and I was permitted to occupy one of the upholstered, swivel chairs that had been appealing to me for the last ten minutes.

But I must not dwell too long on details, and in connection with the dining-room will only say further that I had never seen such palms as those that were profusely distributed about the saloon. One of them, I remember, reached nearly to the ceiling.

The only other matter I consider to be of sufficient importance to dwell upon before rehearsing to you the final scenes attending the sinking of our ship, is in connection with the patriotic concert that was given for the benefit of the seamen's fund. Having become acquainted with those who were arranging it, I was asked if there was anything that I could do to assist, and replied that I might sell programmes, which offer was accepted, and I was given the programmes and started on a round of the first-class cabins and state-rooms. My first sale was to a man who I was informed soon afterward was Mr. Vanderbilt, an American millionaire. I asked him to buy, but he said that he had already purchased one. I then thought, of course, that I had been preceded by another seller, but when he smiled and handed me a five-dollar bill, saying that he couldn't resist my good-natured smile, I concluded to go further among the first-class passengers. I informed him that I would have to look for change, whereupon he said that he expected no change. I met with similar success in nearly all of the cabins and on the decks, and soon had realized well on my programmes.

The concert itself was pronounced a success by all who attended, and we felt that it was more than a success since we had realized nearly twenty pounds, which we felt would be a fine gift to the fund for which it was intended.

On Thursday, which was the day following our memorable concert, we arose early and went on deck to enjoy the breeze. The sea was calm excepting for the slight ripples that are characteristic of the Atlantic so early in the day. Before noon, however, the water was as smooth as the floor of the room in which I am writing, and we were very happy in thinking that the remainder of our voyage would be made under favorable weather conditions, and that before another sunrise we would be landed, and our journey completed.

The elder of my companions (Mrs. Whiret [*sic*]) had been ill for the greater part of Wednesday night, and was still feeling badly on Thursday morning. But I induced her to dress, and assisted her to the deck, and I have been deeply grateful and all my life will be for being permitted to render her such an assistance, as it was the means of saving her life when the explosions occurred. Being on deck at that time, she was among the first of those who were saved.

At noon we were greeted with the sound of the first luncheon bell, and feeling warm, and not in the least hungry, I decided to have a bath and be ready for the second luncheon, believing that a dip would serve to increase my appetite. I left Mrs. Whiret [*sic*] on deck and went to our cabin where I secured a change of clothing and proceeded to the bath.

Fortunately I took my raincoat with me, as I thought I might not have time to dress fully before the second bell, and such proved to be the case. I had scarcely finished the bath when the bell sounded for second luncheon, and as it was permissible to go to the dining-room at lunch hour clad in negligee, I slipped on my raincoat, and hurried to lunch.

The bath had improved my appetite, and I was feeling as though I could go through the meal with a will. I took my place at table, and had given my order. It then occurred to me that I would like a salad, and as the steward placed the soup before me I was on the point of ordering the salad, when there came the most terrible crash, which seemed to tear everything to pieces, and to rend the ship asunder.

There was a rush for the stairs, and everyone was trying to ascend the narrow stairway. Realizing that something of a terrible nature had occurred, I seemed to be possessed of super-human strength, and was able to push through where stronger persons were being held back. Someone shouted: 'We have been torpedoed,' and I realized for the first time that we were doomed. As I fought my way

up the stairs, I was thrown on my knees three times. Near the top of the stairway there was an officer shouting 'Keep cool,' and his words seemed to have the desired effect, as the terrible crush subsided and those of us who were nearing the top found it less difficult to ascend. But about this time the ship started to list heavily to one side. At one time I feared that we were turning over. It seemed to me at that time that it was requiring hours of time for us to reach the deck, but in reality it all occurred in a very few minutes. When we reached the deck I had difficulty in holding my feet, as there seemed to be such a slant to everything upon which I stepped that I feared being thrown overboard each time I moved one foot ahead of the other.

The screams of the women and children were terrible to hear. Wives were being torn from their husbands and lifted into the lifeboats. Children, who in the terrible crush of humans, had become separated from their parents, were being handed from man to man and on into the boats. Women were fainting and falling to the deck, only to be carried overboard by their own weight. The decks by this time were becoming more difficult to stand upon. I was trying to find a lifebelt, as I realized that without one I would stand little chance of being saved, as I had given up all hope of being able to reach the lifeboats.

Just as I was giving up in despair, and was about to resign myself to the fate of the brave men who would be left on the ship, I was grabbed from behind and a brave young man said, 'Here, mother, take this belt,' and with that he helped me to get into it, and remained with me until I had it properly adjusted.

I said, 'God bless you, young man,' and turned to speak further with him, but he was gone. As I did not see him among the survivors, I believe he was lost, and never will I forget his brave deed, for I feel certain that he gave his life to save mine, and when I think of him I unconsciously quote: 'Blessed is he, for he gave his life for his brother.'

Up to the time of securing the belt I had not realized that the life-boats were being rapidly filled. But I was made aware of this being a fact by an officer, who was British to the core. He spied me in a crowd of men, and speaking so as to be heard above the screams of the women and the shouts of the men, he ordered the men to make way for me as, to quote him: 'The last boat is leaving and this lady must go.' Those men stood aside and let him through to me, and taking me by the hand he assisted me to the rail. By this time the last life-boat was swinging clear of the ship, and as the *Lusitania* was now listing so heavily, it was impossible for the men in charge to swing back far enough for me to step aboard. But the officer who had brought me to the rail was equal to the emergency, and when he said: 'Mother, I guess you'll have to jump for it,' and believing this to be my only chance, I jumped. I landed just over the edge of the boat on all fours. Just then the ropes on one end of our boat must have held fast, or else the sinking ship must have given a terrible roll, for we were brought up against the side of the ship with an awful crash and were thrown into the water. Fortunately we were nearly down when the accident occurred and had not far to fall, but the confusion was great. Those who did not have life belts sank almost immediately. On every hand were floating bodies, their upturned faces showing white and ghastly. I was so close to the *Lusitania* I could have reached out and touched her, but her motions at this time caused waves that carried me some distance away. All this time I was floating on my back, and try as I would I could not turn over. This fact alarmed me greatly, since I believe that my life belt was on wrong, and later this proved to be correct. At times the waves would wash over my face and fill my mouth with water, and I called upon God to save me. Each time a bit of wreckage would float against me I would take courage and think that a boat was near and that they were trying to reach me, but when the drift would float by I would again be possessed of the fear that I was destined to float around until I could no longer survive, and then to die. I could see myself being washed ashore a lifeless corpse, and I believe that had such wild thoughts continued I should have died from the shock of them, but

again I was given hope by feeling something sharp coming up my neck, and into my hair, and the next instant my head was raised with a jerk and a steady voice said to me, 'Easy now, I have a hook in your hair. Our boat is loaded, but your gray hair forbids us to leave. We are going to pull you part way into the boat until we can adjust our load, and then we will try to get you into a seat.' I was overjoyed, and could think of nothing to say but 'Thank God, thank God, I am being saved.' They pulled me up so that my head and arms hung into the boat, and after a few minutes they pulled the upper part of my body over the side and left my legs in the water. We drifted this way for a long time, so long, in fact, that my legs were numb, and I wished that they might soon be able to find a place for me. But I was so thankful for having been rescued that I decided to stand the terrible pains that were shooting through my body, until they became absolutely unbearable, and then ask them to please drag me in farther. After a while they seemed to get the weight properly adjusted, and I was dragged in. I raised my head just in time to see the last of the *Lusitania* as she sank beneath the waves. As she sank there was a mighty rush of water, and we were rocked until we nearly capsized, but the men who were handling our boat were expert seamen, and after a moment of anxiety as to our being able to survive the heavy wash, we righted again, and the men took to the oars. It was now exceedingly quiet that I wondered at it, but the answer came to me in the mute, upturned faces that floated by, and as the gravity of the situation seized upon me, I thanked God that He had spared us a like fate. It was terrible to look upon children, oh, such little children, floating away out there on the ocean. Children who that morning where the pride of loving parents, and who were now the dead victims of a fiendish hate for mankind in general. These dear children had been sacrificed for the lust to kill, even though the killing be of infants. These thoughts came uppermost, and for several moments I hated the race that made war on women, and war on children, and I would have given everything for revenge. But, naturally, this period of

hate changed into one of thanksgiving, and I said to those aboard: 'People, if any of us have never given ourselves to God, now is the time. We are passing through a terrible experience, and without His help, we will be powerless.' Nearly everyone prayed; some of the prayers were so full of joy at being thus far delivered safely that we for the moment forgot those poor unfortunates who were being washed about us and wept for the very joy of it.

But we were not yet out of danger, and when someone started the cry of submarine, we all looked in the direction to which he pointed, and there, sure enough, was what we all took to be a submarine, but which proved to be but huge fish sporting in the waves. However, we had been given a scare, and the men rowed like mad. An old gentleman who sat opposite me asked me if he could put his feet against my knees so that he might give a stronger stroke with his oar, and I consented to do so. Several times it seemed that he would shove his feet clear through me, but I knew that he was doing his best, and tried hard to keep from crying out with the pain of it.

After we had been going for three or four hours without citing a vessel of any description, we saw a tiny speck on the horizon that appeared to be getting bigger. We watched it steadily, and it proved to be a fishing boat. We all shouted ourselves hoarse, little realizing that it was a useless expenditure of breath, as our voices would not carry half of the distance between us. We soon saw, however, that they were headed our way, and later we knew that we had been sighted and that it was a rescue boat. They came alongside, and we were taken aboard.

It was a dirty, smelly, fishing craft, but never did a ship of any description look so good to me, and as soon as they had lifted me aboard I fell to the bottom of the boat and lay there until one of the old men in charge came and lifted me up and offered me hot tea.

The tea helped to warm me up considerably, but my teeth chattered and my limbs shook as though afflicted with the ague. Soon we sighted another boat,

which proved to be a cutter in search of any boats that might be adrift. They sighted us about the same time and turned their prow toward us, and in less than an hour they were alongside and we were transferred, I having to be carried; and we found that they had picked up several other boat loads, as we recognised many of our friends with whom we had become acquainted aboard the *Lusitania*. A stewardess took my clothes (all I had on was a raincoat and shoes and stockings) and dried them. We were given more tea, and by the time land was sighted we were in fairly good shape. From then until we arrived at Queenstown, the time was spent in endeavoring to locate relatives or friends who might have been rescued by the same ship we were now on, and those who were successful were overjoyed. But those who searched in vain were to be pitied.

Having no relatives accompanying me, I, of course, could but sympathize with those who were less fortunate, and notwithstanding the fact that I have seen much sorrow in my life, it seemed to me that this must be a crowning sorrow, and I broke down completely when called upon to view the intense suffering of those mothers and wives and husbands. One young man whom I had met came to me and endeavored to control himself, but with tears streaming down his cheeks, told me in a broken voice that he had lost his Mary. I remembered her as having sung 'The Rosary' on the night of the *Lusitania* musical. For a moment he turned and gazed out to sea, as though he was taking a last look at the resting place of his wife, who had not ceased to be his sweetheart. Then, seeming to gain composure, he turned to me, and in a slow, steady tone, with his right hand raised to heaven, he said: 'Before God and man, I swear that as soon as I set foot on land, I will become a member of the King's army, and I will never rest until I have had vengeance for the murder of my wife, or until I lose my own in attempting my revenge.'

There were many similar scenes, but many more where grief was too deep for composure. It was these that were responsible for my breakdown.

Those bowed heads, the trembling bodies as sob after sob came forth, were more than I could bear, and I collapsed.

Upon arrival at Queenstown, I was assisted to a hotel, where I received every kindness.

After a day of rest I felt able to be about, and as I had lost all of my money as well as clothing, with the *Lusitania*, I was forced to wear a suit provided by some kind person at the hotel.

Being anxious to resume my journey, and to arrive in London at the earliest possible moment, I did not tarry in Queenstown longer than was necessary, but made ready to leave on the earliest train in order to be with my dear sons, as I felt that I could better bear the terrible reaction that must follow, if I had them about me.

I may have made a feeble attempt to set before you in detail the circumstances surrounding the sinking of the *Lusitania*, but I pray that it may not be as futile in interest as lacking in expression. That it was murder we cannot doubt, and for this murder we must have what reparation we can get by decisively defeating the perpetrators of such a dastardly and cowardly deed. But the greatest of all punishments that we on earth can give to these murderers and baby-killers is to stand organized to the last man if necessary, and take from them their military power that was so complete, and force them to their knees, begging for mercy in their impotency.

Our men will treat their women with respect, and well they know that no man who belongs to the army of Britain would loose a torpedo to murder their wives and mothers, but I trust and pray that the time will come when they will hear the echoes of the screams of the dying as our women and babies sank to their death.

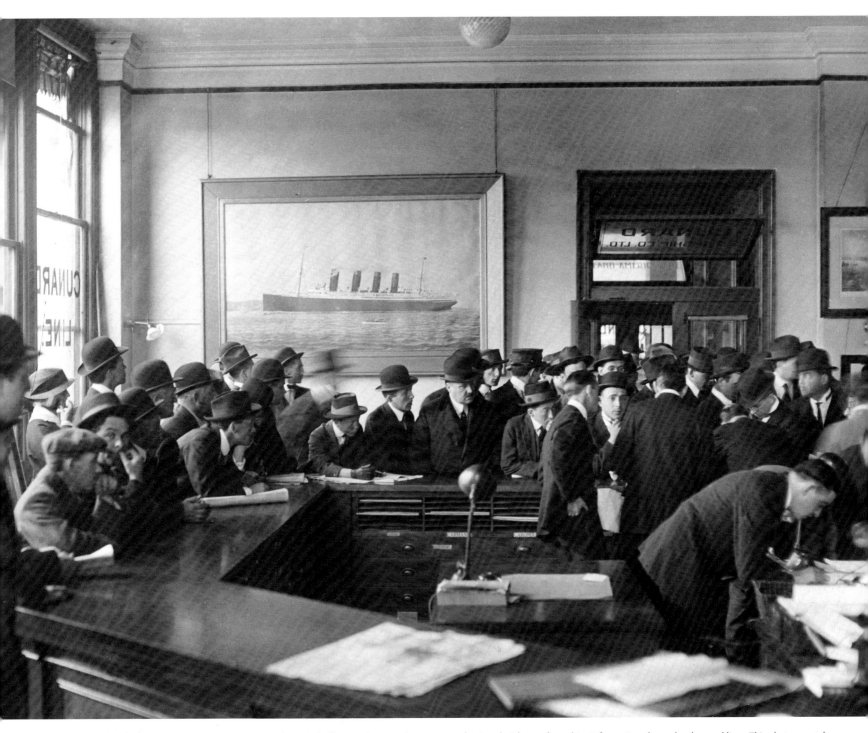

Immediately after news of the torpedoing began to spread, Cunard offices in the US and Europe were besieged with people seeking information about the doomed liner. This photo was taken in Cunard's New York office on State Street while relatives and friends of those on board wait for news from a Cunard official.

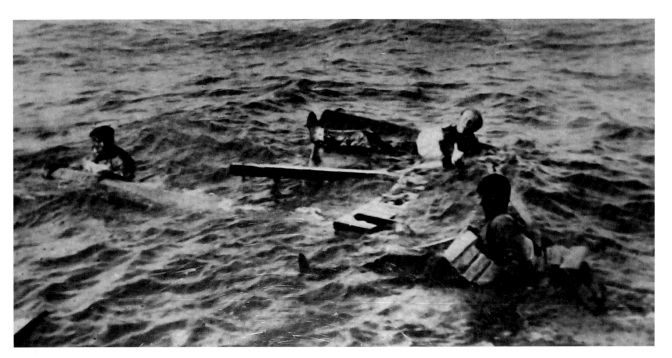

What are purported to be survivors of the sinking in the water shortly after the disaster may be, in fact, a propaganda image. The details of the lifebelts that the 'survivors' are wearing are correct for the ship and are probably real, although it is likely a staged photo.

A number of temporary morgues were set up in Queenstown to handle the large number of victims.

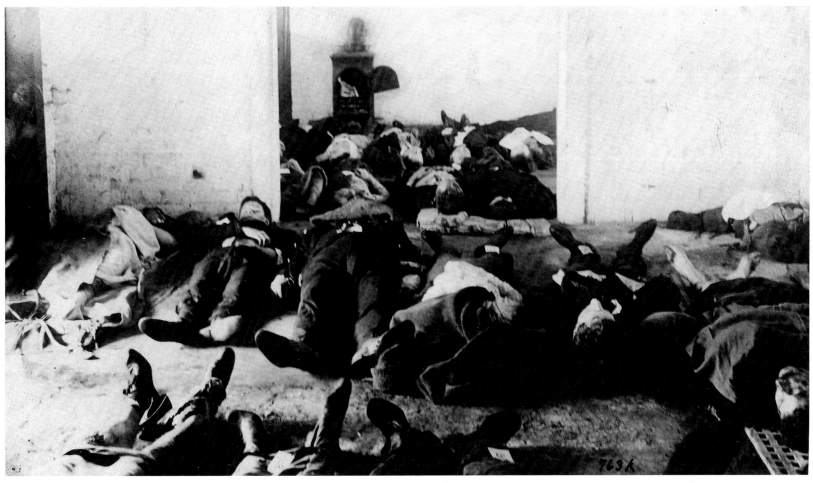

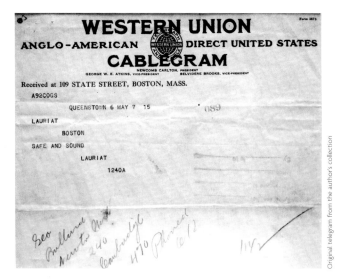

Original telegram from the author's collection

The three-word message on this telegram sent by first-class survivor Charles Lauriat told his family all they needed to know.

First-class survivor Oliver Percy Bernard in Queenstown the day after the sinking. After his return to London, he created the series of well-known sketches for the *Illustrated London News* depicting how *Lusitania* foundered.

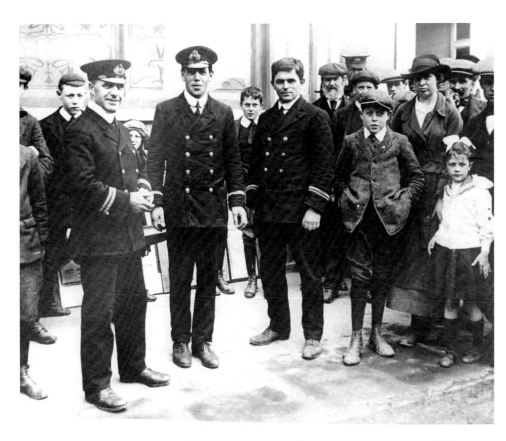

Three of the four officers to survive the disaster. From left to right are First Officer Arthur Rowland Jones, Third Officer Albert Arthur Bestic, and Third Officer John Idwal Lewis.

Third-class passengers George and Elsie Hook visit Frank Hook in a Queenstown hospital. Frank's left leg was broken by a falling lifeboat.

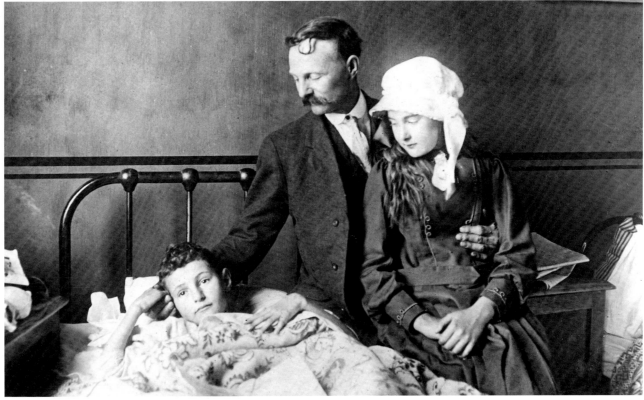

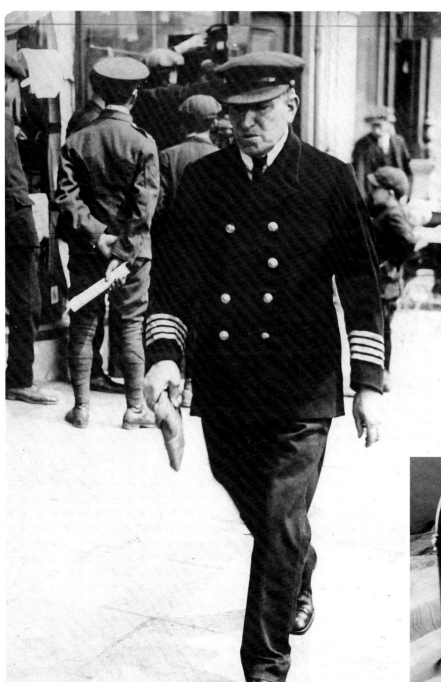

Still wearing the uniform in which he survived the disaster, Captain Turner walks through Queenstown. In the months and years following the disaster, his memories of the sinking must have weighed heavily on him.

Second-class passenger Miss Catherine Leipold (left) and third-class passenger Miss Winifred Keloway rest in a hospital in Queenstown.

Having lost their mother and four siblings in the disaster, John and Edith Williams (front row, left and right) were taken care of by Mrs Leahy and her daughter (seen here) during their stay in Queenstown after the sinking.

On 9 May, soldiers began digging three mass graves in Clonmel Cemetery. Given the amount of confusion in the weeks and months following the disaster, it is little wonder that there are errors in the official lists produced of those lost and saved. For example, two-month-old Thomas William Docherty was saved, but Cunard had him on the list of lost until the middle of August, more than three months after the disaster. Infant Campbell McKechan was also thought lost and was listed that way in the official book of lost and saved prepared in March 1916. In fact, he survived the disaster but died in September 1915.

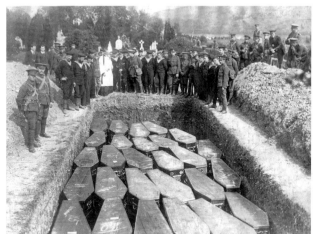

Religious services are about to begin at Mass Grave C in Clonmel Cemetery. This was the first grave used, and seventy victims were interred here – among them are Alice Loynd (see photo on page 116), Thomas Marsh (husband of Anna Marsh, see photo on page 148), and James Aitken (see photo on page 90). Until his death in 1936, survivor Walter Storch sent a postal money order to Cunard's Queenstown office for 10s every year so that flowers could be placed on the graves.

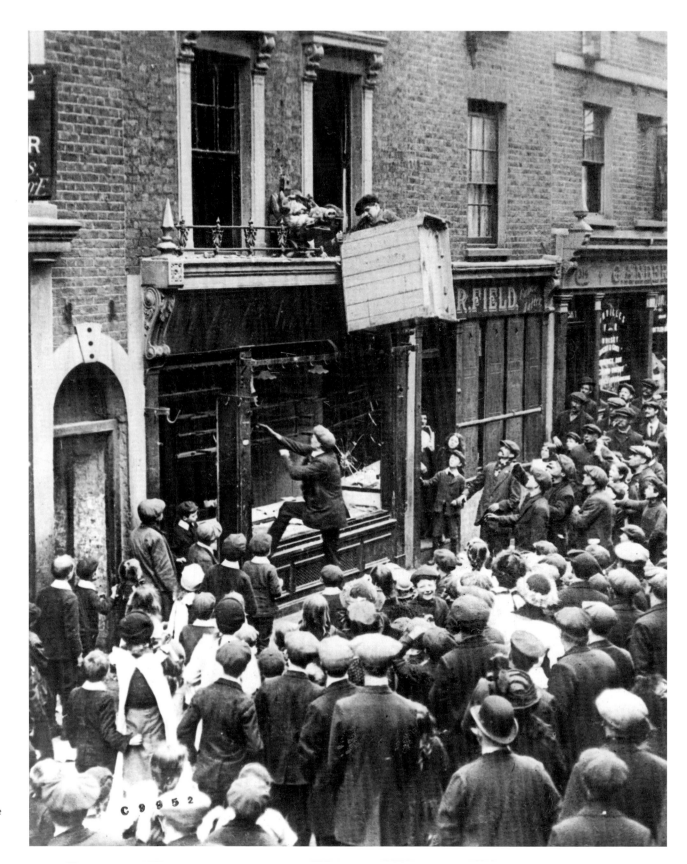

Riots aimed at anyone with a German-sounding name broke out all over the UK when news of the *Lusitania*'s sinking became known. Here, a German shop in London is ransacked.

Many of the burials in Queenstown took place so quickly that a number of victims had not yet been identified when they were buried. Written in chalk on the left-hand coffin is: '69 Unidentified Female 6 yrs.' She was buried on 10 May in Mass Grave B. It was later determined that the girl was third-class passenger Lily Lockwood. The coffin on the right contains first-class victim Mr Thomas Boyce-King. The plaque on the casket appears to read 'Thomas Boyce King, Died May 7th, 1915.' Mr King's body was returned to the United States on board the ss *New York* on 14 May.

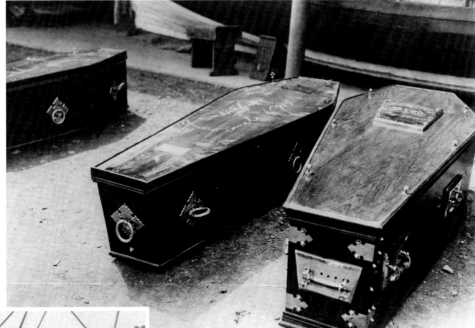

The ss *New York* arrived in the United States on 24 May carrying the bodies of eight identified victims. Here, a crated casket is being unloaded from the steamer.

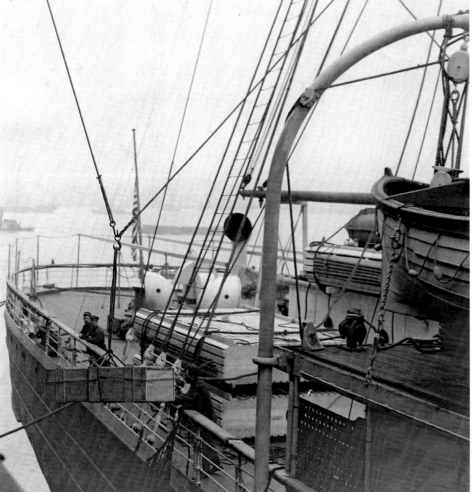

Thomas Harper & Sons, Ltd., regret to inform you of the loss of Mr. J. H. Harper, Managing Director, who was returning home from a business trip to U.S.A., by the ss. "Lusitania," when that vessel was torpedoed off the coast of Ireland on Friday, the 7th instant.

Phœnix Needle Works,
Redditch, England. May, 1915.

First-class passenger John H. Harper was lost in the sinking and his body was never identified. His company sent out black-bordered cards announcing his death.

On 20 May 1915, James H. Campbell, the Town Clerk of Queenstown, sent an official letter of sympathy to A.D. Mearns, the General Manager of Cunard. It reads:

Dear Sir,

I desire to state for your information & that of the Chairman & Directors of the Cunard Steamship Coy. that at the last meeting of my Council, a resolution was passed unanimously, tendering to your Company, the Council's sympathy on behalf of the people of Queenstown, on the loss sustained by the Company, in the sinking of the magnificent steamship Lusitania, involving the sacrifice of many hundreds of valuable lives. In conveying to you the terms of the resolution, I desire to assure you that I associate myself very *sincerely indeed* with the action of the Council & would point out that the manifestations of sympathy, & ready generous succour extended to the survivors by the people of Queenstown on the night of the lamentable disaster, *were beyond all praise*. In like manner too, the people's work & tender sympathy when the dead were being landed & interred were both priceless and touching in the extreme. Assuring you of my esteem & regard.

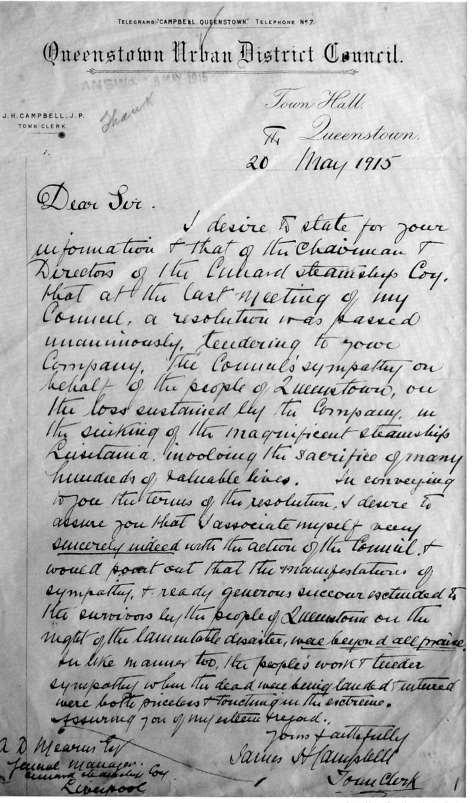

Original letter from the author's collection

6

A WORLD IN MOURNING

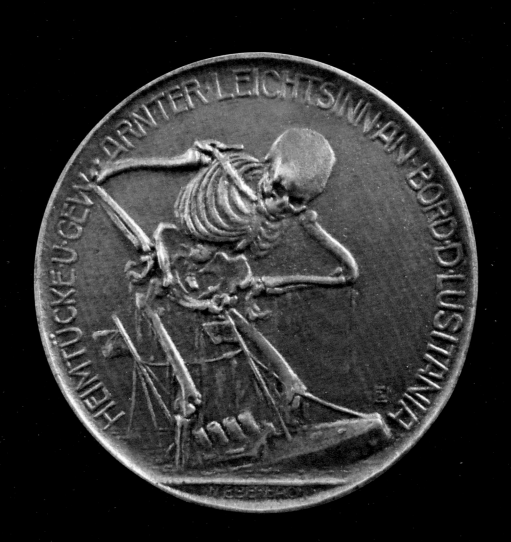

The day after the sinking, two surviving crewmembers, Second Steward Robert Chisholm and Assistant Purser William Harkness, were tasked by Cunard with the grim assignment of identifying whatever victims they could as dozens of bodies were recovered and brought to Queenstown. Burial arrangements also needed to be made, and the Queenstown office assisted in having identified remains shipped home to relatives. The White Star Line expressed their deep sympathy to Cunard and offered to make no charge to ship any victims back to the United States.

Locally stationed soldiers began digging the three mass graves in Clonmel Cemetery on Sunday, 9 May. The first burials began in Mass Grave C the following day. The coffins were loaded onto horse-drawn wagons by The Royal Garrison Artillery for the precession out to the cemetery. Police, the military, and hundreds of onlookers lined the funeral route. Each wagon was met at the cemetery gate by soldiers of the 4th Irish Regiment, who carried the coffins to the burial site and lowered them into the grave. The Bishop of Cloyne performed the Catholic service, and burial rites were also conducted by representatives of the Church of England, Church of Ireland, and other denominations.

The majority of the recovered victims were buried in Clonmel Cemetery. Bodies were recovered as far away as the west coast of Ireland, and victims who were found any distance from Queenstown were turned over to the local police, who handled the funeral arrangements.

A Requiem Mass was held at St Coleman's Cathedral the same day as the first burials. In attendance were dozens of survivors, Admiral Coke, and representatives of the naval and military staff. A Church of Ireland service was also conducted by the Revd Archdeacon Daunt.

The search for bodies continued. On 10 May, the Dutch tug *Poolzee* was steaming about 20 miles south of the wreck site and found sixteen bodies — five women, nine

R.M.S. "LUSITANIA"

FROM

NEW YORK, May 1st, 1915.

RECORD OF

PASSENGERS & CREW.

Original book from the author's collection

Planning for what is commonly known as 'The Grey Book' began on 24 September 1915. The General Manager's office at Cunard wrote:

With a view to possessing a complete and official record of the loss of life, etc., in connection with the 'Lusitania' Disaster, it is suggested to have printed in pamphlet form, the following information:

List of Passengers and Crew
List of Missing
List of Survivors
List of Identified dead, shewing place of burial, date, and to whom property has been handed.
List of Unidentified dead, with full particulars of property found on remains, also tabulated statement

This pamphlet, whilst serving its purpose as a standing record, would be most helpful for reference, and in dealing with future inquiries. Such a record would be greatly appreciated by the Company's Offices and Principal Agents.

An estimate for this work has been received from Messrs. Turner & Dunnett, which is attached herewith. If approved, it is recommended that 150 copies be ordered.

Unfortunately, the attachment showing the cost of production has been lost.

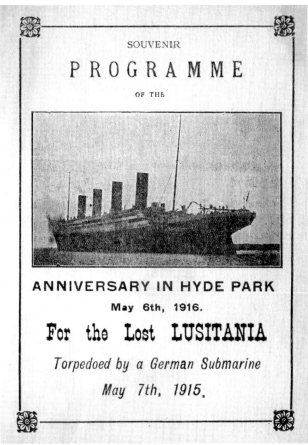

Original programme from the author's collection

Point, in the vicinity of Dingle. The station officer gives us this information by telegram and says that the marks are '43 persons W.M. 474, 12-8-13 intact and in good condition.' We have written to him for full details.

In connection with the boats generally the writer paid a short visit to Baltimore last week in the hope of getting the 'Shark people' to bring the boats, or some of them, to Queenstown ... At Baltimore there are seven boats, one ordinary lifeboat No. 3. Of the other 6, five appear to be McLean and one chambers. In some cases the numbers appear to have been painted over and are not very clear. The chambers boat is in good condition, but the others are somewhat damaged, 4 of them having a plank or two stove in, and the 5th slightly damaged in the stem. None is so damaged as not to be worth taking to Liverpool ...

The last survivor to leave Queenstown was third-class passenger William George Cook, who was discharged from the General Hospital on 14 July 1915, and left for Birmingham at 3 p.m.

Not unexpectedly, survivors and victims' families began inquiring about compensation for their losses.

On 6 May 1916, an event was held in Hyde Park, London, to commemorate the first anniversary of the disaster. It was on this occasion that the builder's model of *Lusitania* was pulled through the streets of London by a team of horses. Oddly, the photograph used on this program to depict *Lusitania* is actually *Titanic*.

This surviving *Lusitania* collapsible lifeboat became a powerful propaganda tool in the months following the disaster. It is boat number 'A2', which can be seen in the photo on page 126. The damage to the side that occurred during the sinking can be seen. It is almost certainly the boat mentioned in the following Cunard memo: 'Referring cable from New York boat was capsized when floated into Schull and bodies of four women and three children were found underneath and in the vicinity...'

men, and two children. All were wearing lifebelts, and in addition to recovering the victims, the *Poolzee* also brought back a few deckchairs and other 'light articles'.

The *Flying Fish* brought more bodies to Queenstown on the morning of 12 May, which were picked up at Baltimore and Castletownshend. Among them were eight women and nine men.

A memorial service was also held in Liverpool on 13 May, and among those present were survivors, bereaved relatives, Alfred Booth, the Lord Mayor of Liverpoool, numerous Directors of Cunard, and representatives of other shipping lines.

As the weeks dragged on, flotsam floated ashore or was found at sea. Captain Dodd, Marine Superintendent of Cunard, wrote:

We beg to advise you that another of the Lusitania's lifeboats has been found floating bottom up and taken into Ferriter's Cove, Sybil

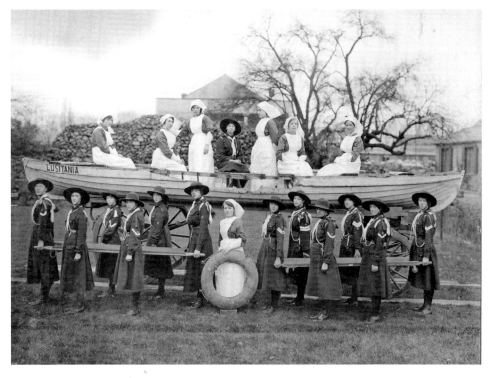

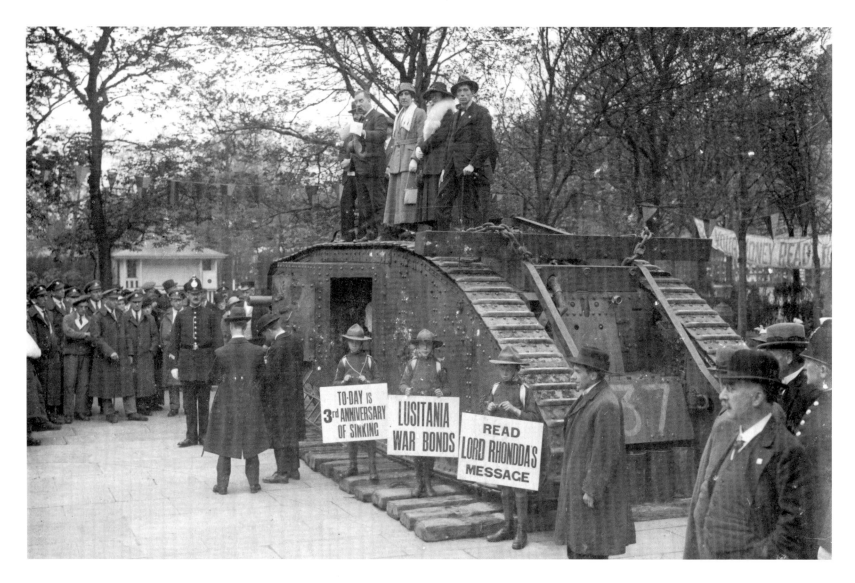

7 May 1918. Throughout the war, the name *Lusitania* was a powerful propaganda weapon. The Lord Rhondda mentioned on the sign was David Alfred Thomas, who had survived the sinking with his daughter, Margaret Mackworth.

Cunard replied to each with a standard reply of, 'We regret that compensation is not payable by us under the circumstances, but would suggest that you forward a copy of this claim ... with a view to obtaining compensation from Germany at the termination of hostilities.'

A Liverpool florist by the name of Mrs Jane Holland asked Cunard for compensation for the plants that the company had hired from her for use on *Lusitania* during the last voyage. Among the items on her claim were palms for the stairs, about 100 table plants for all three classes, and hanging plants in the Verandah Café. She first wrote to Cunard on 25 June 1915 asking for £30 2s 0d. Not surprisingly, Cunard denied liability and refused to pay, but she wrote again on 12 October. Cunard once

again denied any liability but offered her £15 in full compensation. Mrs Holland gratefully accepted.

One of the last bodies recovered was that of Junior 7th Engineer Alfred F. Wheelhouse. His remains had floated several hundred miles and washed ashore around the west coast of Ireland near Ballyduff, Co. Kerry. A telegram received by Cunard from the police at Ballyduff on 24 July, reads:

Body of a man washed ashore at Kilmore Head. Arms, portion of body, feet and one leg missing. No clothes except trousers, black serge. In pockets gold watch No. 71649. Words English. Make this case guaranteed to wear ten years. Lancashire Watch Co.,

Ltd. Prescott England on dial. Double breast gold chain curb pattern round seal suspended in centre, silver match box attached to end of chain with name A. Wheelhouse engraved on it. Six pence in silver and one cent.

Alfred's mother Matilda was informed by Cunard that her son had been found, but she was not told the state of the body in an effort to ease her distress. Alfred's remains were quickly buried in Kilmore churchyard. Mrs Wheelhouse received her son's effects on 28 July and made arrangements to travel from Liverpool to visit the grave at the beginning of August. After making the trip, Mrs Wheelhouse wrote to Cunard on 9 August 1915 to thank them for their kindness.

On the first anniversary of the sinking, the Queenstown Urban District Council organised 'Decoration Day' with the cooperation of Cunard. The commemorations cost around £35 and took place at 3.30 p.m. on Sunday, 7 May 1916. On the same day, flags on all Cunard ships and buildings around the world flew at half-mast.

In November 1916, Cunard contacted John Brown to obtain an estimate for building a replacement for *Lusitania*. The price quoted was £2,260,000, but nothing came of the idea because after the war ended, Cunard purchased HAPAG's *Imperator* to replace their lost liner.

For several years, impromptu memorials popped up at the graves in Queenstown. One of these was from the husband of second-class victim Margaret Butler. It consisted of a bouquet of artificial flowers, a small marble cross, and a photo of Mrs Butler, all enclosed in a glass case. The inscription read: 'In memory of my dear wife, Margaret Butler, drowned on the Lusitania. Vengence [sic] is Mine, saith the Lord; I will reply.'

About five years after the disaster, the mass graves had seen better days and needed freshening up. A local Queenstown resident, Stephen Glasson, wrote to Cunard offering various plans as to how the graves of the *Lusitania* victims could be improved, along with a regular schedule for maintenance. Because the work by the previous contractor had been 'done in a very inferior manner,' Cunard engaged Glasson at a price of £53 per year.

Once every month, the Queenstown office sent a representative to the cemetery to check on Glasson's

A l'ombre de la Liberté... *ÉTATS-UNIS*

In the shadow of Liberty.

LUSITANIA

DE RUYTER IS DAT NU DE VIJAND?

Victory! Hurrah!
Lusitania has been revenged

Kiss
729

work and reported that it had been 'faithfully carried out' and that 'there is little doubt that ... he takes a personal interest in the work.' Glasson's contract was renewed each year, although Cunard did try on a number of occasions to obtain a reduction in price.

By 1920, when Glasson was first hired, Cunard had become keenly aware of the bad public relations and the effect on their reputation if the graves were not well maintained. Cunard realised that sightseers might visit the graves of the 'victims of the abominable outrage,' and on 10 May 1920, they wrote:

> In view of the resumption of the call of the steamers [at Queenstown], it was agreed ... that for this occasion [the fifth anniversary of the sinking] it was advisable to place 3 Wreaths and flowers on the 3 principal graves at a cost of £2 to avoid any possible criticism ...
>
> It is recognised by those who are aware of the circumstances that the Company have devoted great care to the graves and this attention is commented upon favourably, especially remembering that the relatives of the victims, with exception of certain of the private graves, have not even made any enquiry as to their condition or upkeep.

The Cunard staff in Queenstown kept watch on the graves and regularly reported to the head office in Liverpool, occasionally sending photos of the condition, particularly in the spring when the flowers were blooming. Mr Glasson took care of the graves at least through 1925, but upon his passing, the job was taken over by the cemetery caretaker at £5 per year. In 1953, the company discovered that '... the former caretaker is deceased and that his widow has been responsible for the up-keep. We think perhaps this arrangement should be discontinued, and we would suggest that a competent gardener be employed at, say, £1 a month to pay more frequent attention to their up-keep.'

Thoughts of erecting a memorial to the victims started almost immediately after the sinking, including one to be placed on the Old Head of Kinsale. The first serious proposals came from an Irish artist named Jerome Connor. In 1925, Connor approached Cunard in New York with a letter of introduction from Mr S.G. Hopkins and said that

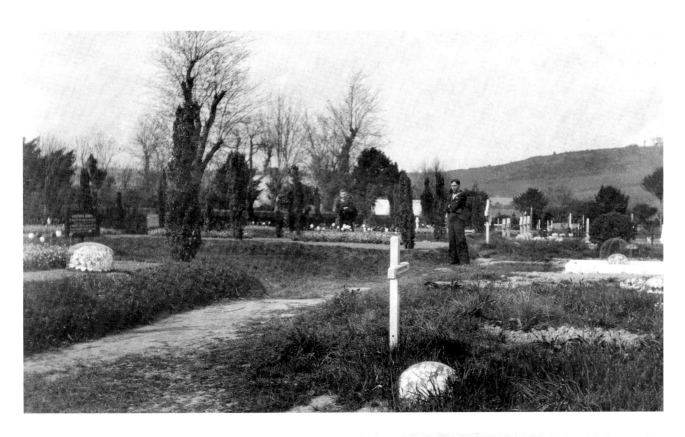

After the United States entered the war, a popular spot for American sailors to visit and pay their respects was Clonmel Cemetery, just outside of Queenstown, where many of *Lusitania*'s victims had been laid to rest.

he had been asked to submit a design for a stone to be placed in Clonmel Cemetery, just outside of Queenstown. During the meeting Connor did not seem entirely sure on whose behalf he was being asked to do the work, but he indicated that Cunard in Liverpool must have been aware of the movement to have a memorial placed.

Shortly after the meeting, Connor sailed to Liverpool and called at the Cunard office, stating that he had been asked to call by Sir Ashley Sparks and saying that 'certain Washington officials' had also expressed a great deal of interest in the project. The proposed cost was given by Connor as about £8,000, and among the backers was William H. Vanderbilt, son of Alfred Vanderbilt who had died in the sinking.

Someone leaked the news about the monument to the press, and Ella Sloane, the mother of *Lusitania* victim Leonard Sloane, wrote to Cunard to find out more details. Cunard replied:

Beyond having heard that Mr. Jerome Connor, the Irish-American Sculptor, was coming to this side to discuss the question we do not know much about

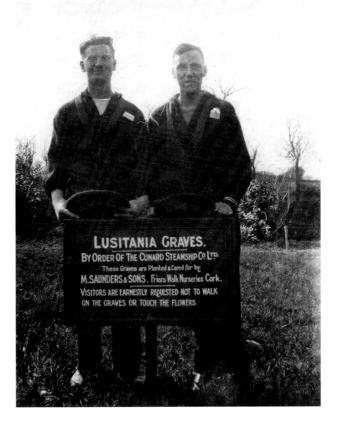

Clockwise from right: This photo of survivors Elsie Hook, George Hook, and Edith Brammer was taken in Queenstown a day or so after the sinking; A Cunard-issued railway ticket for third-class passenger Elsie Hook was saved in the pocket of her father George when *Lusitania* sank. It was issued in New York on sailing day and is stamped inside '*Lusitania*, May 1, 1915'; This newspaper printed on board *Lusitania* is dated 7 May 1915 and was saved from the disaster in the pocket of third-class survivor George Hook. In the upper left-hand corner, his daughter Elsie (who had also survived) wrote years later: 'Dad must have had this in his pocket when the ship went down.' A number of newspapers from the final voyage are known to exist, including one from 6 May and one from 5 May.

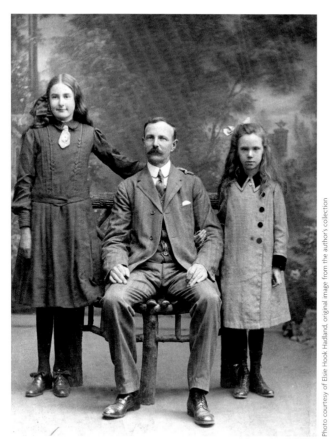

Photo courtesy of Elsie Hook Hadland, original image from the author's collection

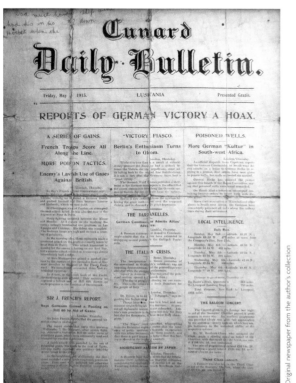

Original newspaper from the author's collection

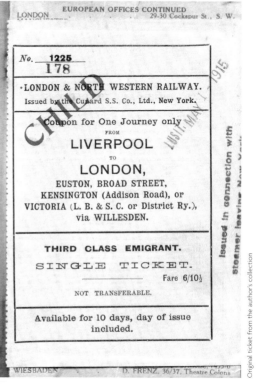

Original ticket from the author's collection

the proposed memorial. The matter, we think, is only in a very elementary stage of discussion …

Cunard also said that they were sceptical that there would be much interest in the UK and were certain that the success of any such 'scheme' would be dependent on the interest shown in America. Despite Cunard's lack of interest, fundraising commenced, and the backers even tried to obtain a donation from the company, but they wanted nothing to do with it. Cunard's head office also wrote to Sir Ashley Sparks in New York and stated that Connor 'was very vague about his proposals,' and it appeared that:

Mr. O'Connor [sic] were creating a job for himself … We think your best plan would be to reply to Mr. O'Connor [sic] that after discussing the matter with us and while thanking him for giving us the opportunity of considering the question, it is not thought desirable to revive memories of the "Lusitania" tragedy, and that under the circumstances the proposal to a erect a memorial is not one with which the Company would wish to be associated.

The next official Cunard mention of the memorial is from 1928, which accompanied a clipping from the *Irish Independent* from 2 November 1928 stating that the monument would be ready the following October. By this time the cost had spiraled to £20,000.

Connor went to great pains to make sure that people understood that the monument was '… not a war memorial … It is a tribute to the dead in the form of a mortuary monument.' The allegorical figure was to be named 'Resurgence' and would be mounted on Irish granite or marble. By October 1932, the Queenstown Urban Council had granted the site and Connor was waiting for the permission of the Memorial Committee to proceed. To quote Connor:

A woman with wings, the figure of peace – with an illuminated cross towering behind her – the symbol of the Christian faith – looks out towards the sea and stands as the world's first peace memorial … It will be the only public monument of any kind in Cóbh.

On 6 July 1933, Cunard Queenstown wrote to the head office in Liverpool saying: 'We beg to advise you that work in connection with the "Lusitania" Memorial has now commenced in Scott's Square.'

Very little was then said about the memorial for the next twenty years. Connor had died in 1943, and by the beginning of 1953, only the base had been completed. Cunard wrote that the company had been in touch with the Town Clerk several years earlier 'in an endeavour to ascertain how this matter stood, and at that time we were advised there was little likelihood of the Memorial being completed. We have again been in communication with Mr. Powell, Town Clerk, and he informed us that the question of completing the Memorial was only as recently as ten days ago revived …'

Cunard wrote and once again tried to distance themselves from the project:

We thank you for your letter of the 10th February [1953] … and have been interested in what you tell us about the revival of the proposal to complete the Jerome O'Connor [sic] Memorial in the Square at Cóbh. If there are any Civic activities in connection with the completion and unveiling of the Memorial we would like you, so far as you can, to keep the Company out of the picture as you will recall that we have all along maintained the view that we did not consider the erection of this Memorial was a necessary or appropriate step, coming so long after the disaster, and declined to associate ourselves with the project …

Then, having reconsidered their position, they again wrote to the Queenstown office:

While we mentioned in our letter to you of the 11th February that the Company had all along maintained that the erection of this Memorial was not a necessary or appropriate step, and had declined to associate itself in any official way with the project, it does occur to us that if you should receive an official invitation to be present at the unveiling ceremony whenever that is held, it might perhaps be good

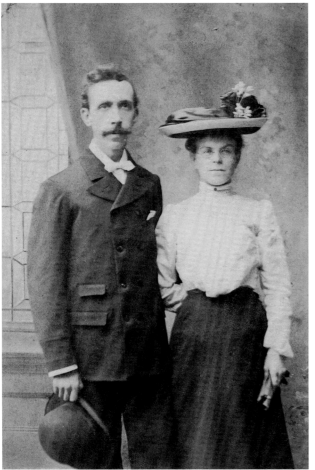

Courtesy Joyce Ramsbottom, author's collection

Clockwise from left: A 1903 wedding portrait of second-class passengers David and Alice Loynd. They were both lost in the sinking, but their bodies were recovered. Alice was buried in Grave C at Clonmel Cemetery, just outside of Queenstown, on 10 May. David's remains were forwarded to relatives for burial near Bolton, England; This marriage certificate for the Loynds was found on David when his body was recovered. Over sixty other individual items were in his pockets; A burial service booklet for David Loynd.

policy on your part to accept, rather than cause any bad feeling in local quarters, and we therefore leave you to be guided accordingly.

Before his death, Connor had completed the bronze figures of the two fisherman, which had been in storage since the late 1930s. The Angel of Peace for the top of the monument, however, had not been finished by the time Connor died. It was finally cast during the autumn of 1953 by an Italian sculptor, although it was not put in place until the late 1960s. Cunard's concern about the unveiling of the memorial seems to have been misplaced because it does not appear that the monument was ever formally dedicated. It stands today in the main square of Queenstown in memory of those who lost their lives on that long-ago spring day in 1915.

This souvenir *Aquitania* pocket knife was won by Francis Frankum in a deck race the day before *Lusitania* was torpedoed. Joseph Frankum's pocketwatch stopped at 2.22 p.m.

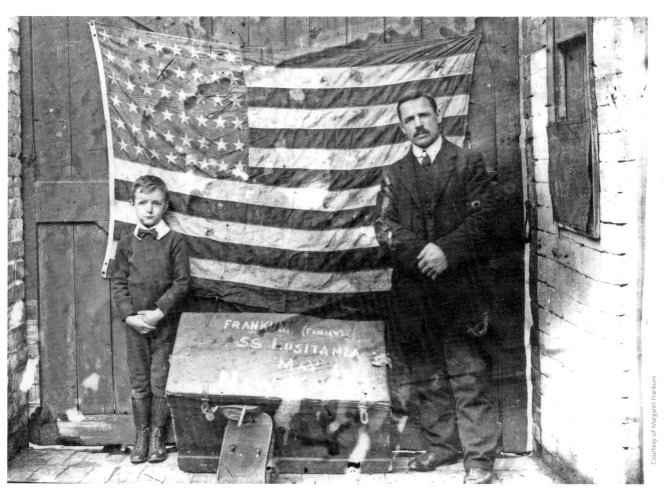

Third-class passengers Francis J. Frankum (left) and his father Joseph. They both survived the disaster, but the rest of the family was lost. Several days after the sinking, the trunk in this photo was found floating off the coast of Ireland by a passing boat. The salver asked for a £5 reward, but when that was denied, he reduced that to £2.50. He finally settled for £2. Among the items inside the trunk was the American flag hanging behind them.

Opposite: Edith Williams and her brother John were the only two of their family to survive the disaster. Their mother and four siblings were lost. The dress she is wearing in this photo was purchased for her in Queenstown the day after the disaster. When the dress became too worn to wear, Edith removed the lace collar and saved it as a keepsake For another image of Edith wearing this dress, see photo on page 103.

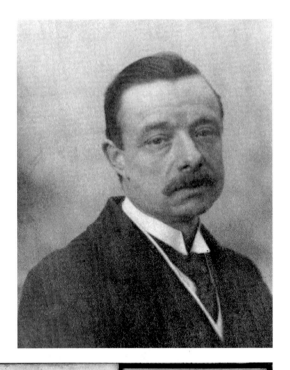

George Griffiths, second-class Saloon Steward. He survived the sinking and was issued this replacement discharge book, listing *Lusitania* as 'sunk by enemy action.'

Discharge book from the author's collection

119

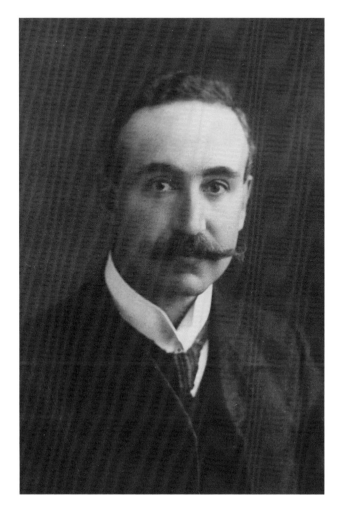

Able Seaman Owen Owens was born in 1850 in Holyhead, Wales, and was lost in the sinking. His widow was presented with this plaque by the British Government in thanks for his service.

Original medal from the author's collection

In December 1915, survivor Rita Jolivet sent an inquiry to Cunard's office in London with a special request. They, in turn, wrote to the head office in Liverpool and explained the situation:

> Miss Rita Jolivet, sister-in-law of the late Mr. George Ley Vernon, who was lost in the above steamer, and we understand buried in a separate grave at Queenstown, advises us that her sister died in America of grief for the loss of her husband, and she has brought her ashes over here. She wishes to bury them in the same grave as Mr. Vernon, and is desirous of knowing whether this could be arranged, and if so, what formalities would have to be gone through. Miss Jolivet was unable to tell us for certain whether Mr. Vernon was buried at the Company's expense or not, or whether her father, Mr. C. E. Jolivet, holds any documents in connection with the grave.
>
> If the above can be arranged we understand that Miss Jolivet will arrange for somebody to proceed to Queenstown with the ashes if it should be necessary.

On 7 January 1916, Miss Jolivet wrote to Cunard again:

> Dear Sirs.
> I have just returned to London & referring to your letter of Dec. 28 I beg to state that I am writing this mail to your Queenstown Office asking for permission to open up the grave of my late brother-in-law, Mr. G. Ley Vernon, to lay the ashes of my sister by his side.
>
> As my brother Capt. Jolivet is returning to London on short leave from the trenches on the 12th & that I myself have to leave for Italy after his departure I am hoping that no delay will be caused at Queenstown perhaps you will be kind enough to write to them to that effect. I would like to start as soon as possible for Queenstown as I myself will bring over the ashes to Queenstown, Sunday if possible or Sat.
>
> Thanking you very much for your sympathy & kind attention to this matter.

Cunard's Queenstown office had made all the preparations necessary for Miss Jolivet's arrival, and they wrote to the company's General Manager in Liverpool on 10 January to give him this account of Miss Jolivet's visit:

> ... The lady arrived here this forenoon and left again by 3.p.m. mail. We had the grave opened and ready for the interment which was duly carried out. She seemed quite pleased with the arrangements made, and expressed her gratitude for the attention shown to her here. She paid all expenses.

Thomas 'Risca' Williams used his fame as a *Lusitania* survivor to promote a series of lectures and concerts for many years after the sinking. These two posters date from 1919 and 1920.

WORLD'S GREATEST SEA HORROR
SINKING OF THE
LUSITANIA

THRILLED MILLIONS

NONE SHOULD MISS IT

SENSATIONAL LECTURE
BY RISCA WILLIAMS WITH THE
ROYAL WELSH CONCERT CO.

Describing this fearful disaster and his 200-foot plunge for life amidst a struggling mass of drowning men, women and children

Hon. Wm. Jennings Bryan Says:
"A LECTURE ONE WILL NEVER FORGET"

STRAT-FORD CONG'L CHURCH
AUSPICES MENS CLUB

STRATFORD, CONN. ADMISSION 50c MON., JAN. 12 8:00 P M

LUSITANIA SURVIVORS

SECOND PRES. CHURCH MON. 17 8:15 P.M.
ADMISSION 50c AUSPICES CHURCH WORKERS SCRANTON, PA. NOV.

THE
ROYAL WELSH CONCERT CO.
SURVIVORS OF THE WORLD FAMED ROYAL GWENT WELSH SINGERS
SAVED FROM THE LUSITANIA DISASTER

APPEARED AT
COLOSEUM
LONDON
ENGLAND

APPEARED AT
CARNEGIE
HALL
NEW YORK

A
Guaranteed
Attraction

De Owen Jones
Director of Tour

RISCA WILLIAMS, Famous Baritone, Author and Composer
BEN DAVIS MISS GENEVIEVE ANDREWS
Eminent Welsh Tenor Gold Medalist-Solo Pianist and Accompanist

Original posters from the author's collection

In early January 1922, one of the earliest proposals for a monument to those lost was unveiled by French sculptor Georges du Bois. Standing 80 feet high, it was to be erected over the wreck. The plan was to anchor the sculpture to the bottom and have cables run to shore that would permit the monument to be illuminated at night and serve as a beacon to mariners. This is the preliminary clay model.

An early design from 1927 for the proposed Jerome Connor memorial.

123

Scott Square (now Casement Square) in Queenstown before the work on the *Lusitania* memorial began.

This rendering of Jerome Connor's proposed '*Lusitania* Peace Memorial' was released in September 1932. A bronze tablet was to bear the names of all the victims, and the inscription was to read: 'To the Memory of All Who Perished by the Sinking of the *Lusitania*, May 7, 1915, and in the Cause of Universal Peace This Monument is Erected.'

The half-finished memorial near the end of 1946.

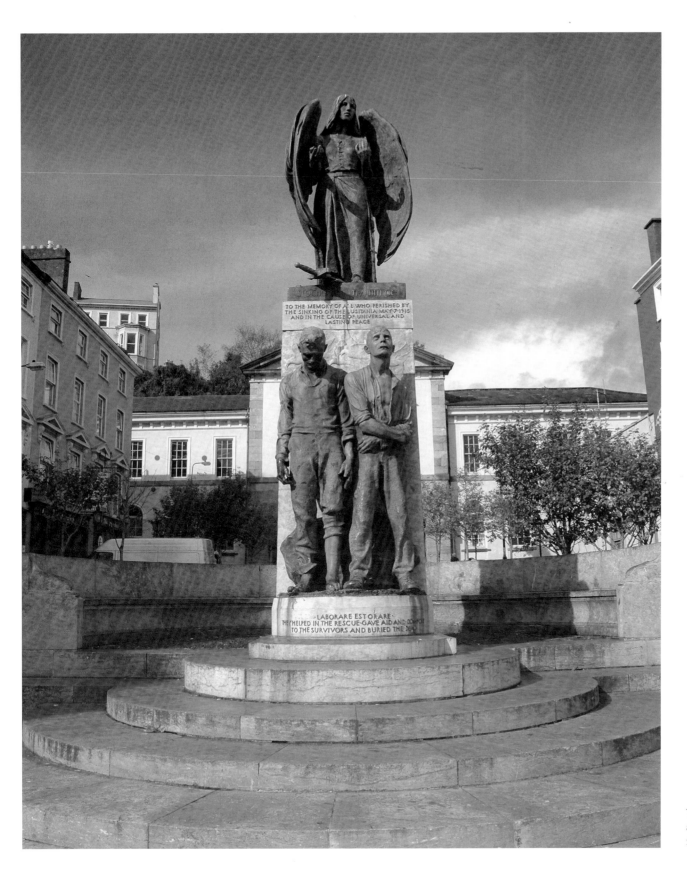

TO THE MEMORY OF ALL WHO PERISHED BY
THE SINKING OF THE LUSITANIA MAY 7 1915
AND IN THE CAUSE OF UNIVERSAL AND
LASTING PEACE

LABORARE EST ORARE
THEY HELPED IN THE RESCUE GAVE AID AND COMFORT
TO THE SURVIVORS AND BURIED THE DEAD

The Jerome Connor Memorial
as it stands today in Casement
Square.

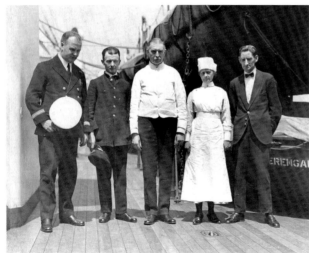

On 7 May 1926, five Cunard crew members, who were also *Lusitania* survivors, took part in a remembrance of the sinking on board *Berengaria*. From left to right are William H. Harkness, Frederick G. Webster, William Barnes, Eliza Craig, and G.H.B. Fletcher. All had been crew on *Lusitania* except Webster, who was travelling as a second-class passenger with his wife Margaret and their three children. Margaret, Frederick Jr, and Henry were lost. Frederick Sr and his son William survived.

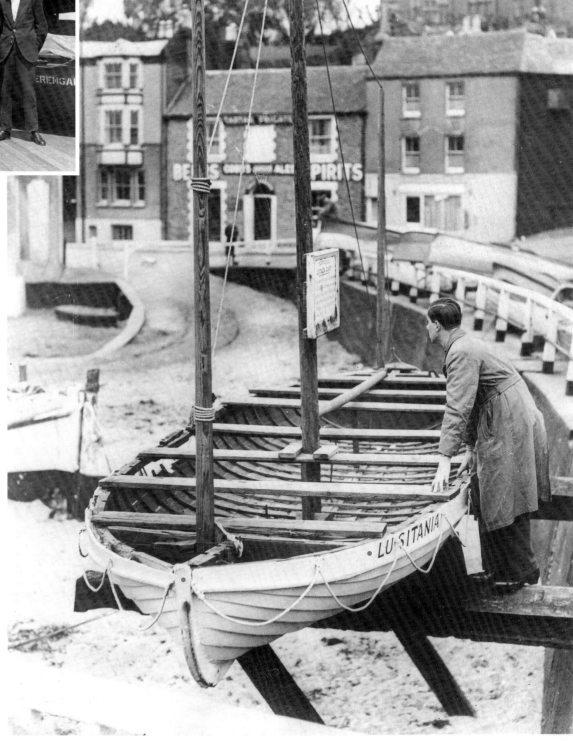

This *Lusitania* lifeboat was used for propaganda purposes before being donated to the Broadstairs Town Council on 17 June 1917. As late as 1947, the boat was still on display. This is the same boat as seen on page 109.

7

A SILENT GREYHOUND

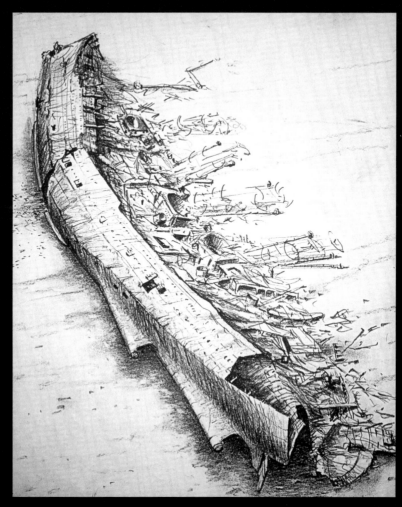

Sketch by Ken Marschall, author's collection.

The wreck of *Lusitania* lies 11.2 miles south and 3 degrees west of Old Head of Kinsale in approximately 300 feet of water on a solid granite bottom. In the century since she sank, there has been no subsidence of the wreck into the sea floor, and very little silting has occurred. The ship came to rest on her starboard side, and she remained in good condition for the next several decades. Images of the wreck from the 1960s, however, show that deformation of the hull had begun, but was not well advanced. Sometime in the 1970s there was a complete collapse of the hull, which became racked out of shape, and now both the starboard side of the vessel and her bottom rest flat on the sea floor, pulling the decks out of alignment and freeing many of them from their attachment points on the port side.

Because of the way the wreck collapsed, the superstructure slid off and has, for the most part, turned into a mass of tangled debris. Little of what is left is easily recognisable, but after the 1993 expedition, an analysis of more than eighty hours of video footage and several thousand photos was conducted by the expedition historians, which resulted in dozens of recognisable features and important locations within the ship being found. Areas down to the level of Upper Deck are clearly visible in the debris. With very few exceptions, there is no interior space remaining between decks in the passenger areas.

Among the best-preserved parts of the wreck is the forecastle although by 1993 this had begun to deteriorate as well, with the heavy machinery beginning to fall through to the deck below. The stem bar and forefoot are severely damaged from the ship's collision with the

As early as October 1915, a gentleman in France wrote to Cunard proposing a plan to dive to the wrecks of *Lusitania* and *Arabic* after the war. He suggested that each liner could be reached through a metal casing as long as the ships did not lie at a depth of more than 100 metres. Cunard passed the letter along to George Dodd, the company's Marine Superintendent, to get his opinion. Dodd replied that 'regarding a suggestion for reaching the "Lusitania" wreck, there is nothing in this; it looks as if the inventor has not worked out his proposition, and it is only a theory ... We do not propose to do anything further regarding the "Lusitania".'

A few other schemes came and went during the following years, and in the early 1930s, Simon Lake developed a plan for salvagers to reach the wreck using a hollow metal tube. This would have given the first look at *Lusitania* since the day she sank, but despite the fact that the tube was built, the expedition never came to pass.

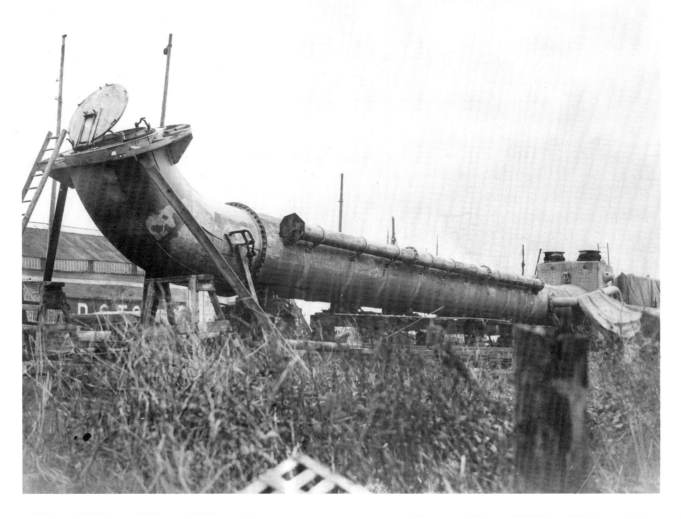

THE SHIP IN RARE ILLUSTRATIONS

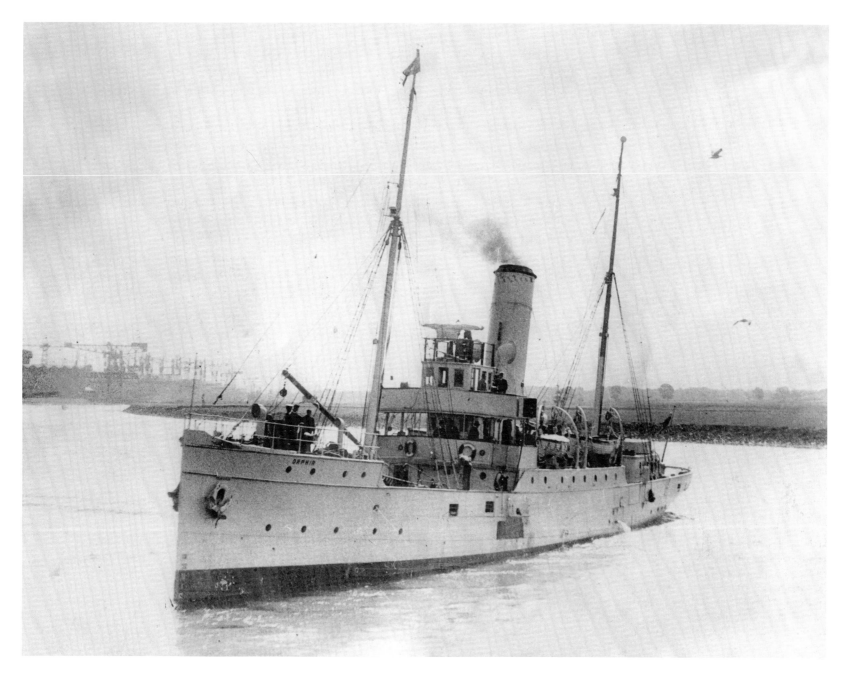

bottom. The hull is broken completely into two pieces and the separation goes right through the centre of the first-class Lounge and the Dining Room below, all the way through to the No. 4 boiler room.

Several implosion holes that appear in the hull in the area of the bridge seem to suggest the possibility of the wreck having been depth charged, probably during the anti-submarine activity of the Second World War. It is very doubtful, however, that the British Government tried to obscure her identity by blasting at the wreck for the simple reason that the brass letters spelling out 'Lusitania' are still clearly visible on the bow. If the government were trying to hide the wreck's identity, it is certain that the name on the bow and stern would have been removed. Nearly all of the damage is certainly nothing more than natural decay.

Most of the area around the stern has never been thoroughly examined, so very little reliable information

In 1935, the former lighthouse-service boat *Orphir* located the wreck of *Lusitania* using an Admiralty depth recorder, and it was reported that the wreck was found at a depth of 312 feet. Among the crew on the search were two *Lusitania* survivors – Third Officer Bestic and Second Steward Robert Chisholm.

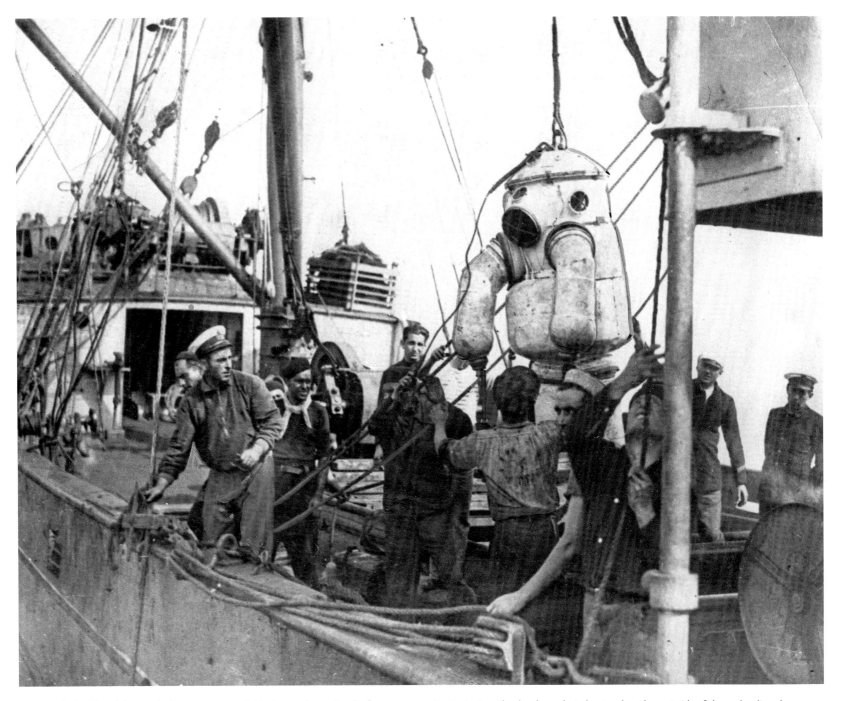

Once *Orphir* had found the wreck, diver Jim Jarrat made his descent, becoming the first man to see *Lusitania* since the day she sank. As he stood on the port side of the sunken liner, he reported back to the surface: 'I am standing on the plates of the ship: I can see her rivets. The hull is covered with slime, but under it there is a little corrosion. I will measure the rivets. They are about 2 inches.' During Jarrat's ascent, his dive suit was caught by an anchor, which almost cost him his life. He never got back down to the wreck because of bad weather. Further dives were scheduled in 1936, but they were called off because of Hitler's march into the Rhineland and the rumblings of the Second World War.

can be given about its condition, although the entire counter has fallen off and has yet to be found or examined.

Numerous schemes to salvage the wreck had been proposed, but the exact location of her final resting place remained unknown for twenty years. In 1935, the *Orphir* located what was believed to be the wreck although no diving was carried out. Later that same year, a diver named Jim Jarrat became the first person to see *Lusitania* since the day she sank. Testing a new type of diving suit, he was able to reach the wreck and walk around for a few minutes on her shell plating. An expedition was planned for 1937, which would have sent back real-time live images from the wreck site. According to diver John D. Craig, the tentative broadcast was scheduled for 6 May 1937. The expedition never took place, but Craig wrote:

It was on that evening that we had tentatively scheduled a broadcast from the *Lusitania*, on the evening of her fatal anniversary. At the time we would have been broadcasting, radios all over the world were flashing news of the *Hindenburg* disaster. We would have been pushed off the air had we been ready to go ...

The first serious dives to *Lusitania* began in the early 1960s. They were conducted by an American diver, John Light, who had bought the wreck from the Liverpool & War Risks Commission for the sum of £1,000 (about $2,800 in 1960s money). He began a series of dives which attempted to disclose for the first time the wreck's true condition and what had happened on that distant 7 May 1915. Light's dives were unsuccessful in reaching their goals for several reasons, one of which was that mixed-gas diving was still several years away and he was making his descents on compressed air at more than twice the recommended depth. He did, however, bring back the first film of the wreck, and even just the few publicly available clips show her in still reasonably good condition.

After Light's dives in the 1960s, the wreck remained undisturbed until 1982, when an expedition lead by Oceaneering International arrived at the site and performed a series of salvage dives over the course of six weeks. Using saturation divers, their examination of the wreck concentrated on several areas of the ship and huge parts of *Lusitania* were not even seen. A number of very important artifacts were salvaged, however. A second expedition was planned for 1983, but because of legal entanglements, this never came to pass. Oceaneering now claims that all of their files regarding the expedition have been lost.

In 1993, an expedition visited the wreck, using Remotely Operated Vehicles (ROVs) and a two-man submersible. For nearly two weeks the wreck was examined and thousands of photographs were taken. Although there have been numerous free dives to the wreck since 1993, much of the information and photos that were obtained from these visits have never been made available to the public for independent examination and analysis.

A dive team visited the wreck in 2011 and recovered several artefacts, including a telemotor, engine telltale (which shows what direction the turbines were running), a Boat Deck window, and portholes. It is hoped that these artifacts will eventually be given to an Irish museum for permanent display.

An early annotated side-scan image of the wreck.

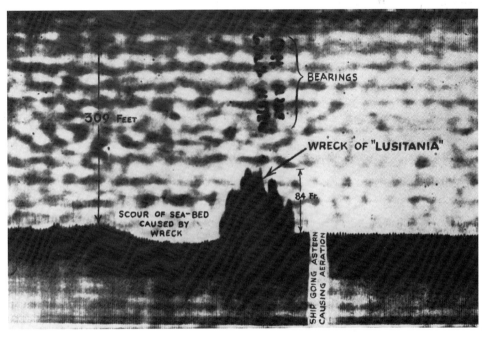

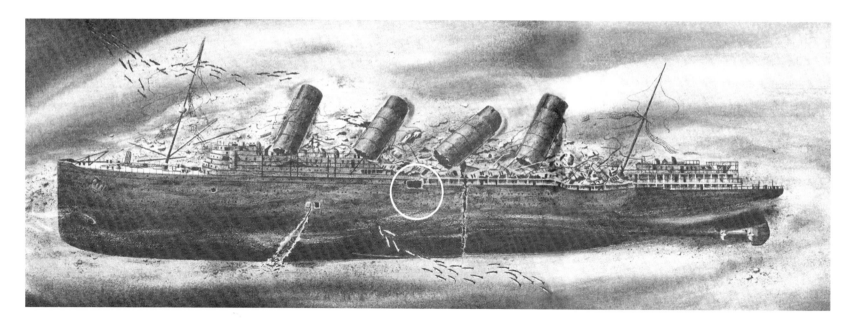

John Light purchased the wreck of *Lusitania* for £1,000 from The Liverpool and London War Risks Insurance Association Ltd. Through the 1960s, Light's team made 130 dives to the wreck, forty-two of which Light made personally. Although many of Light's observations turned out to be incorrect, what should be remembered is that he was diving on air at a depth of 300 feet, far beyond the limits of safe diving at the time.

The above rendering of the wreck shows what Light said he observed. Unfortunately, it is not possible to know exactly how accurate this depiction is because it appears the superstructure had completely collapsed by the 1982 expedition. However, from the few available seconds of footage taken of the wreck by Light and his team, it is evident that *Lusitania* was still in fairly good condition in the 1960s.

The circled area is where Light thought he saw signs of tampering with the wreck. See the image at right for a close up of what he described. Unfortunately, no photographic evidence of this hole exists; so we will never know exactly what Light saw.

EPILOGUE

In the 1927 annual report to the company's shareholders, Cunard's Chairman Sir Thomas Royden made special mention that the 1903 agreement with the British Government that had created *Lusitania* and *Mauretania* was to end on 16 November with the final £130,000 payment on the loan. He said:

> With the knowledge we have acquired since the agreement was made it is unlikely that any arrangement on similar lines will be made by this company with His Majesty's Government in the future.

This is a curiously honest statement. It is clear from Royden's comment that Cunard of 1927 — a post-war Cunard with all its war losses, a post-immigration Cunard, a Cunard dealing with the war's aftermath and the subsequent massive increase in shipbuilding costs and its resulting debt — was not happy with the terms of the 1903 agreement, but the contract is certainly what saved the company from collapse. Hindsight is always 20/20, but at the time the agreement was signed, Cunard had little choice if they wanted to survive. Without the subsidy that created *Lusitania* and her sister,

Cunard would ultimately have been absorbed by another line and ceased to exist.

With her important place in Cunard history, it is unfortunate that *Lusitania* is remembered today for the final eighteen minutes of her career rather than what she accomplished during the prior seven and a half years in advancing shipbuilding and transatlantic transportation. What's more, the *Lusitania*'s sinking did more to hurt the German cause than to help it. How different would history have been if Walther Schwieger had allowed the liner to reach her destination, depriving the British propaganda machine of one of their most valued 'assets'. It is tempting to consider what would have happened had *Lusitania* reached Liverpool as scheduled on 8 May and survived the war. Like most other large pre-war liners, she certainly would have continued in service until the Great Depression and probably would have sailed in various capacities trying to earn her keep until the mid-1930s, when she would have joined the 'parade to the block' after the merger of Cunard and the White Star Line. Because of the decision of a single man, *Lusitania* is still with us while nearly every other liner is gone.

With the passing of Audrey Pearl Lawson Johnston, the last survivor of the sinking, on 11 January 2011, the final living link with the ship was gone, and *Lusitania* became merely photos in a book and words on a page. As the decades pass, *Lusitania* becomes a little less recognisable. Her once elegant staterooms and lounges where passengers spent leisurely days in mid-Atlantic, now host only schools of fish. Her engines, once the pride of Cunard's engineers, are frozen and will never again astonish the world with a new speed record. She is now nearly forgotten to the world at large aside from a few dedicated historians and brief mentions in history books.

With the quickening deterioration of the wreck, physical evidence of what sent *Lusitania* to the bottom is disappearing, and the answer to that question will probably always remain a mystery.

After the tragic, deliberate destruction she suffered and the worldwide controversy surrounding her loss for the past century, she may yet take this one secret with her through eternity.

In this photo from June of 1969, John Light and his crew of divers examine a diving bell to be used in their salvage expedition to the wreck. They are on board the salvage ship *Kinvarra*, a converted 383-ton trawler. The expedition never took place, but the divers had planned to spend periods of fourteen days inside the diving bell. They hoped to retrieve 1,500 tons of non-ferrous metal, copper bronze, gunmetal and brass, as well as the ship's propellers, which were expected to fetch a total of about £37,000.

SALVAGED ITEMS

In 1982, a salvage expedition to the wreck of *Lusitania* was conducted by Oceaneering International, and during the six-week operation thousands of artefacts were recovered – from small items like spoons to three of the liner's four propellers. In 1989, the crow's nest bell and whistle from the second funnel were auctioned in London. Because of the low prices realised, the remaining artefacts were not publicly auctioned but were sold at a private, sealed-bid auction in 1990. Nearly all the available artefacts were purchased, but for some reason a number of items were not listed as for sale. These were eventually disposed of without anyone having the opportunity of purchasing them. Here is a gallery of some of the fascinating items recovered.

Two of *Lusitania*'s three anchors were recovered. The anchor in the centre of this photo at right is not from *Lusitania*, and the liner's starboard anchor remains in place on the wreck.

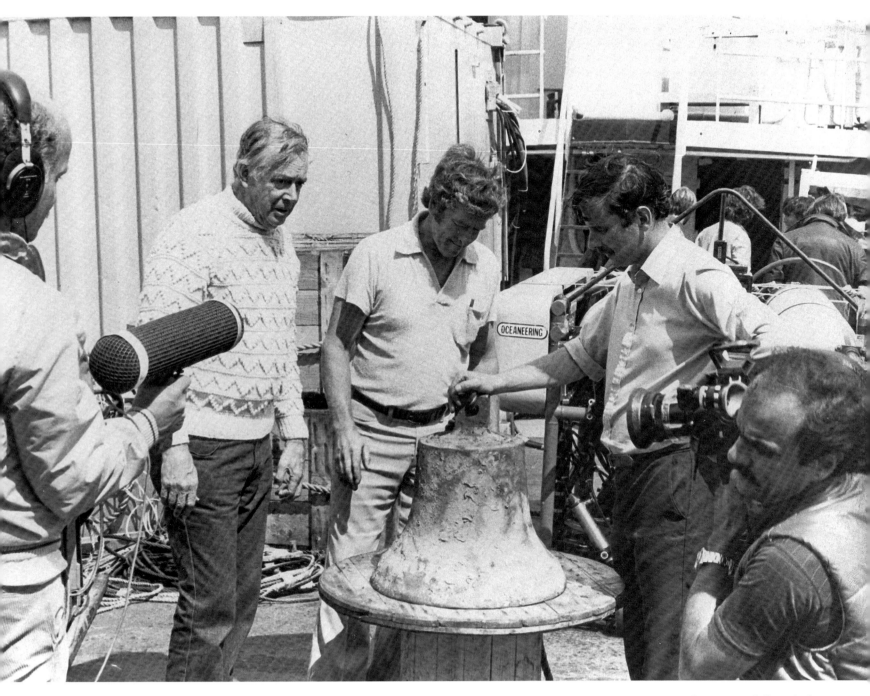

The crow's nest bell was the first
item brought to the surface.
In 1989, it was offered for sale
at Sotheby's in London with an
auction estimate of £15,000.
If the sale had gone well,
Oceaneering would have publicly
auctioned the thousands of
other recovered artefacts.

Prismatic skylights were located on the forecastle and fantail and allowed natural light into interior spaces of the ship. Four were recovered. See archival photo below for two *in situ* on the forecastle.

Prismatic skylight from the author's collection

The whistle from the second funnel was also put up for auction in 1989. The price estimate for this superb artefact was £3,000.

Whistle from the author's collection

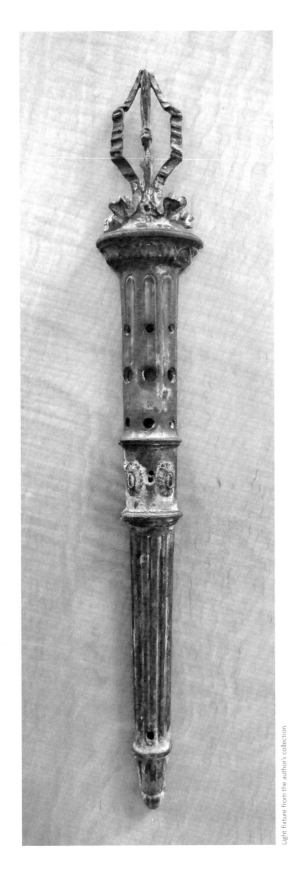

Light fixture from the author's collection

This partial torch light fixture comes from either the first-class Entrance on Boat Deck or the first-class Dining Room. The remains of the gilding can still be seen.

The green marble pillar bases (shown here) from the forward end of the first-class Lounge. For comparison, the archival photo shows the pair from the aft fireplace because, unfortunately, no clear photo of them *in situ* from the forward end of the room has been found. The view bottom left shows them after a quick cleaning with some warm water.

Rosette from the author's collection

Very few rosettes like this are visible in archival photos. As far as can be determined, this one may have come from the fireplace in the Boat Deck Entrance.

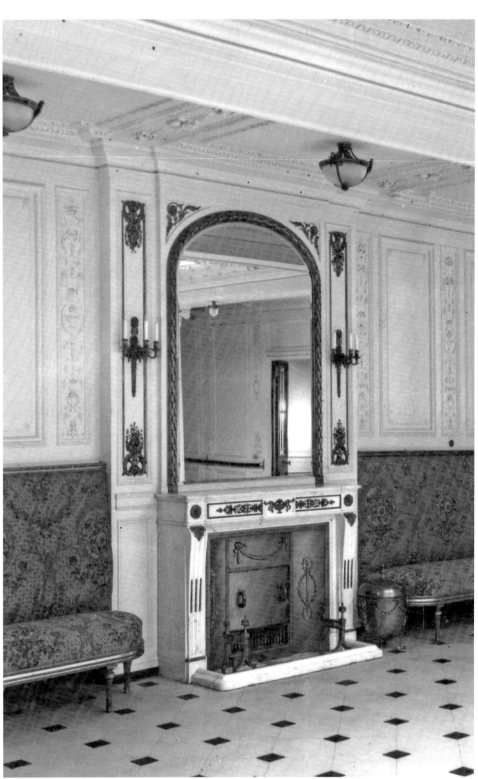

A round vent inlet from the first-class Entrance on Boat Deck, on which white paint can still be seen.

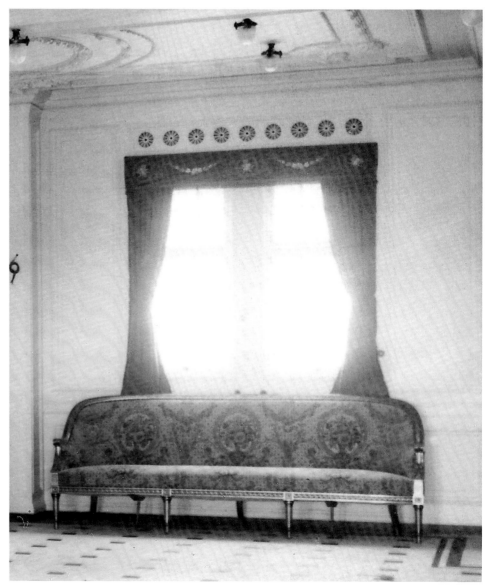

Vent from the author's collection

Glass panel from the author's collection

This pane of acid-etched window glass is from one of the forward first-class public areas on Boat Deck, most likely the Entrance or the Lounge. Not only did it survive the sinking in one piece but also the collapse of the wreck. Once salvaged, it was wrapped in a thin piece of cardboard and placed in the bottom of a box with heavy metal fittings placed on top of it. After all that it went through, it is amazing that it is intact.

This pattern of china was used in first class on *Lusitania* and *Mauretania* for a brief period before the First World War and appears in a single archival image of *Lusitania*'s Dining Room. This pattern can be found scattered on the wreck itself as well as throughout the debris field.

Although it was not known at the time of recovery, one of the most surprising finds during the expedition was a few reels of film for the silent movie *The Carpet from Bagdad*. Although the film was not in viewable condition, individual frames from the film were able to be saved.

In 1982, several hundred fuses were recovered from the wreck, and this was the first time that physical evidence of her carrying munitions had been found. During a dive to the wreck in a submersible in 1993, the author saw a number of them lying on the hull.

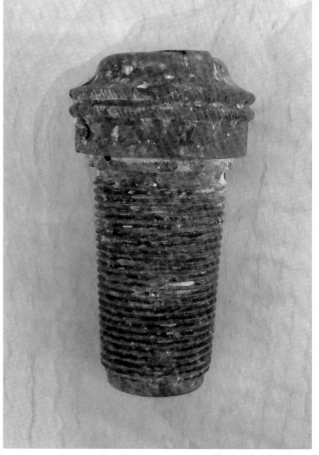

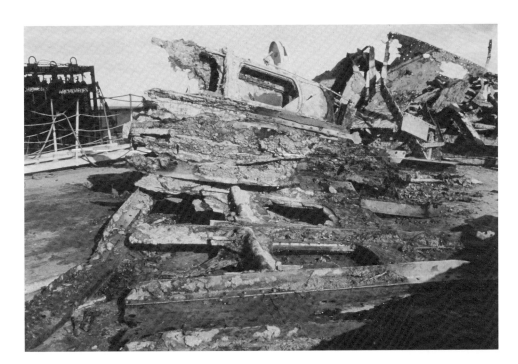

One large section of superstructure was salvaged with several window frames still embedded in it. Unfortunately, because no one on the recovery expedition knew the ship well, it is not known which part of the wreck this piece was from. What became of it and the numerous windows is a mystery.

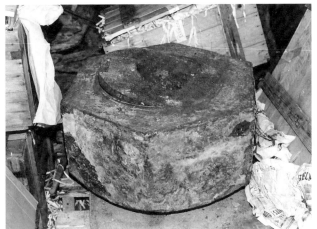

A securing nut for one of the propellers.

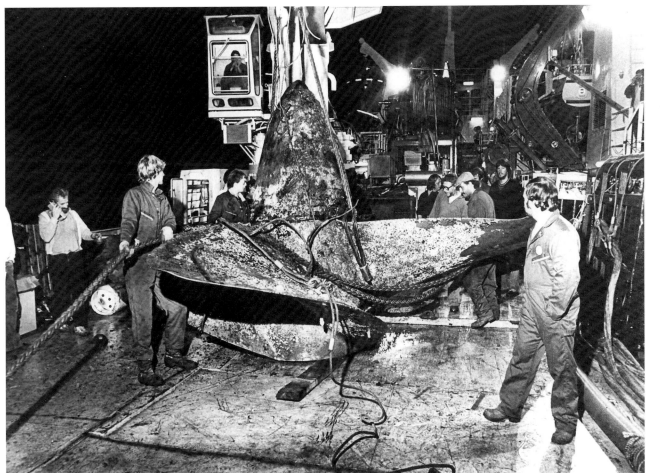

Three of *Lusitania*'s four propellers were blasted from their shafts using plastic explosives. The fourth propeller remains attached to the ship. As a sad ending to the life of one propeller, it was melted down and turned into sets of commemorative golf clubs.

THE PEOPLE

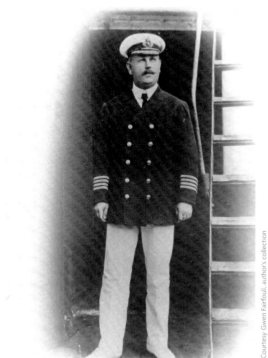

James Clarke Anderson, Staff Captain. Lost.

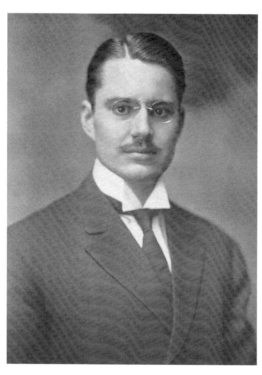

Lindon Wallace Bates, Jr, first class. Lost.

Elise Schauring Bouteiller (lost) & Virginia Loney (saved), first class.

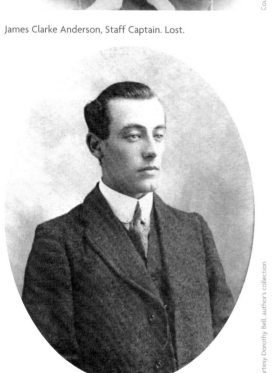

Harold Chantry, second class. Lost.

Mina Chantry, second class. Lost.

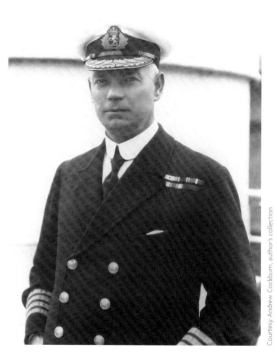

Andrew Cockburn, Senior Second Engineer. Saved.

Edwin Martin Collis, second class. Saved

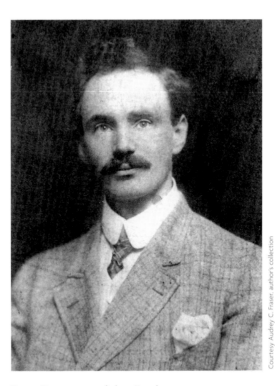

Ernest Cowper, second class. Saved.

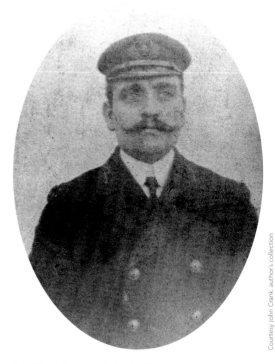

John Crank, Baggage Master. Lost.

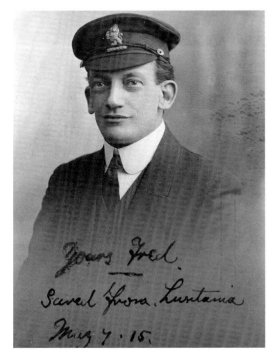

John Frederick Deiner, first-class waiter. Saved.

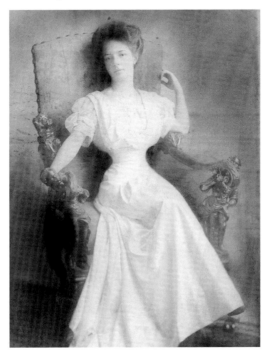

Mary Picton Stevens Hammond, first class. Lost.

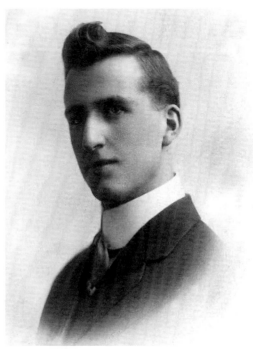

Percy Hefford, Second Officer. Lost.

Courtesy Audrey C. Fraser, author's collection

Courtesy John Crank, author's collection

William Hendry, first-class waiter. Saved.

Dean Hodges & William Hodges, Jr, first class. Both lost.

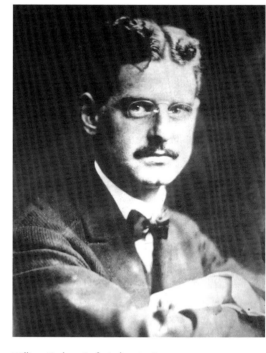

William Hodges, Sr, first class. Lost.

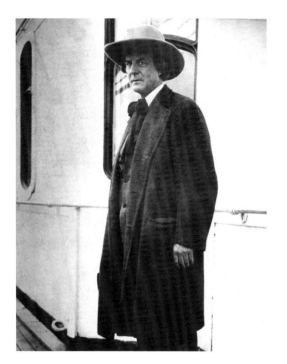

Elbert Green Hubbard, first class. Lost.

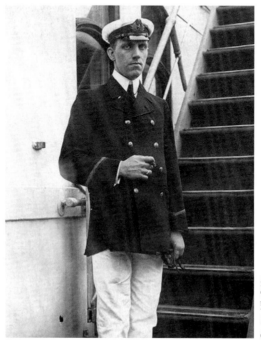

George Hutchinson, 1st Electrican. Saved.

Courtesy Mike Poirier

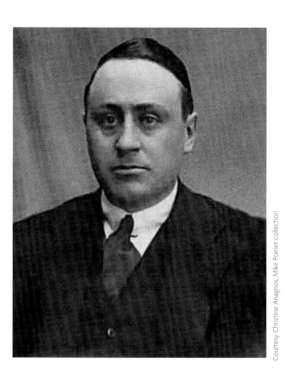

Charles Thomas Jeffery, first class. Saved.

Courtesy Christine Anagnos, Mike Poirier collection

Courtesy Alice Lines Drury, author's collection

Alice Maud Lines, first class. Saved.

Courtesy Kit Abbott Mead & Patricia Abbott Michl, Mike Poirier collection. From the book *Into the Danger Zone*

Allen Donnellan Loney, first class. Lost

Courtesy Kit Abbott Mead & Patricia Abbott Michl, Mike Poirier collection. From the book *Into the Danger Zone*

Catharine Wolfe Brown Loney, first class. Lost.

Courtesy Karen Kingswell, author's collection

Harry Long, third class. Saved.

Francis John Lucas, second class. Saved.

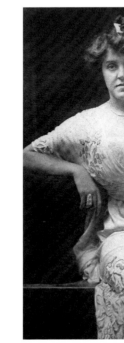

Courtesy Harding Macdona, Mike Poirier collection

Amelia Bishop Herbert Macdona, first class. Lost.

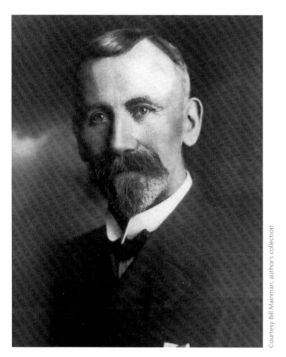

Courtesy Bill Mainman, author's collection

Alfred Reid Mainman, second class. Lost.

Courtesy Bill Mainman, author's collection

Alfred S. Mainman & John V. Mainman, second class. Both lost

Courtesy Elsie Hook Hadland, author's collection

George & Elsie Hook, Anna Marsh (right), third class. All saved.

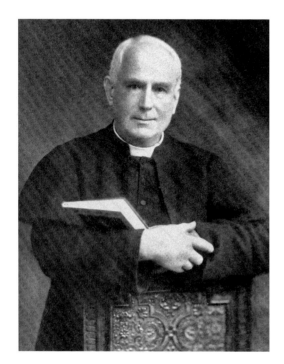

Fr Basil William Maturin, first class. Lost

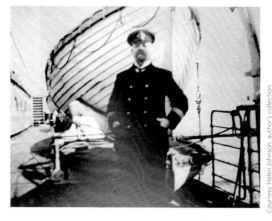

Courtesy Helen Johnson, author's collection

James Alexander McCubbin, Purser. Lost.

Frederick John Milford, second class. Saved.

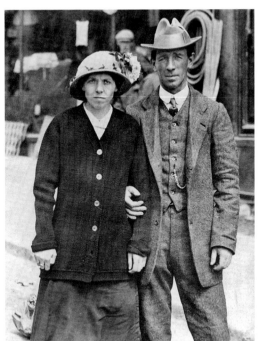

Fannie Jane Morecroft, Stewardess. Saved.

Gerda Theoline Neilson & John Welsh, third class. Both saved.

Charles Edwin Paynter, first class. Lost.

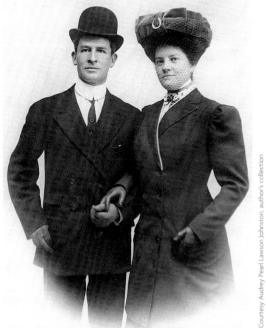

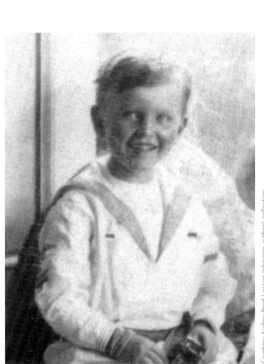

Amy Whitewright Warren Pearl & Susan Whitewright Pearl, first class. Both lost.

Frederic Warren Pearl & Amy Lea Pearl, first class. Both saved.

Stuart Duncan Day Pearl, first class. Saved.

149

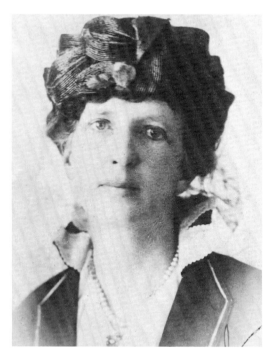

Mabel Pearson, first class. Lost

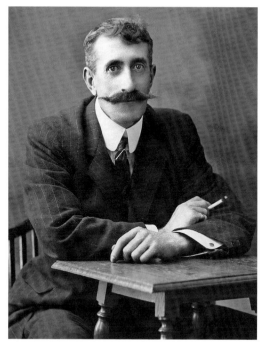

John Teather Piper, Chief Officer. Lost.

Courtesy Prudence Jones, author's collection

Harriet Plank, second class. Saved.

Courtesy Margaret Collister, author's collection

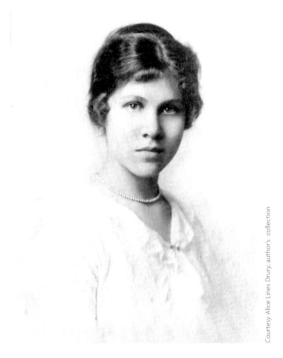

Courtesy Alice Lines Drury, author's collection

Greta Anna Jacobina Reuter-Lorentzen, first class. Lost.

Courtesy Cecil Richards, author's collection

Cecil Henry Richards and Thomas Percy Richards, second class. Both saved.

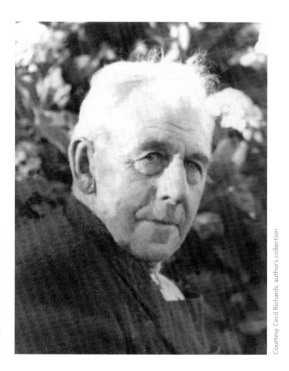

Courtesy Cecil Richards, author's collection

Thomas Henry Richards, second class. Saved.

Courtesy Tony Scott, author's collection

Courtesy Hallie Slidell, author's collection

Thomas Slidell, first class. Saved.

Arthur Scott, third class. Saved.

George Scott, second class. Saved.

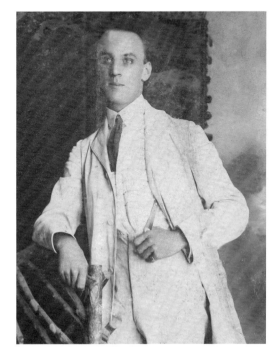

Henry Becker Sonneborn, first class. Lost.

Alfred Gwynne Vanderbilt, first class. Lost.

Harold Stanley Venn, second class. Lost.

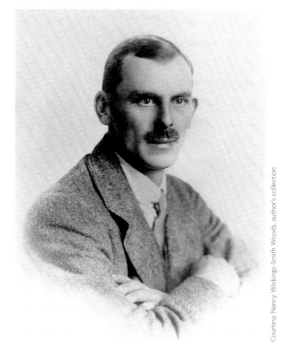

Cyril Wickings-Smith, second class. Saved.

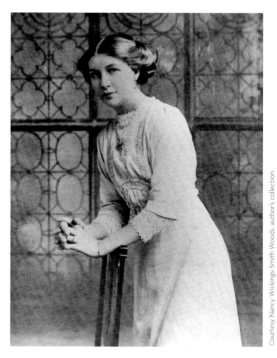

Phyllis Bailey Fenn Wickings-Smith, second class.

Annie Williams, third class. Lost.

Ethel Williams & Florence Williams, third class. Both lost.

APPENDIX 1

'Lusitania' Loss 7th May 1915.

Statement Showing Receipts and Payments in Connection with Lifeboats and Rafts Salved from This Vessel.

1915		£
Aug. 18	Receiver of Wreck. Kinsale.	1. 7. 2.
Sep. 23	Receiver of Wreck. Appledore.	4. 9.
Oct. 31	Thos. Ensor & Sons. Cork. Same of 2 boats	6. 0. 0.
Nov. 30	Jno. E. Levis. Skibbereen. Sale of 2 boats	4. 0. 0.
Nov. 30	G.S. Kelway. Sale of Boats at Cardiff	6. 0. 0.
Dec. 23	Receiver of Wreck. Fenit—sale of small articles.	5. 2.
1916		
Feb. 8	Receiver of Wreck. Baltimore. Sale of small articles.	4. 5. 10.
Feb. 16	J. Beamish. Skibbereen. Sale of 1 boatraft.	2. 0. 0.
Feb. 19	Dr. Macaura. Skibbereen. Sale of 1 lifeboat and 4 boatrafts.	10. 0. 0.
Nov. 1.	Receiver of Wreck. Fenit. Sale of 2 boatrafts.	11. 9.
Apl. 10	Receiver of Wreck. Baltimore. Sale of 2 lifebelts.	12. 6.
Apl. 10	Receiver of Wreck. Kinsale. Sale of 2 boatsails.	5. 2.
May 30	2 Collapsible Boats sold at Castletownbere & Schull.	3. 0. 0.
May 30	O'Reilly, Queenstown. 2 Deck Chairs sold	5. 0.
June 30	Receiver of Wreck, Limerick. 10 Oars	9. 11.
June 30	Receiver of Wreck. Kinsale. 2 lifebuoys.	6. 5.
	Total:	39. 13. 8.

INVENTORY OF ITEMS RECOVERED FROM THE WRECK OF THE *LUSITANIA*

Note: This inventory is compiled from two different lists produced at the time of salvage. A number of items were incorrectly identified by the salvagers on the original inventories, and as far as possible the correct description of each item appears below in the notes column, which was compiled by the author.

 The 'where recovered' column is taken directly from the Oceaneering lists. Because the divers were not familiar with the ship, the recovery location listed may not be correct.

Description	Quantity	Where recovered	Date recovered	Notes
Bell	1	Seabed		Crow's nest bell
Brass window frame	1	Aft from seabed	10 Sept 1982	Thermotank trunk inlet frame 24¾ inches x 12¼ inches
Ship's telegraph with pedestal complete with handle and chain (brass)	1	Forecastle area	12 Sept 1982	A docking or anchor telegraph Recovered from the bridge debris
Forecastle Deck light panels	3	Forecastle area	12 Sept 1982	Prismatic skylights 2 off 14 inches x 12 inches 1 off 14 inches x 8 inches Three are listed but four were recovered
Large pipe with bell-mouth end 11 feet x 12 inches copper	1	Seabed	13 Sept 1982	Waste steam pipe from the No. 2 funnel
'Minton' child's chamber pot (ivy leaf pattern)	1	No. 3 funnel area and grand entrance	13 Sept 1982	No Cunard markings Probably not in-service equipment
Wedgwood plates with Cunard crest	60-70	No. 3 funnel area and grand entrance	13 Sept 1982	'Spiderweb' pattern
Minton jug, damaged	1	No. 3 funnel area and grand entrance	13 Sept 1982	Blue delft pattern. This is the only piece of this pattern recovered

Assorted dishes, slight damage	Unknown	No. 3 funnel area and grand entrance	13 Sept 1982	'Spiderweb' pattern
Wedgwood plates, damaged	Unknown	No. 3 funnel area and grand entrance	13 Sept 1982	'Spiderweb' pattern
Large brass window frame with metal filigree work	1	No. 3 funnel area and grand entrance	13 Sept 1982	3½ feet x 2½ feet
Handwheel & gears, brass	1 set	No. 3 funnel area and grand entrance	13 Sept 1982	Watertight door control from Shelter Deck
Narrow brass window	1	No. 3 funnel area and grand entrance	13 Sept 1982	Thermotank trunk inlet frame
Porthole	1	No. 3 funnel area and grand entrance	13 Sept 1982	
Porthole frame	1	No. 3 funnel area and grand entrance	13 Sept 1982	
Silver-plated spoons. Kitchener head on handle	244	Specie Room	15 & 19 Sept 1982	The number listed here is preliminary. The final number of these spoons recovered was 6,270
Brass boxes containing chronometers	361	Specie Room	15 & 16 Sept 1982	Watch mechanisms
1 full reel and ¼ reel of film	2	Specie Room	19 Sept 1982	These reels are from the silent movie *The Carpet from Bagdad*. It is the only copy known to exist
Wooden box – spoon container	1	Specie Room	19 Sept 1982	This box apparently held some of the Kitchener spoons
500Kz Sonar Fish – Decca	1	Stern area	19 Sept 1982	This was lost on the wreck in April 1982 during the initial survey of the site
Odd pieces of picture framework and fragments of paper	n/a	Specie Room	19 Sept 1982	
Porthole (complete) some damage to flange during cutting process	1	Mail room area	22 Sept 1982	Surrounded by a section of shell plating
Porthole — shattered glass	1	Mail room area	22 Sept 1982	This is a pivoting sidelight
Length of piping – copper and brass	1	Seabed No. 3 funnel area	23 Sept 1982	
Large window frame	1	Seabed No. 3 funnel area	23 Sept 1982	Note in original inventory states 'Promenade or Boat Deck'
Ventilation unit complete with broken operating handle and lug, brass	1	Seabed No. 3 funnel area	23 Sept 1982	
Marble pillar bases	2	Seabed No. 3 funnel area	23 Sept 1982	From the forward end of the first-class Lounge
Ship's steam whistle	1	Seabed No. 2 funnel area	23 Sept 1982	4 feet x 6 inches. From the second funnel

Door frame portion – brass and wood	1	Seabed No. 2 funnel area	23 Sept 1982	Section of an exterior door. Original brass lock removed after salvage and lost. 6 feet x 2 inches
Propeller complete with nut (loose)	1	Stern area	30 Sept 1982	
Propeller complete with steel cone, shaft, and nut	1	Stern area	30 Sept 1982	
Sections of shell plating from hull	3	Mail and Specie Room	30 Sept 1982	These were cut from the hull to gain access to the Specie Room. These hull sections were discarded after the sealed-bid auction in 1990. They had not been offered to bidders
Detonators, military (fuses)	1 box	Specie Room	9 Oct 1982	
Shovel – bad condition	1	Specie Room	9 Oct 1982	Only the handle remained
Propeller complete with nut and some shaft minus steel cone	1	Stern area	9 Oct 1982	
Large gold watch (fob) cases, size 2	17	Specie Room	10 Oct 1982	
Medium silver watch cases	2	Specie Room	10 Oct 1982	
Small gold watch cases, size 6	6	Specie Room	10 Oct 1982	
Assorted watch cases	154	Specie Room	11 Oct 1982	
Spoons	2	Specie Room	11 Oct 1982	
Wrist watch case, silver plate	6	Specie Room	12 Oct 1982	
Watch case, gold	4	Specie Room	12 Oct 1982	
Watch case, silver plate	1	Specie Room	12 Oct 1982	
Lead curtain weight	2	Specie Room	12 Oct 1982	
Buttons, white	2	Specie Room	12 Oct 1982	
Lady's pince-nez, 1 glass only	1	Specie Room	12 Oct 1982	
Black leather clog	1	Specie Room	12 Oct 1982	
Brass cases complete with timepiece, large	39	Specie Room	12 Oct 1982	This count is changed later in the inventory to 131
Brass cases complete with timepiece, small	109	Specie Room	12 Oct 1982	This count is changed later in the inventory to 139
Assorted watch parts	1 bucket	Specie Room	12 Oct 1982	
Gold watch case, size 2	2	Specie Room	12 Oct 1982	
Gold watch case, size 6	6	Specie Room	12 Oct 1982	
Silver plated watch case, size 1	1	Specie Room	12 Oct 1982	
Brass cases complete with timepiece, large	92	Specie Room	15 Oct 1982	
Brass case, empty, large	1	Specie Room	15 Oct 1982	

Brass case, empty, small	30	Specie Room	15 Oct 1982	
Fuses, brass	813	Specie Room	15 Oct 1982	
Large brass ornamental piece from stern area	1	Specie Room	15 Oct 1982	6 feet x 2 feet Complete with 13 securing bolts
Assorted pieces of wood – brush back, handle, and picture frame parts		Specie Room	15 Oct 1982	Also included in this lot was part of a musical instrument
Old pieces of paper – Chinese wallpaper		Specie Room	15 Oct 1982	Patterned paper that appeared to be in flattened rolls.
Assorted items – pieces of china, pieces of metal, buttons and lead curtain weights, broken bottle parts.		Specie Room	15 Oct 1982	
Film (reels and part of)	2½	Specie Room	15 Oct 1982	These reels are from the silent movie *The Carpet from Bagdad*. It is the only copy known to exist

Totals handed over to R.O.W* Pembroke after final count as follows:

Spoons (Kitchener) – 6,270
Fuses – brass – 813
Watch cases – 200
Brass cases complete with timepieces (large) – 131
Brass cases complete with timepieces (small) – 139
Brass ornamental section complete with 13 securing bolts – 1
Propeller – 1

*Receiver of Wrecks

Brass curtain ring	1	Seabed adjacent to No. 3 funnel area	22 Oct 1982	
Brass rosette	1	Seabed adjacent to No. 3 funnel area	22 Oct 1982	
Brass vent plate	1	Seabed adjacent to No. 3 funnel area	22 Oct 1982	Round, decorative vent cover
Pen holder – wood and brass	1	Seabed adjacent to No. 3 funnel area	22 Oct 1982	
Brass ornamental piece from section of wall. Boat Deck grand entrance	1	Seabed adjacent to No. 3 funnel area	22 Oct 1982	Decorative back of sconce, missing arms
Rectangular piece of patterned glass	1	Seabed adjacent to No. 3 funnel area	22 Oct 1982	Intact acid-etched window pane from either the first-class Entrance or Lounge
Pieces of patterned glass	2	Seabed adjacent to No. 3 funnel area	22 Oct 1982	Shards from the windows of the first-class Smoking Room
Silver plate pepper pot	1	Seabed adjacent to No. 3 funnel area	22 Oct 1982	

Rail holder – plated brass	1	Seabed adjacent to No. 3 funnel area	22 Oct 1982	
Knives	4	Silver Room area	22 Oct 1982	
Fish knives	6	Silver Room area	22 Oct 1982	
Forks	15	Silver Room area	22 Oct 1982	
Small fork	1	Silver Room area	22 Oct 1982	
Teaspoons	3	Silver Room area	22 Oct 1982	
Server	1	Silver Room area	22 Oct 1982	
Table spoon	1	Silver Room area	22 Oct 1982	
Dessert spoon	4	Silver Room area	22 Oct 1982	
Mask, brass	1	Silver Room area	22 Oct 1982	Decorative piece from a first-class light fixture
Pepper mill complete with some peppers and base	1	Silver Room area	22 Oct 1982	Silver
Brass/copper plated rim, bent	1	Silver Room area	22 Oct 1982	Rim from first-class light fixture
Brass wall bracket	1	Silver Room area	22 Oct 1982	
Colusion?	1	Seabed No. 3 funnel area	23 Oct 1982	Probably brass interior part of lift operating mechanism
Large brass windows	6	Seabed No. 3 funnel area	23 Oct 1982	These were still embedded in a piece of superstructure and may be from the upper level of the first-class Dining Room
Window frames, small	2	Seabed No. 3 funnel area	23 Oct 1982	Ventilation inlet frames
Brass vent units complete with operating handles	2	Seabed No. 3 funnel area	23 Oct 1982	
Small oval brass porthole frame	1	Silver Room area	23 Oct 1982	Brass rim from entrance sign over exterior door
Circular porthole	1	Silver Room area	23 Oct 1982	
Brass cap/screw unit	1	Silver Room area	23 Oct 1982	
Anchors	2	Bow area	23 Oct 1982	
Copper ingot	1	Bow area	24 Oct 1982	
Reels of brass sheet	29	Bow area	24 Oct 1982	
Copper & brass bar	1	Bow area	24 Oct 1982	10 inches long
Box of suspender clip belts	1	Bow area	24 Oct 1982	
Floor drain valves	2	Seabed	24 Oct 1982	
Valve unit brass	1	Seabed	24 Oct 1982	Fire hydrant coupling
Large brass window	1	Stern area	25 Oct 1982	
Porthole complete	1	Seabed stern	25 Oct 1982	

Wedgwood plate, small with small chip	1	Silver Room area	25 Oct 1982	'Spiderweb' pattern
Small brass window frame	1	Stern area	25 Oct 1982	Thermotank trunk inlet frame
Wedgwood dinner plates	25			'Spiderweb' pattern
Wedgwood large dinner plate	1			'Spiderweb' pattern
Wedgwood side plates	33			'Spiderweb' pattern
Omelet or hors d'oeuvres dishes	5			
Wedgwood saucer	1			'Spiderweb' pattern
Baking dishes	2			
Hors d'oeuvres dishes	6			
Hot pot bowls	2			
Bottles	10			
Part of a wooden bottle rack	1			
Pressure gauge bodies	2			
Steel gear wheel plate	1			
Wall brackets	3			
Door hole frame	1			
Knives, plated	15			

RMS LUSITANIA
A HISTORY IN PICTURE POSTCARDS

ERIC SAUDER

9780750962803

Forthcoming from the author:

Using rare period postcards from his personal collection, maritime researcher Eric Sauder tells the history of Cunard's legendary *Lusitania* from construction to her tragic sinking in 1915 by a German torpedo. *Lusitania* was the largest liner in the world when she was built and was also technologically superior to anything that then existed, setting the standard for every transatlantic liner to follow. Her story is one of supreme triumph yet also devastating loss.

Through often previously unpublished postcards, this gripping maritime story is brought to life. These vivid postcards offer a fascinating glimpse into every part of the ship's career and loss, including construction, fitting out, trials, service, interiors, people, sinking, graves, and propaganda.

Available in the series:

THE UNSEEN OLYMPIC
THE SHIP IN RARE ILLUSTRATIONS

PATRICK MYLON

9780752466262

THE UNSEEN BRITANNIC
THE SHIP IN RARE ILLUSTRATIONS

SIMON MILLS

9780752497716

Visit our website and discover thousands of other History Press books.

www.thehistorypress.co.uk